The Opposite of Cold

The Opposite of Cold

The Northwoods Finnish Sauna Tradition

Michael Nordskog

PHOTOGRAPHY BY Aaron W. Hautala

FOREWORD BY David Salmela

INTRODUCTION BY Arnold R. Alanen

UNIVERSITY OF MINNESOTA PRESS
MINNEAPOLIS · LONDON

Published by the University of Minnesota Press
111 Third Avenue South, Suite 290
Minneapolis, MN 55401-2520
http://www.upress.umn.edu

Book design by Brian Donahue / bedesign, inc.

Library of Congress Cataloging-in-Publication Data

Nordskog, Michael.
 The opposite of cold : the northwoods Finnish sauna tradition / Michael Nordskog ; photography by Aaron W. Hautala ; foreword by David Salmela ; introduction by Arnold R. Alanen.
 p. cm.
 Includes bibliographical references and index.
 ISBN 978-0-8166-5682-0 (hc : alk. paper)
 1. Finnish Americans—Minnesota—Social life and customs. 2. Finnish Americans—Superior, Lake, Region—Social life and customs. 3. Sauna—Minnesota—History. 4. Sauna—Superior, Lake, Region—History. 5. Minnesota—Social life and customs. 6. Superior, Lake, Region—Social life and customs. I. Hautala, Aaron W. II. Title.
 F615.F5N67 2010
 977.6'0049541—dc22
 2010019418

Printed in Italy on acid-free paper

The University of Minnesota is an equal-opportunity educator and employer.

16 15 10 9 8 7 6 5 4 3

Contents

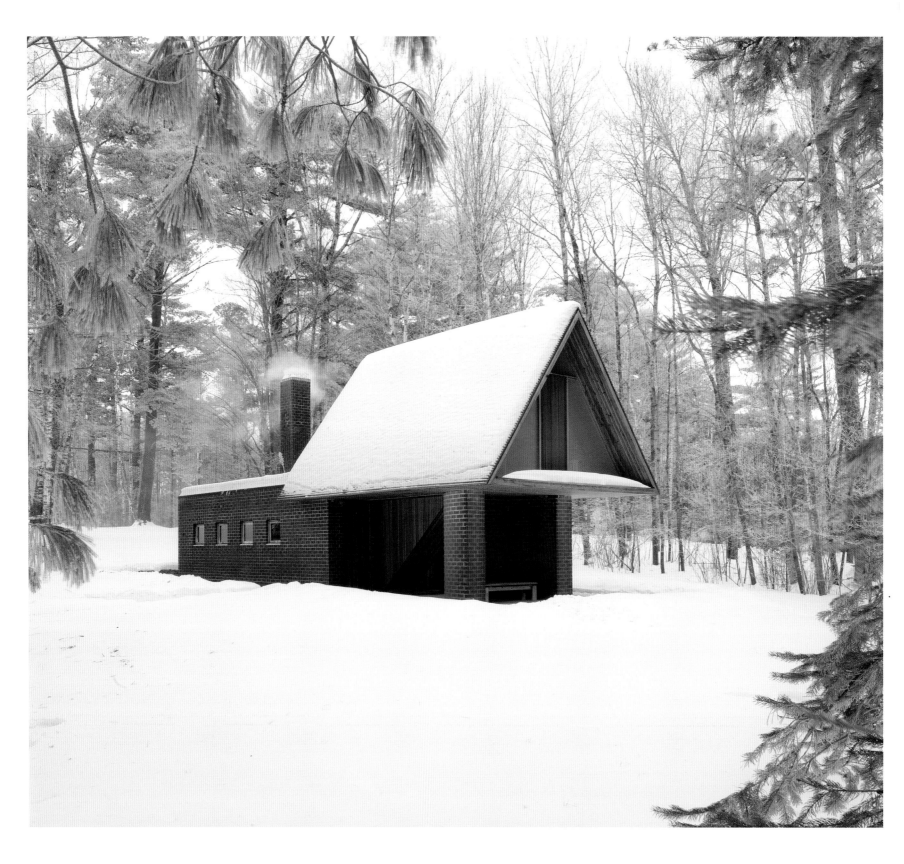

The sauna, introduced to America by Finnish immigrants, has become a significant building type in the colder regions of North America. This is particularly true in northern Minnesota, where I grew up and now maintain an architecture practice. I have been doubly blessed in life to have

been born into a culture that celebrates this ancient bathing tradition and then to have the professional opportunity to encourage local adaptation of sauna far from its Nordic origins.

Most early American saunas were built of logs, and many of them started as basic *savusaunas* (smoke saunas) that reflected the economic realities faced by the immigrants and the forms best suited to traditional skills. As a pioneer family's prospects improved, a metal stove and chimney soon replaced the open hearth. If an updated sauna was built, the basic layout likely remained the same, but wood-frame construction was used. As successive generations of Finnish Americans and other sauna enthusiasts enjoyed increasing prosperity and broadening perspectives, the functional possibilities greatly expanded. My own family history bears out this progression.

In 1902, my father was born in a sauna that stood next to Pike River in Peyla Township near Lake Vermilion in northern Minnesota. As one of many buildings on the immigrant farmstead, the sauna served many functions, and prominent among them was taking a sauna as an excuse to relax and socialize. Neighbors would visit for an evening of sauna, coffee, and *pulla* (Finnish biscuit). Wednesday and Saturday were usually sauna nights, and Christmas and midsummer featured special saunas.

At the family home where I grew up, the sauna migrated to the basement, after house foundations advanced beyond a stone perimeter surrounding a crawl space. The sauna was our only means of bathing until a shower was installed in the steam room. More recently the electric stove made sauna even more convenient, though it took time for us to realize that convenience had upstaged the special qualities of the old wood-fired stove.

Today, my own family sauna is situated on the top floor of our home, with a large window overlooking the Duluth harbor and Lake Superior. We have a balcony for cooling that has an equal

David Salmela's best-known sauna design is the Emerson Sauna in Duluth, Minnesota.

vista of the city and lake and catches Lake Superior's infamous cool breezes. Such qualities as transparency, ventilation, and elegant craftsmanship have raised the sauna to an art form.

During my career as an architect I have designed approximately thirty saunas, and several received an American Institute of Architects Minnesota Honor Award for architecture. The Emerson Sauna won the highest national award for all building types, a National AIA Honor Award for Architecture, one of only thirteen recipients of this award in 2005. Its geometric forms are an exercise in proportions and massing, and it is not at all a vernacular sauna.

The Emerson Sauna sits away from the house on its lakeside site. As one approaches it, the material quality and beautiful craftsmanship make it very warm and welcoming and totally fitting to the notion of what a sauna should feel like. Inside, the mystery of the forms resolves into a logical relationship with the bathing and the cooling process. The staircase up to the cooling porch raises the level of expectation of what a modern sauna, even in America, can be.

I have never lived in a place for long without a sauna, and I have learned that nostalgia for sauna is as great as the actual experience. So the cultural practice continues. Perhaps American saunas can never quite attain the authenticity of saunas in Finland. Though we American Finns have the same blood coursing through our veins, our culture is quite different, and we must create our own sauna traditions as well as our own sauna architecture.

But one thing is the same in all places: the physics of water thrown on hot rocks turning to steam to clean the pores, ease the stress of the day, and enhance enjoyment of the open night air. ▪

The intimate sauna on the top floor of the Salmela home in Duluth offers views of the city, its harbor, and Lake Superior.

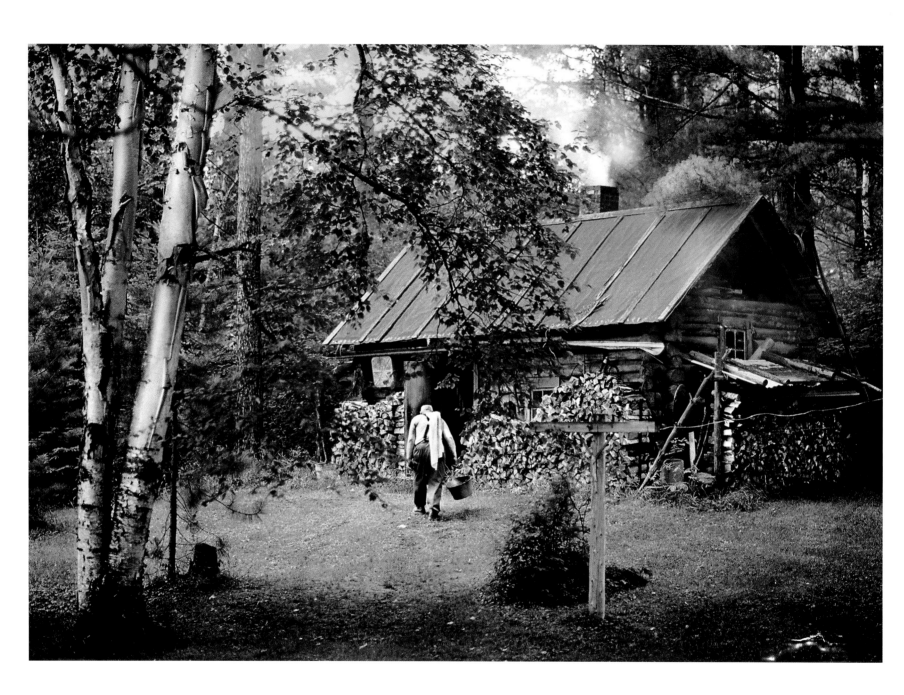

The Sign of the Finn

"Finns have been just as curious as Columbus; they have always looked ahead, ever hoping for favorable places to live," wrote Finnish American journalist Matti Fred in a newspaper account from 1878 that described the movement of his immigrant compatriots to and through the Michigan copper-mining towns of Calumet and Hancock. The date of Columbus's 1492 encounter with the New World is marked by a national holiday, but relatively few people are familiar with the Finns' arrival dates in North America or the contributions they made to the development of cooperative organizations and the fabric of political, religious, and cultural life in the United States and Canada. There is one exception to this pattern, a cultural and hygenic bathing practice that has long served as "the sign of the Finn" and that, of late, has become a well-known phenomenon throughout the world: the sauna.[1] No matter where Finns settled—whether in North America, in areas of Europe outside of Finland, in Australia, or even in a few scattered South American enclaves—the sauna has always been a central feature in their everyday lives.

In North America, small groups of Finns and Swedes first arrived on the continent during the 1630s and 1640s, when they established the New Sweden colony along the Delaware River valley in what now forms parts of Delaware, Pennsylvania, New Jersey, and Maryland. The "Delaware Finns" were drawn from a much larger group of émigrés who during the early 1600s had been recruited from the eastern reaches of Finnish Savo and Karelia to settle the hilly uplands of Värmland in west-central Sweden. The number of Finns who subsequently immigrated from Värmland to the Delaware Valley may have exceeded the size of the Swedish contingent that made that move. There is strong evidence that the Finns' Savo-Karelian log-building and land-clearing techniques were adopted by other groups on the American frontier, but the Finns' sauna traditions did not persist and soon faded into oblivion, as did traces of Finnish language, Lutheranism, and folklore.[2]

Very few Finns immigrated to North America during the next two centuries. A significant event occurred in 1809, when, after hundreds of years of Swedish rule, Finland became a Grand Duchy of Russia; Finland's status within the Russian domain

Jim Brandenburg, *A Trip to the Sauna near Embarrass, Minnesota, 1989*. Photograph courtesy of Jim Brandenburg.

would continue until 1917, when independence was achieved. During the early decades of Russian rule, Finns settled in Sitka, the czars' Alaskan capital. These Finnish expatriates built their saunas, but after the United States acquired Alaska in 1867, most Finns departed Sitka, and the rain forest climate quickly erased any evidence of saunas from the landscape. The gold rush in 1848 attracted Finns to California, some of whom remained on the Pacific Coast, and hundreds of Finnish sailors departed from ships at various American ports during the 1850s. Census information indicates that by 1860 the largest concentration of Finns was in the San Francisco area, where more than one hundred men and a small number of women and children resided. Any saunas erected by these Finns would have been destroyed by the earthquake in 1906, if not by the late nineteenth-century expansion of the city.

The formation of America's first permanent Finnish settlements and "Finntowns" began in 1864–65, when small groups of émigrés established themselves in south-central and west-central Minnesota and in Michigan's "Copper Country." From 1864 to 1914 more than three hundred thousand Finns made their way to the United States; another sixty thousand immigrated to Canada, most during the 1920s and 1950s.

Michigan and Minnesota quickly emerged as the Finns' most important destinations. Eventually, concentrations of their compatriots would also appear in New England, especially Massachusetts; in sections of the mid-Atlantic states; in the Great Lakes states of Ohio and Wisconsin; along the Pacific Coast in California, Washington, and Oregon; and to a lesser extent in the northern Great Plains and Rocky Mountain states. Ontario attracted the largest number of Canadian Finns, followed by British Columbia and the prairie provinces. But since the 1880s no region of North America has been more heavily populated by Finns and their descendants than the contiguous northern sections of Michigan, Minnesota, and Wisconsin. When southwestern Ontario's Finns are added to the total, Lake Superior clearly serves as the center of North America's "sauna belt."

The thousands of Finnish immigrants who established new farmsteads in the Lake Superior region faced an immediate task: providing shelter for themselves and their livestock. If time and resources were limited, the initial cabin would serve both as a dwelling and as a sauna, but more likely the diminutive shelter became a sauna following the construction of a larger residence. The timing of sauna construction, as well as the functions performed therein, depended on individual and family circumstances.

Josefiina Tuomela Kästämä, a young girl when her family reached a rural New York Mills homestead during the autumn of 1877, has provided one of the few detailed accounts of early Finn-

This log public sauna next to an alley once catered to Finns in the small town of Gwinn, Michigan. One door allowed sauna bathers to enter or exit the changing room, while the other provided access to and from the steam room. Patrons waiting in the nearby house were informed by a bell when the changing room was empty. Photograph by Arnold R. Alanen, 1999.

ish farmstead development in Minnesota. When the train carrying the Tuomelas arrived in New York Mills, the family moved to the homestead claim, where they immediately constructed a simple shelter for their cow and ox. After spending the winter months with neighbors, the family then moved into a small building that served as a combination residence and sauna. During the ensuing winter, the four cows and two sheep now owned by the Tuomelas were ensconced in a new barn, and logs were selected and cut for the house that was constructed the following summer.[3]

Today, most people probably are not aware that prior to the 1920s Finns typically bathed in a chimneyless *savusauna* (smoke sauna). The unique features of a savusauna, including the rather complicated process of firing the stove (*kiuas*), are described and illustrated throughout this book. While a few examples of savusaunas are fortunately still extant in the Lake Superior region, no traces remain of the dugout versions that some early Finnish pioneers used for brief periods of time. To find such an example today, one must travel to the treeless, semiarid Couteau region of Saskatchewan, where Hjalmar Ylioja moved a savusauna, built in 1943, to a hillside site during the 1950s and modernized it by add-

ing a metal kiuas, chimney, and dressing room. While a Lake Superior dugout sauna would have used logs for the roof and support members, Ylioja's materials, other than the earth itself, were limited to locally available scrap lumber. When fuel was in short supply, Canada's prairie Finns even employed dried cow chips to heat their saunas.[4]

Finnish immigrant writers occasionally mentioned the presence of saunas in the cultural landscape of the Lake Superior region, sometimes describing them as their "favorite accommodation."[5] But the actual sauna-taking process received no attention from Finnish American writers. This is understandable, since descriptions of rituals and procedures were not needed by a people who had experienced the sauna since birth and who already knew "how to sauna."

While Finnish immigrants seldom wrote about sauna practices, the comments of outsiders were relatively factual but also ranged from the naive to the bizarre. One account from 1890 by Sarah Sherwood, a Illinois teacher who spent a summer among Finns in a rural area west of Duluth, called the sauna a "Russian bath." Describing its kiuas as "a stone arch . . . built and filled with loose stones to form a cube," she wrote that the sauna could stay hot for almost an entire day. The young teacher would spend an hour in the sauna, "rubbing with a coarse towel and perspiring," but she

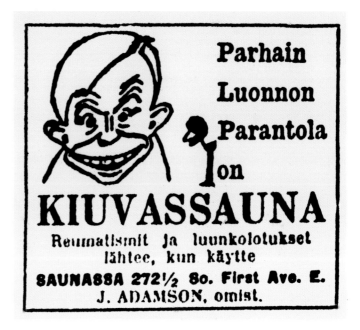

never ventured to the top benches, "the higher ones being in too warm an atmosphere."[6] In 1897 a newspaper report from Ishpeming, Michigan, termed the "popular" Finnish institution "a bath of [the] primitive kind" and included a matter-of-fact description of its internal workings: "The steam is produced by heating a pile of rocks built upon an iron stand. A fire is built beneath the stones and when they are as hot as it is possible for them to be, water is poured upon them, this raising the steam which furnishes the bath."[7]

A rather outrageous interpretation of turn-of-the-century sauna practices is from Esko, Minnesota, where a non-Finnish farmer complained that local Finns entered strange-looking huts each Saturday evening to engage in rituals that called on their gods to bring good fortune to themselves "and wrath upon their neighbors." Eventually, other community members realized that the Finns' motive was simple cleanliness, a fact confirmed several years later by Glanville Smith, who offered a rational and accurate account of his sauna experiences in the state's northern backwoods during the winter of 1932–33. Writing for *Atlantic Monthly*, the aspiring Minnesota author observed that bathing in a sauna "was treated as a social affair" by people who "live in a cold, lonesome country, and believe in getting together and heating themselves through and through." After lucidly recounting the heat and steam (*löyly*) produced within a sauna, Smith then described the bracing impact that a bucket of ice water or a roll in the snow had on one's body. The sauna, he concluded, "makes a man very limber, and God knows he is clean after it."[8]

One Finnish-language source that always included information about saunas was the advertisement section of immigrant newspapers. These notices profiled the public saunas that appeared in cities and towns with sizable Finnish populations (modest public saunas in small towns were seldom, if ever, advertised). The earliest public facilities were usually heated by a traditional kiuas, even though they posed a fire hazard in urban areas; it also was difficult to secure a steady supply of firewood within cities. By the early 1900s, the public saunas in larger cities were typically equipped with steam-heated radiators. When such a sauna appeared in Hibbing, Minnesota, a reporter for an English-language newspaper wrote, "you can get thoroughly sweated for 15 cents provided you do not object to being sweated in company." Each room was "lined with radiators," and "the bath consists entirely in turning on as much heat as the bather can endure."[9]

Duluth, sometimes called "America's Helsinki," had as many as fourteen public saunas during peak years. Initially, most of the city's Finns and the public saunas they patronized were situated

Mesaba Parkin Sauna

on auki yleisölle joka lauantai kello 3—10 j. pp.
Muina aikoina voivat järjestöt vuokrata ja pitää saunapaarteja.

Viola Turpeinen orkesteri soittaa Parkissa Tanssit

Lauantaina, t. k. 17 päivä.

M. P. Johtokunta, Box O, Gilbert, Minn.

along St. Croix Avenue (now Canal Park Drive), located only a short distance from Lake Superior. In 1909, J. K. Voutilainen called his Suomalainen Sauna, open thirteen hours each Tuesday, Wednesday, Friday, and Saturday, "the best doctor in America"; two years later Korkki & Saari identified their new facility, available for just ten cents per bath, as "Duluth's best sauna." By 1920 some public sauna operators, such as J. Adamson, had moved beyond St. Croix Avenue to nearby locations on First Avenue East and elsewhere. Adamson claimed that the "best natural remedy" to rid oneself of "rheumatism and aching bones" was a wood-fired *kiuvassauna* (a dialect variation of kiuas); indeed, the Adamson sauna may have been the only such public facility located close to Duluth's downtown district in 1920. Two years later the Duluth Steam Bath Company's owners described their new sauna, also on First Avenue East, as "a most modern, luxuriant, and complete institution of its kind, beautifully finished, perfectly and scientifically equipped." One wonders how the operators accommodated the large crowds that undoubtedly attended the grand opening, a day when the company promised "insofar as it may be physically possible, a free bath to every one without an exception."[10]

Especially popular among residents of the Finntown in Minneapolis was the sauna located in the Wells Memorial Settlement House on North Eleventh Street. Touted in 1915 as the "best bathing place in Minneapolis," men were charged twenty cents, whereas women could enter for just fifteen cents. Tub baths and showers were priced at ten cents each, and the services of a Finland-trained masseuse or masseur were also "available in the same place."[11]

My parents were born in remote Finnish farming communities in Minnesota, so it is quite likely that both of them first saw the light of day in a sauna. Although my place of birth was a Wadena County hospital, I received a quick introduction to sauna rituals on my grandparents' farms in Snellman (Becker County) and Salo Township (Aitkin County). As I approached nine years of age, we moved to the Salo Township farm my maternal grandparents initially established in 1910. Our house and those inhabited by virtually all of the neighbors had one feature in common: no bathroom. My friends and I may have envied the "townies" who could avoid treks to cold outhouses during the winter, but we did not begrudge their bathtubs and showers. Who needed such amenities when we had a personal sauna?

Today, I recognize that a boyhood spent on a hardscrabble dairy farm decades ago offered many rich and varied opportunities, even if the work and chores were never-ending. Among my most vivid memories are those associated with the sauna. Without fail, our sauna was heated every Saturday evening, except when we occasionally went to a neighboring farm. A sauna during the winter months served as our humble spa, a place where the glowing fire in a dimly lit room warmed us before we spent the next week in a drafty farmhouse. Equally meaningful were the daily sauna sessions throughout several weeks of the summer. After pitching hay and lifting bales in a confined and stuffy barn loft, nothing could surpass a sauna for removing accumulations of hay dust, grime, and sweat and for relieving sore muscles. Sitting outside after enjoying a sauna and watching the sun set (even while battling voracious mosquitoes) offered a direct link to one's "Finnishness" in a Minnesota context.

Unlike the days of my youth, when hotter was often better, I now prefer a mellow sauna. But my insistence concerning the correct pronunciation of the word has not mellowed. Nothing is more grating to those of us who respect the Finnish language than to hear sauna pronounced as "sah-na" or "saw-na." To learn the correct pronunciation of sauna, please give careful attention to the initial pages of Michael Nordskog's narrative. And, of course, savor Aaron Hautala's photographs, which reveal how ancient and modern sauna traditions still persist throughout the Lake Superior region during the early twenty-first century. ▣

The Opposite of Cold

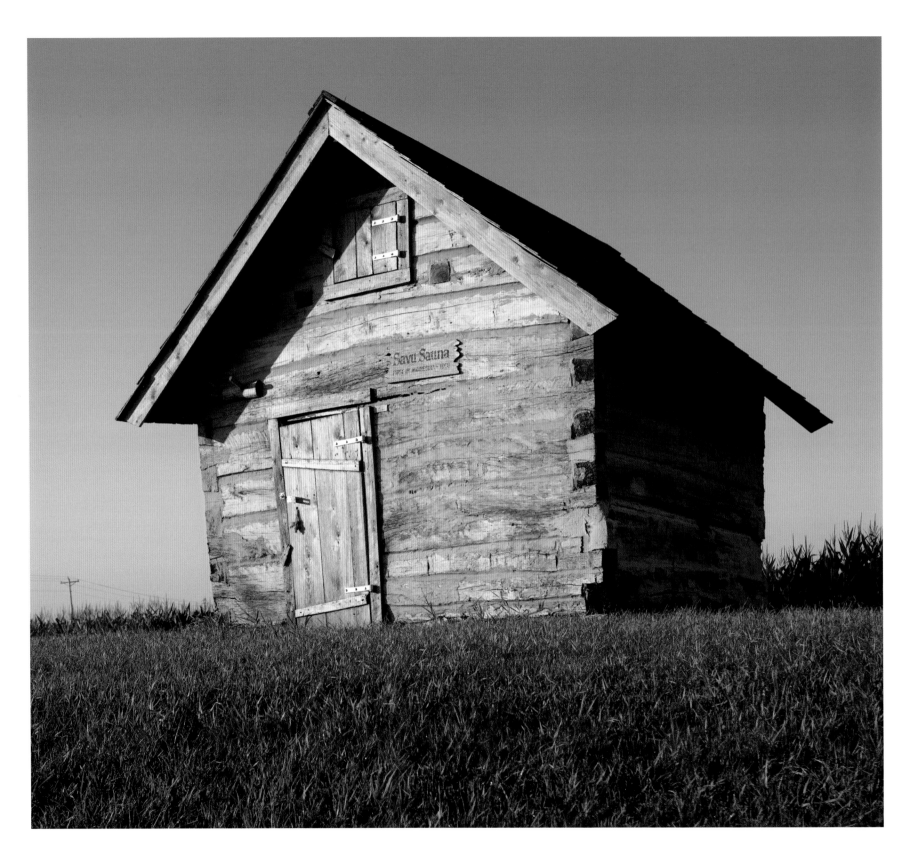

Sauna
in the New World

For those who come to this book with little knowledge of the Finnish sauna as traditionally practiced in northern Europe and in North American immigrant communities, two guiding principles bear a quick explanation. The first is that the word is pronounced "sow-na," with a diphthong

drawing out the transition from the *a* to the *u*, similar to *sauerkraut* and distinct from *fraud*.

Sauna is the one Finnish word that has achieved international familiarity. While sauna by any name will cleanse as well and leave the slow practitioner just as refreshed, you will not get off on the right foot with an ardent purist by rhyming your pronunciation with "donna." To a very real extent, they may suspect that you are referring to a place that is a sauna in name only, either a front for promiscuity or a funky room next to a hotel pool within which actual water is forbidden. As you begin to speak the word authentically, you will undoubtedly be corrected in general conversation (no lesser maven than *Jeopardy*'s Alex Trebek once dismissively corrected a contestant who had a decidedly Finnish last name), but you will feel better for making the word last a little longer, and you may even notice that your sessions of steam and heat become more pleasurable for this simple cultural concession.

The other principle is that this book is concerned not merely with a bathing practice but with a specific type of outbuilding on the landscape. Throughout the region in question—essentially the Lake Superior hinterland in Ontario and the northern counties of Michigan, Wisconsin, and Minnesota—dedicated bathhouses on a lakeshore, streamside, or a discreet distance from a farmhouse are very common. The typical structure is twenty feet long by about ten wide with a single entry, evenly divided into two rooms, with a chimney.

If you are traveling along a county road in wooded country regularly interrupted by small clearings, and intersected by roads with names that end in *i* or *ala* or *nen*, you are in the heart of North American sauna country. Any buildings you see that are similar to the structure just described have very likely been used as a family bathhouse. In the 1960s, University of Minnesota–Duluth cultural geographer Matti Kaups found that the presence of outbuilding saunas on farms in the region was a telltale marker of

This savusauna, a simple structure built in 1868 near Cokato, Minnesota, is the oldest extant example of a Finnish immigrant sauna in North America.

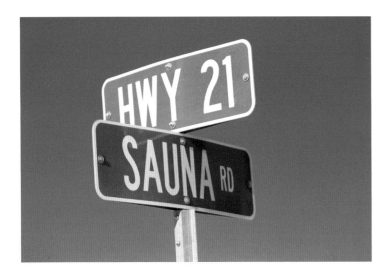

ethnic identity. Ninety percent of Finnish American farmsteads had a sauna (a higher percentage even than on farmsteads in Finland), and saunas were common at all types of Finnish residences. Kaups casually observed that the sauna competed favorably with television as an evening activity among Finnish Americans.

Sauna is one among the world's many hot bathing traditions, which include the Russian *banya*, Turkish *hammam*, Japanese *furo*, and various Native American sweat lodge practices such as the Navajo *inipi* and Ojibwa *madoodiswan*. In the other Scandinavian countries, it is often called *bastu* or *badstu* rather than sauna. Whether one engages in such a practice for bathing, healing, ritual, or relaxation, the essential objective is to enter into a room that is much warmer than we humans will ever encounter in nature. And regardless of how much one enjoys or merely endures the present sensation of such extreme experience, it is fair to assume that most appreciate best of all the condition that follows its completion: a feeling of buoyancy, limberness, and cleanliness that leads to excellent sleep and a fresh start at shouldering one's worldly burdens. In the sauna context, the degree to which you are willing to alternately roast and scald yourself is a fair measure of the Finnish concept of *sisu*, a personal quality that is quantified by strength, perseverance, and stubbornness in fairly equal proportions.

Sauna Road and Highway 21, Embarrass, Minnesota: a sure sign that you are in the heart of North American sauna country.

Sauna remains a source of ethnic pride among Finnish Americans. Barberg farmstead, Cokato, Minnesota.

Carl Gawboy, "Finnish Birdbath!" From *In with the Finn Crowd* (St. Cloud, Minn.: North Star Press, 2002). Courtesy of Carl Gawboy.

The sauna tradition, which derives most significantly from present-day Finland, has enjoyed widespread popularity across cultural boundaries. The essential component of a traditional sauna is the *kiuas*, a wood-burning hearth used to heat rocks that produce an abundance of steam when doused. Several developments have made sauna practice more convenient and accessible: chimneys, concrete floors, running water, and electric stoves. Even the elemental sauna stones are abandoned by some for brick or ceramic substitutes, or even for generating the steam from hot iron. But implacable dry heat interrupted by waves of *löyly* is the essence of sauna—a word that derives from the concept of the soul and describes an elemental component of a premodern Finn's world akin to water, earth, metal, and death. (Say "loo-loo" and your pronunciation would probably be understood in Helsinki, because that is about as close as an American larynx can get.)

These humble structures provided a warm place for births and the application of remedies, allowed farmers to dry their grain, and hosted the preparation of the dead for burial. Bathhouses of such construction may have been built on North American shores over a thousand years ago in the Viking settlement at L'Anse aux Meadows in Newfoundland. While no such hearth has been identified at that site, the foundations of a structure essentially identical to a Finnish *savusauna*, or smoke sauna, have been unearthed at Sandnes, the Viking farmstead on the southwestern coast of Greenland, complete with wooden platforms for bathers and "enormous quantities of badly scorched stones."[1] More certainly, the Swedish colony on the Delaware River in the present states of Delaware, Pennsylvania, Maryland, and New Jersey featured saunas: the residence of Governor Johan Printz on Tinicum Island, an area now dominated by the Philadelphia International Airport, included such a bathhouse.

But an indelible historical imprint endures in the Finnish American settlements of the upper Midwest, places like Cokato, New York Mills, Embarrass, and Esko in Minnesota; Oulu, Brantwood, and Marengo in Wisconsin; Calumet, Misery Bay, Negaunee, and Kiva in Michigan; and Ontario locations ranging from Thunder Bay to Sudbury. A vast inland sea dominates the middle of this region: Superior, the highest, freshest, coldest, and greatest of the Great Lakes.

Following the rapid popularization of sauna across the United States in the 1950s and 1960s, a number of volumes were published to instruct readers about building techniques, health benefits, and the proper way to enjoy the Finnish bath. This book does not address these issues except to the extent that it shares the views of Finnish American descendants and others who enjoy sauna. Enjoyment of heat and steam is a very subjective matter,

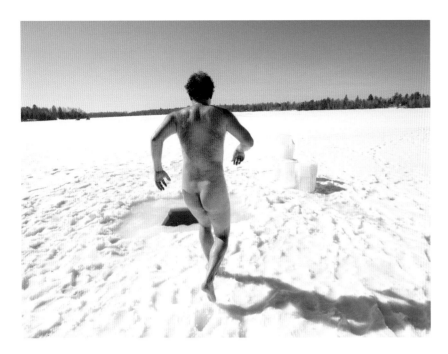
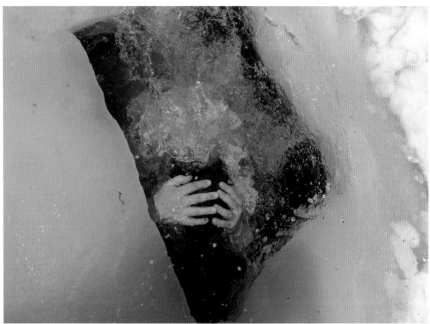

Although never routine among Finnish American bathers or other enthusiasts, plunging through the ice in the winter is perhaps the most feared and the most respected activity of sauna culture.

and an untold number of first-time participants have been forever discouraged from a healthful practice because an overzealous hellion imposed a scalding cloud of steam too early, then impugned their mettle. A fair remedy: in Finland, many extend the common courtesy that the person with the least experience controls the vital production of löyly by throwing water on the rocks. I tend to prefer a temperature of about 190°F at the outset, but raising three children into the lakeside tradition, my wife and I have found that 140° to 150° is an ideal starting point. Putting a kid in charge of the dipper produces interesting results.

This book is dedicated to the endurance of sauna in the often frigid heart of the North American continent, a most sensible place for this practice to thrive. The first subjects that the book considers are a variety of immigrant homestead saunas, structures that would not have endured to this day without the tremendous dedication and passion of a handful of descendants and preservationists. The hard-working, skilled immigrants who created these saunas can serve as examples to us all for their clever use of on site materials and ancient methods, not to mention their acknowledgment of the primacy of a good hot bath as a cornerstone of the homestead.

Next, we will look further back at the Finnish origins of sauna, not only by examining its everyday role and development in the

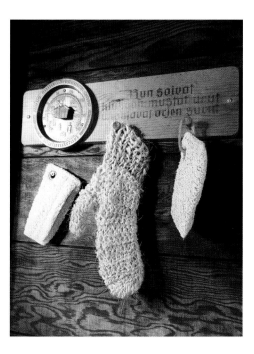

The health benefits of sauna range from a deep feeling of cleanliness to a sense of renewal. The proverb engraved into the wood of this sauna (*Kun soivat kiukaan mustat urut unohtuvat arjen surut*) translates as "When the stove's black organ plays, one forgets the sorrows of everyday."

region, but also by considering sauna as a cultural motif, from the stories collected by Elias Lönnrot in the *Kalevala* to the works of later noted artists, composers, and writers. Finns certainly do not debate the merits of sauna. They just do it, again and again, because their parents and grandparents did, it is a perfect antidote to a cold swim, it meets winter on its own terms, and it feels good. But it is also a galvanizing national ritual, and for their role as keepers of this tradition, the world owes them a debt of gratitude.

"The North American Lakeside Tradition" considers the second species of sauna in North America: saunas as a form of recreation, from structures near the cool shallows of the region's many lakes to sauna as a center of social interaction. Most Finnish immigrant organizations made sauna a part of their mission, and sauna has been invoked as a benefit for participants in groups as disparate as secular cooperatives, social clubs, and Lutheran congregations.

With a growing population and the efficiencies dictated by urban and workplace installations, commercial operations arose to meet the demand for sauna in cities like Port Arthur, Hancock, Duluth, and Virginia. "The Value of Heat" looks at public saunas that served the needs of immigrant loggers and miners, as well as the traditions of stove manufacture that continue into this century, including the largest distributor and manufacturer of sauna components in North America. A few public saunas also survive in the region, providing a warm place on a Saturday night for regulars or giving a family a good room to test out the process before a basement installation.

The final chapter looks at sauna practice by several contemporary enthusiasts, from families that continue their Finnish traditions, to architects and their patrons who find its presence essential in a northwoods setting, to practitioners of healing arts who recognize the calming effect of this practice on their clients. The word *enthusiasts* is not used lightly: if you have dedicated yourself to construction and maintenance of a separate bathhouse and are willing to spend hours preparing for a proper cleansing, we are not talking about a physiological demand that can be acquired over the counter. In this sense, sauna is to shower what a homegrown, sun-warmed tomato is to ketchup. Not that processed tomatoes do not have a place in the diet. But sublime flavor does not come from a packet or can, and no one would likely claim to enjoy repeated showers over a period of several hours. We hope this book will feed the curiosity of those who are exploring the idea of a home sauna and serve as a guide to those who want to learn more about this wonderful bathing practice. ▪

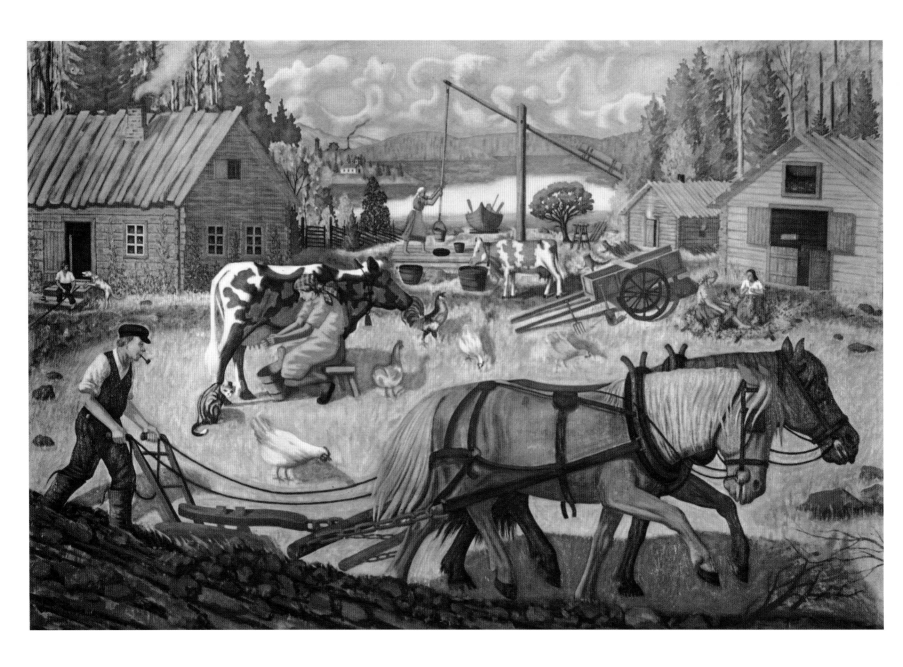

⊡ Juho Rissanen, *Finnish Farmstead*, 1944. The sauna was usually located a sufficient distance from the house to minimize the risk of spreading fire. This painting was commissioned by the Minnesota Finnish-American Historical Society and was destroyed by fire in 1961. Courtesy of the Minnesota Historical Society.

Immigrant Saunas in the

Lake Superior Region

Europeans who were drawn to the promise of America by advertisements or letters home all went through various degrees of cultural cleansing as they adapted to the economies and social norms of their new country. Among these many immigrant groups, the Finns have a strong

reputation for independence and resistance to the unifying impulses of the cultural melting pot. This is a broad generalization, and of course many immigrants soon dissolved their baggage, set out to leave their past behind, and became indistinct Americans in homogenized communities. But unlike some who drew a paycheck from the resource extraction economies that fueled the settlement of the northern counties of Michigan, Wisconsin, and Minnesota— French Canadians, Swedes, Cornish, Italians, Slovenians, and Norwegians—many Finns abandoned full-time employment as miners or millworkers and ventured out to make a living off the land in the not-necessarily-too-close company of people who spoke their language and shared their ways.

Because much of the prairie to the south and west was fully utilized by agrarian settlement, Finns in the Lake Superior watershed merged into the edges of a boreal wilderness. Most concentrations were not too far from the copper and iron mines that they had left behind, because in many cases the changes came gradually.

Many American Finns dedicated their future to land that could not be farmed without several seasons of labor to clear fields and unburden rocky soils, in country where productivity was further constrained by a short growing season. But immigrant peasants from Finland possessed a legacy of knowledge for making a living off just such lands, producing rutabagas and potatoes, and hay for dairy operations, and supplementing with fish and game. Along with some seasonal wages from logging or other employment, an abundance of Finnish American homesteads achieved a thriving subsistence and brought forth a hardy native-born generation.

Without compare, the iconic characteristic of these farms was the sauna, a distinct outbuilding that was often the first structure built at the homesite, according to immigrant folklore. With its own hearth and a solid roof, it provided a ready shelter for homesteaders as they began to carve a living from the north woods, then became a dedicated bathhouse once a proper house was built. Throughout the life of the farm, frequently enduring even the advent of running

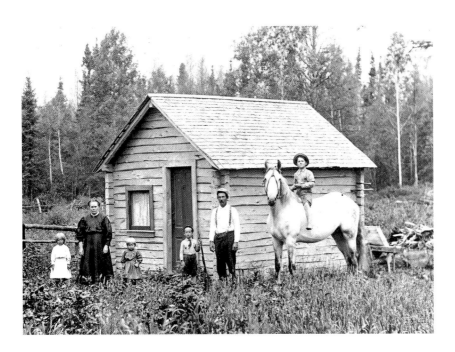

"A Finnish immigrant family in front of their first shelter in which they lived and bathed while the house was being built. Later it was a sauna." Photograph and caption from the papers of University of Minnesota Duluth geographer Matti Kaups, who studied Finnish immigration in North America. The photograph depicts the Aho family of Karvenkylä, north of Chisholm, Minnesota, around 1905. Courtesy of the Immigration History Research Center, University of Minnesota.

The Cokato savusauna, built in 1868, was moved from its original roadside location because non-Finnish neighbors complained about public nudity and demanded its removal. It is now a proud monument to Finnish pioneers at a well-traveled rural corner near Cokato, Minnesota.

water in the farmhouse, the sauna provided a place to bathe and host a healthful and spirited activity during weekly social gatherings among neighbors. As fields expanded, families grew, and roots deepened, the typical sauna saw use on Wednesday and Saturday nights, with much more frequent heatings during seasonal events like summer haying. But where this practice of bathing in another building was noticed by American neighbors, especially those who did not come from the other Nordic countries, sauna gave Finns an early reputation as strangers in a new land.

The sensational nature of the Finnish homestead sauna in America is on full display in a front page exposé from the *Minneapolis Times* on July 20, 1901. In the "Finnish Farmers of Minnesota," the Finlayson community located halfway between Minneapolis and Duluth is subjected to a less-than-flattering examination that includes a depiction of a "Finnish Steam Bathhouse." The article's subtitle loudly proclaims that "A Whole Family Lives in One Close, Foul-Smelling Room—They Wear Dirty Clothes but Are Fond of Turkish Baths." In the grand tabloid tradition, the content of the article does not quite live up to the headline, and the writer certainly does not fail to praise the thrift and enterprising energy of these immigrants. But sauna is a central, differentiating theme: "However neat a Finn may be, he wears his clothes for a long time without having them washed, but even the poorest of the people

have their Turkish baths." After savusauna "they dash pails of cold water over each other and retire to the outer room to dry themselves with towels. Then they resume their soiled clothing."

The spotlight shone on sauna by the *Minneapolis Times* is not so surprising in 1901, when work in the mines and cutover acres for settlement were abundant and Finnish emigration to the United States was at its strongest. But the earliest settlers in the region date back to the decade of the Civil War, when Finnish miners were recruited from northern Norway to the Copper Country of Michigan's Lake Superior coast and a few intrepid families and bachelors traveled up the Mississippi to Minnesota to plant home stakes in the Big Woods west of Minneapolis.

The Cokato Savusauna

Minnesota's Cokato settlement has left behind what has long been accepted as the oldest sauna in the Great Lakes region, and there is no better candidate for the title of the oldest extant example on the continent. If any sauna remnant of the Delaware colony endures, or if some *banya* hybrid from a Russian outpost near Sitka, Alaska, has somehow survived that sodden climate, its provenance is unknown. Finnish merchant seaman left Porvoo or Helsinki or Vaasa

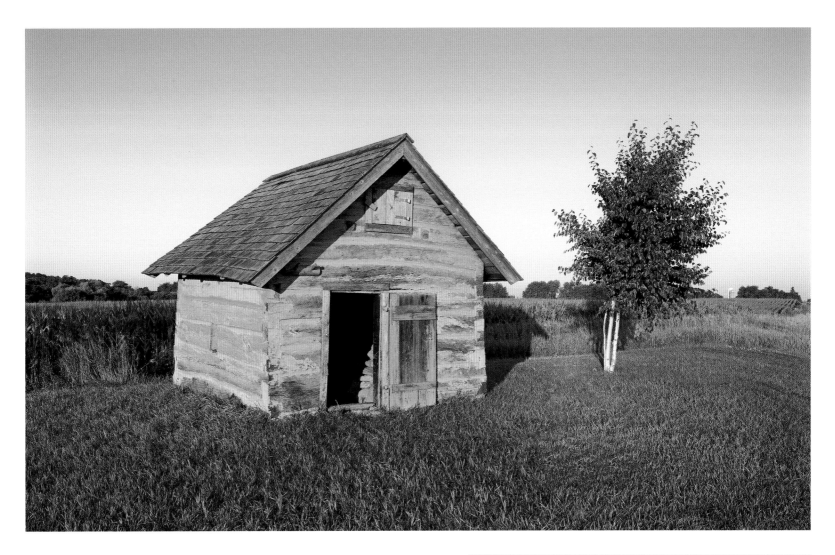

in earlier decades, and no doubt many ended up after a vagabond life at sea with a little farmstead that required a savusauna. Perhaps such a building, or parts thereof, still functions as a shed or guesthouse annex in New England or the Appalachian woods. But the oldest known sauna in North America is the lovingly preserved log savusauna at Temperance Corner, the Finnish American historical site north of Cokato.

The Cokato Finns were preceded one year earlier in Minnesota by a few homesteads in Birch Cooley Township near Franklin on the Minnesota River in Renville County, fifty miles to the southwest. A few of these immigrants had traveled up the Mississippi River to Red Wing early enough in 1864 to have served in the late hours of the Civil War before moving westward to unsettled Minnesota. The St. Paul & Pacific Railroad, soon to become the

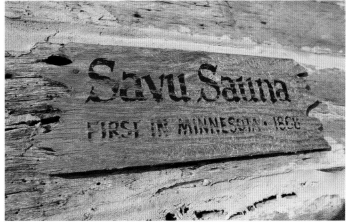

Great Northern, would not launch westward from Minneapolis for a few years yet. But as early as 1856, the first elements of a pioneer society were in place in western Wright County. Scandinavian and Irish pioneers had already carved out homesteads near Cokato, and plenty of land was still available for homesteading. In June 1865, after a long day's walk west from Minneapolis, Mathias Kärjenaho left his worn-out companions Peltoperä, Westerberg, and Wiinikka behind when they decided to camp for the night, thus earning distinction as the first Finn to reach Cokato.

Their wives stayed in Minneapolis while the men began immediately to blaze their mark on their patch of the Big Woods, the broad swath of deciduous forest between the north woods and prairie that now is blanketed with agricultural endeavor. A fair comparison of the struggles these families would face can be found in Laura Ingalls Wilder's accounts of her family's experiences ten years later along the banks of Plum Creek, not far beyond the Finns at Birch Cooley. But the annals of the Wright County Historical Society provide vivid details of life on Cokato's Finnish farms. Vagabond bachelor Finns wandered the county and stayed at the farms of those who would house them periodically for what work they could provide. A mystic hermit named Johnny Saari, who lived in caves hollowed out of prairie dirt and lined with scavenged boards, had the legendary power of diverting destructive storms away from farms by sheer concentration. A local midwife would visit neighboring farms and sneak up on the inhabitants, cutting fringe from garments because it was bad luck.

In addition to the savusauna at Temperance Corner, a ten-by-twelve-foot cabin portrays the small and few comforts enjoyed by the first Finnish pioneers. The tiny structure was reportedly home to more than fifteen people at times during 1866 and 1867, sleeping head to toe throughout that first winter. No sauna survives from the earliest homesteads, which were a stone's throw from Temperance Corner. The site is named for the society hall that has sat since 1896 on the southeast quadrant of the rural intersection, hosting everything from gymnastics meets, boxing matches, plays, and itinerant musicians to present-day occasions of the Cokato Finnish-American Historical Society. The smoke sauna, built of white oak, sits permanently affixed on the edge of a seasonal sea of corn. With the aid of native son Harvey Barberg, who recalled how these dovetailed corners arrived at this site, this building tells a compelling story of how sauna stood for Finnish otherness in the nineteenth century.

Among the second wave of immigrants who arrived the next summer was one man who would play a central role in the community for generations. Isak Barberg, Harvey's great-grandfather, came from a border village on the Tornio River (Tornionjoki),

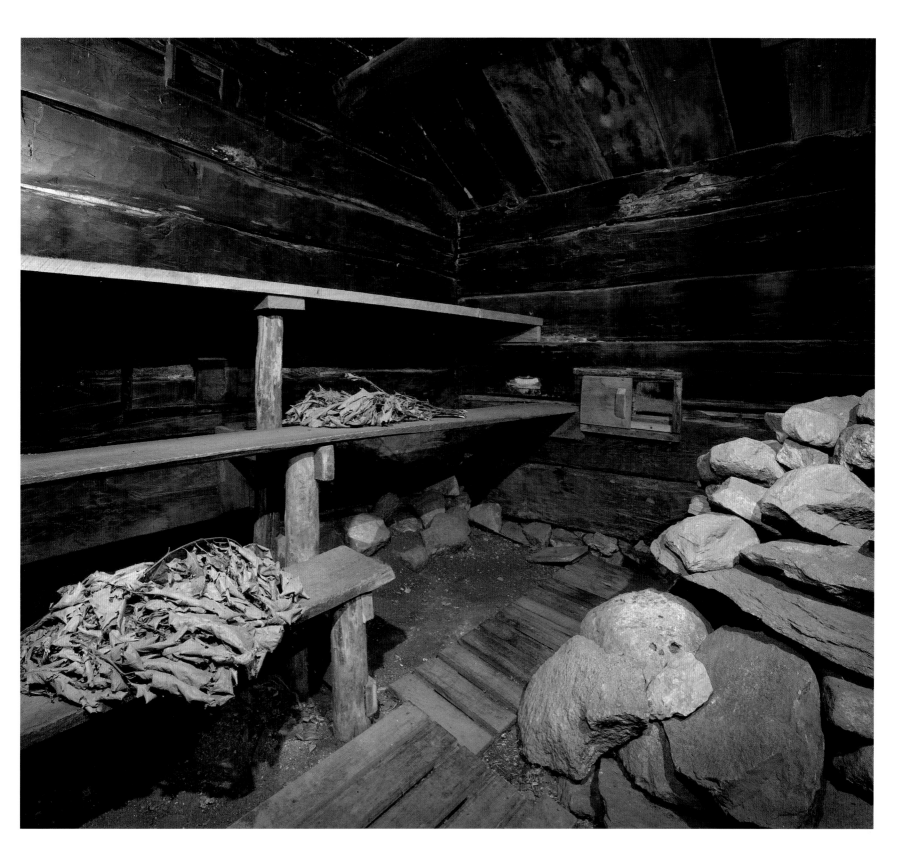

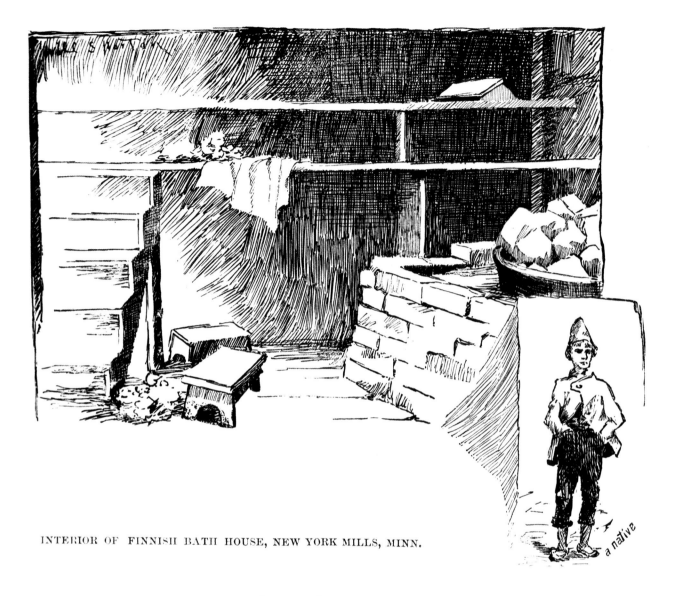

INTERIOR OF FINNISH BATH HOUSE, NEW YORK MILLS, MINN.

which defines Finland's border with Sweden near Övertorneå. Leaving a village just thirty miles south of the Arctic Circle, Isak and his wife, Eva, were northerners in an extreme sense even among Nordic peoples. They brought two children with them to America, and along with two other Finnish families, settled in Section 18, one township to the west of their countrymen. A follower of the Lutheran revivalist Lars Levi Læstadius, Isak became the first lay minister in the community and served the Apostolic Lutheran Church from 1872 until 1883, performing 218 baptisms and 78 burials as the community flourished.

That the Cokato savusauna has endured so long is a marvel in itself, for the passive ventilation of the hearth can easily lead to destruction if the fire keeper is careless or overeager. And the perils to a homestead sauna were not only internal: periodic forest fires swept the area, destroying saunas, granaries, and threshing sheds. The Barbergs lost a daughter, their barn, and all of their cattle save one when a fire the girl was tending in the farmyard to heat water surged on the strength of a powerful gust. But this log sauna has survived since 1868, when together with neighbors Nils Selvälä and Peter Salmonson, Isak built a bathhouse centrally located and available to all three homesteads. The ten-by-twelve-

foot building features no dressing room. Just to the right inside the door, an abundant heap of stones gathered from the fields formed the rock hearth kiuas. A high bench lined the back wall, near one of two ventilation openings on the gable ends to let the smoke escape, with intake vents low on the other two walls. A large wooden tub held water for bathing.

Every Saturday throughout the year, the neighbors would take turns heating the sauna, unless the windswept winter prairie had temporarily buried it away under deep snow. Each family enjoyed the great naked outdoors afterwards to cool down, a perfectly common and shameless element of their upbringing. The sauna served its purpose quietly for almost two full decades, but its convenient placement among the three properties ultimately proved its undoing.

The sauna was built near the boundary line between the Barberg and Selvälä farms. As the township prospered and new neighbors settled the outlying countryside, a road into town was extended along the property line. The farmers no doubt welcomed this development, but a public easement now divided the Finnish enclave. The sauna stood in plain view of passing strangers, among them non-Finns who could not help but stare at the Finns cooling their bare heels and naked above. *History of the Finns in Minnesota* describes the community fallout most directly: "This, of course,

led to all sorts of grumbling and muttering about the strange ways of the Finns." By 1885, local authorities had ordered the sauna removed but refused to share in the expense. Nils Selvälä, who had purchased Barberg's share, took his claim for damages to court and won. *History* states Selvälä's response somewhat cynically: "With the money in his hands, Selvälä tore down the sauna and built a new one on his farm."[1]

But Harvey Barberg knows different. He still owns his great-grandparents' farmstead and can point out where the scandalous sauna sat, right next to his present driveway. He and his family still enjoy weekly baths in the sauna that Isak tucked discreetly behind the log farmhouse and away from the town road in the 1880s, after the cooperative with Selvälä and Salmonson had been dissolved. A sign of hard-earned progress, the Barberg sauna is frame-built, has a long-serving chimney, and has a commodious dressing room.

Barberg has decades of experience as a building inspector and an intimate familiarity with the frugality of his people. He explained that if Selvälä's building were ever "torn down" while its logs were still intact, a subsequent purpose for them was found. Selvälä kept up with the Barbergs by building a better bathhouse, and the fitted logs of the old savusauna were assembled as a shed in a new location. The building was never again used as a sauna but

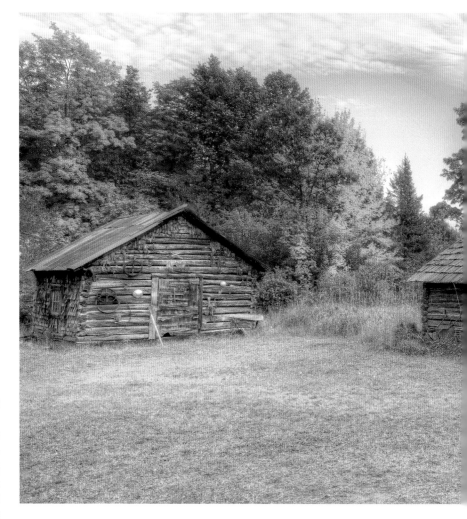

The Hanka farmstead near Tapiola, Michigan, serves as a living museum to Finnish immigrant settlement of the Lake Superior region. Among the familiar characteristics of Finnish farms are modestly scaled buildings, their intimate arrangement, and the ever-present ladder on the roof.

was relocated several times before being dedicated at its present location on Memorial Day in 1950.

Barberg is genetically fluent in sauna and happily shared such knowledge as a word for savusauna-induced carbon monoxide poisoning: *häkä*. He is an avid participant in the local historical society, and his knowledge played an important role in the restoration of the sauna in summer 2008. Several of the logs were deeply compromised by dry rot, the lowest logs were in close contact with the soil, and the logs had been thinly plastered at some point, perhaps in an attempt to preserve them. Barberg's generation has carried the torch a few decades further, and at least for the coming decades, its enduring roadside presence for passersby of all stripes seems assured.

Sauna was crucial to the Finnish farmstead, and the common wisdom that Finns settled the land by first erecting a structure that eventually became their bathhouse is buoyed by a sea of family stories. If a neighbor's sauna were available, then perhaps that project could be delayed. But for the trail blazers, building a first, small structure in which they could live protected from nature seemed like a smart and prudent progression. Ludwig Bajari, who grew up on the northwest shore of Cokato Lake on his immigrant parents' farm, put it plainly: "No respectable Finn could live in the wilderness very long without a sauna. . . . The sauna was really the heart of the farmyard just as the kitchen was the heart of

the house. Finns always felt sorry for the 'other language' people who didn't know enough to build one for themselves."[2]

On Erick and Sophie Bajari's 1870s farmstead, the sauna had many important functions beyond bathhouse: it served as a laundry in the winter, it heated a cauldron of water for butchering and other important needs, and both meat and fish were smoked and cured within. "If one was not careful while bathing, he would need an extra scrubbing to wash away the soot where he had touched the wall," Ludwig recalled, for these early buildings were all savusaunas. Unburdened by the extra expense of a stove and chimney, this immigrant structure was perfectly adapted to a pioneer economy.

The Cokato and Franklin communities are far from Lake Superior, but the earliest settlers had long-distance ties to the mining communities of Michigan's Copper Country, and Cokato received a wave of Finnish settlers from Calumet in the 1870s. As

more Finns arrived to extract copper from the hills above Lake Superior, economic interaction became evident: in 1879, an advertisement in Hancock, Michigan, in one of the first Finnish newspapers in the New World, *Sankarin Maine*, states that Peter Lahti of Franklin "will bring a large number of the best milk cows to Hancock and Calumet as soon as the shipping season opens."[3] Overland, this would have meant a journey of nearly five hundred miles, well before the advent of the Soo Line connecting Minneapolis to Sault Ste. Marie via the Upper Peninsula. Although Lahti's actual delivery strategy is unknown, one option would have been barging or herding the cattle to a railhead at St. Paul, then shipping them north by rail to the port of Duluth, and continuing by boat over Lake Superior, a journey that suggests purposeful cultural ties that eclipse the simple arithmetic of economics. The historian Armas K. E. Holmio identified the likely market: nearly every Finnish residence in Hancock at the time had its own small cow barn—in such an isolated community, self-sufficiency was an important priority. Meanwhile, some Michigan Finns were beginning to feel the incentive to forge their own far-flung communities in the local cutover woods.

The Hanka Farmstead

Not all Finns who left Michigan's copper mines journeyed west to take advantage of the rich agricultural potential of the prairie, and by the 1890s such opportunities had diminished. Herman Hanka was born in Jurva, Finland, in a region where vast tracts of narrow farmsteads on slow meandering rivers served port cities such as Vaasa, the regional capital of Ostrobothnia. Pohjanmaa,

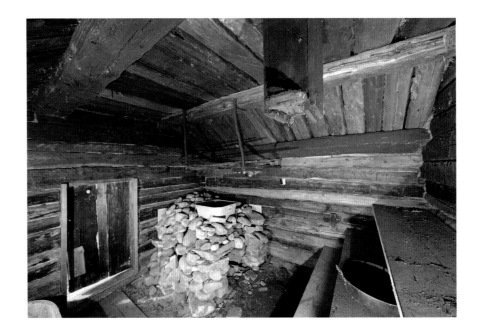

as the region is known in Finnish, is the most common birthplace of Finns who would eventually settle in the Lake Superior region. Hanka married Miina Perala from the nearby village of Teuva, and they had four children before seeking a better life in America in the late 1880s.

Hanka first worked in the mines but fled that dangerous occupation after an explosion killed the miner standing next to him and destroyed most of Herman's sense of hearing. The conditions that a miner faced in the 1890s—minimal pay, unpredictable layoffs, imminent danger, and backbreaking labor—convinced some to file homestead claims in the area and take their chances on their own endeavors. One of the earliest sites was given the fitting name Toivola—"Vale of Hope"—and the first building constructed was the sauna of Daniel Eevonen. The Hankas eventually followed to the sprawling settlement. Herman would never earn much for his family from that point forward, and the family had welcomed three more mouths after arriving in Michigan. But the woods provided opportunities for a family with strong, young children. The Hankas relocated to nearby Misery Bay on the western shore of the Keweenaw Peninsula, halfway from Houghton-Hancock to Ontonagon.

But the Hankas did not thrive at Misery Bay—Miina felt too isolated with the nearest neighbors over three miles away. Her-

man traded the farmstead for a shotgun, and the family moved across the peninsula to a promising community of Finnish families that had started in the summer of 1890 on the shores of Otter Lake (Saukkojärvi), surrounded by fertile acres and rich with fish. Holmio's description of the industry of the first settlers invites incredulity, but it also clearly identifies their priorities: "the building of the first sauna illustrates the kind of energy and enthusiasm which characterized these pioneers. The work of cutting and shaping logs began in the dim light of dawn. By sunset the sauna was ready for use. Before winter set in, every family had a sauna, constructed cooperatively."[4] Northern white cedar, easily worked and durable, was the log of choice for saunas near Michigan's Superior shore.

The Finns named their community Tapiola for the home of the lord of the forests in the *Kalevala*. On a broad whaleback of cutover pine to the southeast of Otter Lake, deer were abundant in the second-growth aspen and maple, and grass grew high in the meadows. In 1896, the Hanka family settled acreage beyond the original farms on the distant edge of Askel Hill. While the site is only three miles from Lake Superior, it enjoys 120 feet of elevation above the vast plain of cold water that dominates the region's climate. The temperature at the Hanka farm could be fifteen degrees warmer when lake air pooled in the bottomlands of the Sturgeon

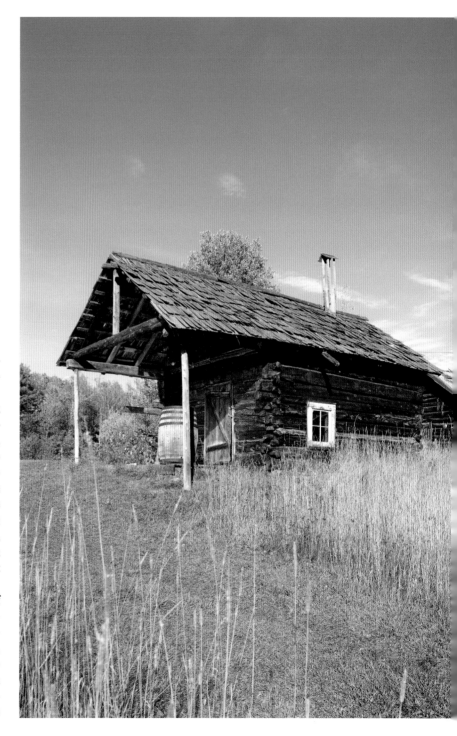

The Hanka savusauna is the best example in the region of a Finnish immigrant bathhouse. The wooden shaft that vents through the roof is a distinctive feature of savusaunas of the past.

River, just a quarter mile from their front porch. Finnish neighbors were right across the road, and the Hankas achieved a durable residence on their forty-acre farm.

We can be grateful for the family's static prosperity, which dwindled to abandonment in the 1960s, for the preserved farmstead sits today exactly as it would have at its zenith in the 1920s. The silver gray log house still holds furniture and dishes and implements such as the tiny lances and other apparatus used in cupping, a therapeutic bloodletting practice that usually took place in the sauna. The barns and other outbuildings feature the tools and farm equipment of a self-sufficient, noncommercial farm operation. The milk house and root cellar bear evidence of long, productive use. In the midst of the forest the family carved out a humble living, and in the midst of that farmyard sits an elegant savusauna.

A signature element of the Hanka sauna is the wooden roof vent, a central chimney that reaches several feet above the ridgeline of the roof but is not directly above the hearth. One notable feature of the structure is evident only upon close inspection. The log walls of the sauna progress from spruce to pine and cedar, and the first six tiers are crudely notched as compared with the more expert fitting of the upper courses—the building was obviously built in two stages. The consensus among the museum's

brain trust is that Herman Hanka started the sauna, but his skills and patience were much diminished after the mine accident. The structure was likely completed by his sons Nikolai and Jallu, who both had a history of building saunas for neighbors in the community. Tapiola grew steadily until 1940, particularly during periods of unrest like the Copper Country strike of 1913 and 1914.

Jallu and his sister Lydia lived out their lives at the farm. After Jallu's death in 1966, the farm was abandoned. Superior Restorations, Inc., purchased the farm in the 1970s to preserve its cultural and architectural assets after a period of disuse, and a host of local volunteers have kept this treasure alive with seasonal bursts of effort. The site is still blessed by a very remote location, and during a visit in the crisp stillness of an early October day, the silence was broken only by the chainsaw of a volunteer carpenter who was working on the barn.

Rueben Niemistö is a native of the area who has served on the board of the Hanka Homestead Museum, and he has many personal recollections of the family. He formerly ran a sawmill in the area, and recalled that the Hanka boys cut hardwood for money to buy shoes and flour, though the maple that succeeded the white pine forest was only worth a little over $1 for a face cord. "Hjalmer talked so much that he didn't get much work done, but then he didn't charge much either."

A second-generation son of immigrants from the Oulu region, Niemistö was intimately familiar with the operation of a savusauna. He vividly recalled from boyhood the heavy responsibility of preparing a Saturday night sauna that would heat the rocks well enough to satisfy a series of neighbors: "I remember putting a fire in by one or two and it being ready by seven, but you had to have dry wood and it had to *roar*," Niemistö said, emphasizing that they usually burned a species that one might not suspect. The northernmost American hardwoods *Populus balsamifera* (balsam poplar) and *Populus tremuloides* (quaking aspen), commonly called "popple" in the north woods, tend to get a little pulpy. Tamarack is extolled in Minnesota for its explosive heat production, and maple is the go-to species in Michigan for those who fire the steel woodstoves that succeeded the simple stone kiuas of immigrant farms. Niemistö explained the reason for an alternative: "Aspen doesn't leave any coals, and that's why we burned it."

The fact that popple quickly dissipated to ash was very helpful, for one cannot comfortably endure a savusauna until after the last traces of combustion are gone. Niemistö recalled festive sauna evenings when multiple families would gather. The women and children would go first, asking if there was any smoke left. Then the bachelors would have their turn and query, "Was there heat?" "Oh, yes, lots of löyly left."

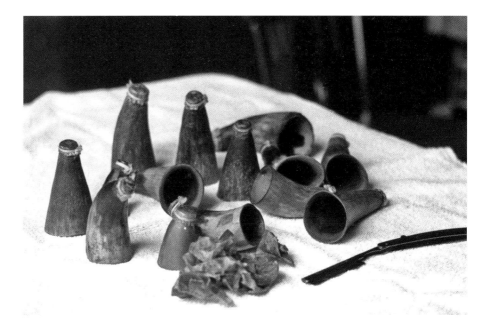

These implements belonged to the *kuppari*, or "cupper." Cupping is a traditional bloodletting practice that many immigrant Finns used in conjunction with sauna and massage as a natural health care regimen. Courtesy of the Immigration History Research Center, University of Minnesota.

Niemistö explained the regional variation in the use of *vihta*, the vegetative bath whisks used in sauna: "We used the cedar . . . we never used birch, and it's soft when you heat it up—the locals considered cedar a better vihta than birch, but you can't tell that to the Finns in Finland. You could harvest cedar any time of the year and preserve them in water for a week after you first used them." And he recalled watching the immigrant generation after a cupping session in the sauna—"the old-time HMO"—by which blood was drawn from short incisions with a cow horn or tapered steel bell: "They would come out invigorated . . . their conception of it was the bad blood would run out of the surface." Niemistö said that his family was still using a savusauna when he returned from military service after World War II, and many saunas endured up to that period without updating the hearth.

Such therapeutic services as cupping were not always capably practiced by a member of the household or near neighbor, and itinerant cuppers would make the rounds from farm to farm to perform the ancient bloodletting for fees and hospitality. One legendary practitioner in the Hankas' world was Eelu Kiviranta, who lived on a farm fifteen miles away to the southwest in Nisula, across a swath of largely Finnish American settlements, from Tapiola through Elo and Pelkie. He traveled the farm roads on his bicycle and performed massage and rustic osteopathy in homestead saunas for neighbors all around the region. He was a self-published poet as well, and by legend spoke only in rhyme as he shared gossip from farm to farm. He preferred the company of women and had a predilection for visiting when the men of the house were away.

Among the Hanka children, only one daughter married, and she in turn had only one child. A book that tells the farm's history includes the reminiscences of family descendant Carolyn Hanka Lindeman, who visited twice as a child and to whom the farm was a "dark," "foreboding," "musty," and exotic place.[5] Julia Klatt Singer beautifully describes a sauna experience from her first visit to an old family farm on the Upper Peninsula in her story "The Saturday Afternoon Bath":

> The first sensation was heat. A thick air too heavy to breathe, too hot to swallow. Then flesh. I had never seen a naked body but my own, never seen my mother in less than her slip, my dad in less that his undershorts and white T-shirt. Even my brother Dan's body was a mystery to me. We bathed together until only a few years ago, but he always wrapped a washcloth around his penis like a loincloth, and made me close my eyes when he got out. I never thought of peeking. What was there to see? I was ten and I didn't have anything interesting to look at.
>
> I glanced around trying to find a place to sit, a place to hold my eyes. The fire flickered through the cracks in the pipe, creating flashes of light

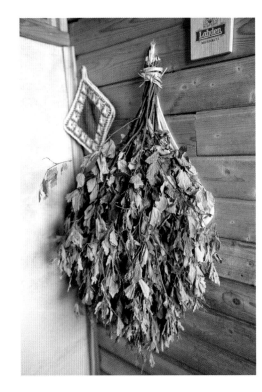

Vihta and *vasta* are regional Finnish words for bath whisks, most commonly made of birch twigs harvested just before midsummer and preserved throughout the year. North American immigrants used other deciduous species as well as northern white cedar (*Thuja occidentalis*).

on my aunts' and cousins' bodies. Big round breasts hung and swayed with ruby and mauve nipples staring right at me. All the women sat talking in Finnish—a quick, rhythmic language that reminded me of snapping beans. I listened hard, hoping to hear a word I knew, but none emerged from the tangled, clicking sounds. They sat with their legs crossed, as if they were having tea. Nobody's body looked like mine, small and flat, lacking description. Their laps were dark and hidden behind small, firm bellies.

I climbed up on the bench and tried to disappear. I felt little and white, my nipples flat and pink. I crossed my legs and closed my eyes and couldn't get the picture of all that flesh surrounding me out of my mind. I didn't want to open my eyes and see it all again, but something about their voices made me want to look. They were all naked, with womanly bodies, sweating, yet acting like nothing was strange.

I remember the heat entering my skin and my lungs and eventually feeling like I was part of it all, merging into the wood bench, their unfamiliar words, and the heat of the fire.

"Time to cool off," my cousin Janice said. She was sixteen and curvy without being fat. "Follow me." She climbed down the bench and led me to the door. I watched as her hips tilted, her butt bouncing up and down with each stride. We entered the hallway and then opened the door to the outside. Light flooded my eyes and I remember blinking hard once or twice before I figured out what was happening. As we stepped into the bright yard someone said, "ready" and Janice laughed yes and a bucket of cold

well water coated our bodies. I opened my eyes and saw most of the men and some of the women all standing around the yard, naked and dripping, chatting like they were at a church picnic. Aunt Ilee came out of the house with an armload of towels and began handing them out. I tried not to look at the men, especially my uncles, with their dark hair and round cylinders of flesh hanging between their legs. I tried not to see them at all, but it was hard. It was broad daylight and the backyard was full of naked people.

I spotted my brother Dan across the yard, running around with Johnnie and a bucket of water. Dan was still wearing his white briefs with the blue waistband. Some of the cousins went back to the sauna for another sweat, some to the house to get dressed for the evening, it was Saturday after all. I stood there naked and warm, white and creamy like milk, feeling the sun's rays on my chest, watching the light breeze rustle the small blond hairs on my arm, with nothing, absolutely nothing, to hide.

The Black Finns of Embarrass

The precise reasons for Finnish homesteading in the region are as varied as the families who chose to settle the cutover woods, but a very common motive was the exclusion that resulted from the first attempts to unionize the mining industry. The twin lodestones for homesteads like the Hanka farm were the vast mineral resources

The caption to this engraving, "The Black Finns," from *On New Shores* by Konrad Bercovici (1925), addresses the perception that the Finns were uniquely alien among North American immigrants; their peculiar language, penchant for radical politics, and practice of communal bathing set them apart.

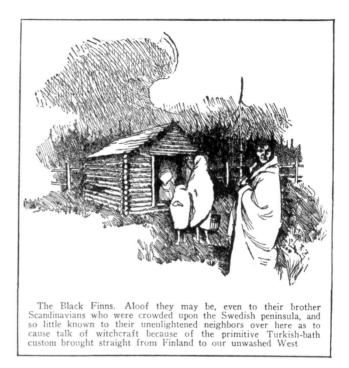

The Black Finns. Aloof they may be, even to their brother Scandinavians who were crowded upon the Swedish peninsula, and so little known to their unenlightened neighbors over here as to cause talk of witchcraft because of the primitive Turkish-bath custom brought straight from Finland to our unwashed West

of the Copper Country and Minnesota's Iron Ranges. The Mesabi and Vermilion Ranges drew direct Finnish immigrants as well as miners relocating west from Michigan's south shore of Lake Superior. Brutal, protracted strikes led to blacklists, and a reputation for union sympathy led to outright discrimination against Finns in many communities. Unlike the Slovenians, Italians, and others, the *Suomalaiset* were equipped by generations of experience to adapt to the hinterland of Minnesota's Arrowhead region and gain some degree of economic independence from an industry that many were convinced would only exploit them.

One such voice was Alex Palo (Palokangas), a native of Kortesjärvi in the Vaasa region. Palo exited the industry in the early 1890s to claim a homestead after working in iron mines nearby in Virginia, Minnesota. Like a northwoods Moses, he encouraged other Finnish miners to settle rural farmsteads. According to one account, "his success as a pioneer led to a group of his working comrades 'rising up from below the earth to its surface.'"[6] When interviewed thirty years later, he typified the Finn's local reputation for independence: "Every Finn he got his steam bath. Every Finn believe in cleanliness, but that is not the only difference ... no Finn in Embarrass will ever go back to the mines. Many have come here from the mines with bad lungs and got healed here. Now nobody will go back any more. We do not want hospitals; we

want farms, and everybody wants such a farm as he wants."[7] The common Finnish maxim "*oma tupa, oma lupa*" translates fairly to "my home, my way."

The Finnish communities of the Arrowhead region drew the attention of Eugene Van Cleef, a geography instructor at the Duluth Teachers College who published a widely reprinted essay in 1918 called "The Finn in America." Van Cleef, who later went on to a professorship at Ohio State University and became a leading Finnish immigration scholar, saw this Finnish presence in deterministic terms: Finns settled this northern landscape because it was remarkably similar to the forests of home. The more complex picture must include availability of mining and logging jobs, combined with the fact that the prime agricultural lands of the heartland were already settled when Finnish immigration hit its peak. But Van Cleef ably characterized the Finn's willingness to pursue agrarian autonomy: "the Finn is not a miner by nature. He is a man of the soil. After working in the mines a few years—the average is from two to five—he uses his savings for the purchase of some land or for taking up a homestead.... To a farmer in the corn belt these northern lands must seem almost hopeless; but to the Finn, where there is land there is hope."[8] Like the Copper Country, Minnesota's Arrowhead also gave rise to a village with the name Toivola, based on the Finnish word for hope.

Erick and Kristina Nelimark's log sauna, now on the National Register of Historic Places, was the largest sauna in Embarrass, Minnesota, when it was built in the 1930s.

Van Cleef offers that the traveler could "very safely identify a Finnish farm from a distance by its number of buildings. Among them may be counted the owner's first shack, his later log cabin, his recent modern dwelling, his never-forgotten bathhouse, a cow barn, perhaps the old one and the new one with its glacial-boulder foundation, a horse barn, a root cellar, several hay barns scattered over the fields, a tool house, a woodshed, and other miscellaneous special buildings." Notably, he never uses the word *sauna* in the article, and he does not seem fully convinced of its benefits: "The teaching of the principles of hygiene and sanitation to the children . . . in the magnificent rural and city schools of the county is proving an effective agency for betterment of home conditions." But he does extol one sociological benefit: "Members of both sexes, beginning with childhood, are educated in the form of the human body and, thereby, that ignorance in later life which so often accounts for sexual immorality is at once discounted."

Van Cleef's view that immigrant settlement was a product of mere wandering until people encountered a landscape that suited their ethnic skills and temperament was common among scholars and other writers of the time. The distinct nature of American Finns drew the attention of a national journalist named Konrad Bercovici, a Romanian Jewish immigrant once described in *Time*

The Tapio savusauna at the Finn Creek Open Air Museum near New York Mills, Minnesota, was built by the family who originally farmed this land, which is now a regional museum featuring other vernacular buildings and hosting a variety of events.

The Waahto sauna at Knox Creek Heritage Center in Brantwood, Wisconsin, was moved to this location and reassembled. Some of its dovetailed cedar logs were salvaged from another abandoned sauna in the area.

magazine as "one of these walrus-mustached foreigners who give a touch of the exotic to the reaches of the Hotel Algonquin in Manhattan." In thirty-five books and five hundred published articles, he revealed a keen eye for cultural distinction, a talent sown in the company of gypsies on his family's Romanian farm—indeed, he welcomed the inference that he himself was a gypsy, cultivating an outsider persona from Paris to London to New York.

After a few early successes in the 1920s, Bercovici was encouraged by a New York editor to write a book about the non-Anglo-Saxon populations of the country, describing their customs, their occupations, and their relations among each other. "Day after day, week after week, month after month, I traveled from city to city, village to village, and state to state," he would later recall.[9] In the resulting 1925 book *On New Shores*, Bercovici examines the vast patchwork of the European cultural imprint in America: Mennonites, Poles, Czechs, Dalmatians, Croats, Germans, Danes, Finns, and Dutch; in Michigan, the Dakotas, Ohio, Montana, Washington, Arizona, Wisconsin, Minnesota, and Illinois.

Bercovici's combination of eloquence and bright scrutiny made him a perfect choice to explore pockets of resistance to America's cultural alchemy: "Underneath the slowly melting surface in the crucible containing the diverse human materials of this country there is a metal that resists the melting . . . the melting pot is yet a plausible theory and not a fact."[10] *On New Shores* includes a chapter called "The Finns of Embarrass, Minnesota," and the writer strives from the outset to expose scandal while visiting the fiercely Finnish community in northeastern Minnesota, fueled by the prejudices of his local guide.

In Embarrass—and in the Finnish communities through which Bercovici traveled by auto from Duluth—the starkest symbol of this resistance was clear to him in the arrangement of the farmstead: "[A]lways there was one little building too many. Generally, it was a square, squat log house, which seemed to be half in the ground, with a wide door and a blind window." The writer fails to find any sin beyond a certain standoffishness in the Finns he talks to, but he freely quotes the guide, a man named Hall, for a more sinister view of these people of the marsh edges: "[T]he Christian Finns are all right . . . like the Norwegians, Swedes, and Danes we have in this State. . . . But the black Finns of Embarrass are not Christians at all. They believe in witchcraft. Every family has its own witch-house close by its living-quarters. And as often as a good Christian says his prayers, these black Finns visit their little witch-houses. It is a funny sight to see the whole family, each one wrapped in a large white sheet, going to this little house to pray to some deity. Now these black Finns, too, are good workers, but we know enough about them to keep away from them."

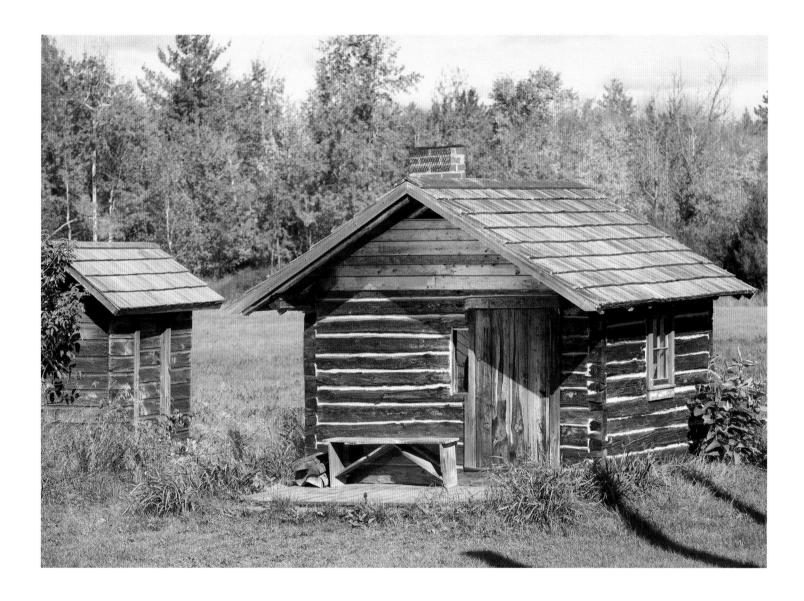

Bercovici confirms that this was not a singular impression, stating that other locals were convinced that the sauna was a place for strange and exotic worship. Wandering north from St. Paul, he had first visited the Danish community of Askov, Minnesota, and praised the disciplined order of the community's Scandinavian immigrants, who were eager to assimilate, perfecting their English faster than any other nationality. But he paints a stark contrast in Finnish Embarrass, where no two Finns and no two houses are alike. By the time *On New Shores* was published in the 1920s, Embarrass had 350 families—the community had grown gradually but without a definite plan; houses faced different directions and were never arranged in rows. "They turned their backs upon strangers. There were no actual villages. There seemed to be no desire to live close together, as was the case with most of the other newly arrived immigrants." He characterizes his trip to Embarrass as a lesson in "outlandishness."

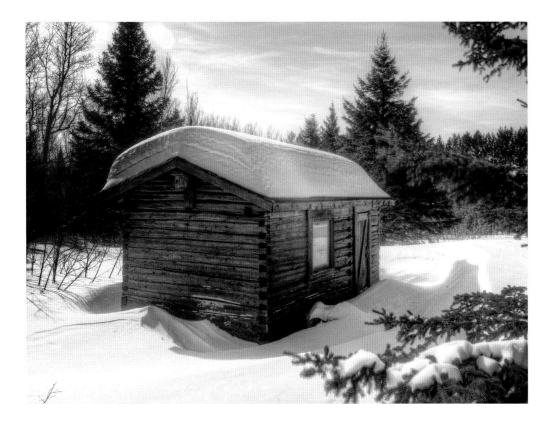

⬅ The Rouska sauna at the heritage site in Finland, Minnesota, displays several sauna implements collected from the local community.

➡ The John Palo sauna in Oulu, Wisconsin, is a rare multipurpose structure with a bathing room, woodshed, and shop. The 1910 farmstead was restored by grandson Duane Lahti and is on the National Register of Historic Places.

Bercovici's portrayal of the Finns, which received wide notoriety due to extensive republication, led to defensive responses in regional newspapers. An editorial in a Minnesota newspaper titled "Finnish People Good Americans" takes on the notion that Finns showed no desire to see their children Americanized: "The Finnish bath house of which Mr. B. writes is becoming modernized on many of the farms, and a wood burning stove on which water is heated steaming hot takes the place of the stone pile. They also have a weed or plant resembling a tobacco plant which is carefully gathered and dried in the fall, and later used as a wash cloth during the bath."[11]

While he clearly understood the value of stoking publicity by fanning the flames of scandal, Bercovici genuinely admired Palo and his neighbors, took issue with those who called them "wild-eyed radicals," and endorsed sauna's benefits: "Needless to say, they are the cleanest, probably the healthiest people in the world."[12] He noted that Finnish farms were said to produce more rye per acre than any other similar locality in Minnesota and that the farmers were inordinately proud of their horses. (Another account from the period claimed that it was typical of Embarrass farms to have a thousand bushels of potatoes invested in their cellars.) Bercovici predicted that it would take at least two generations for Finns

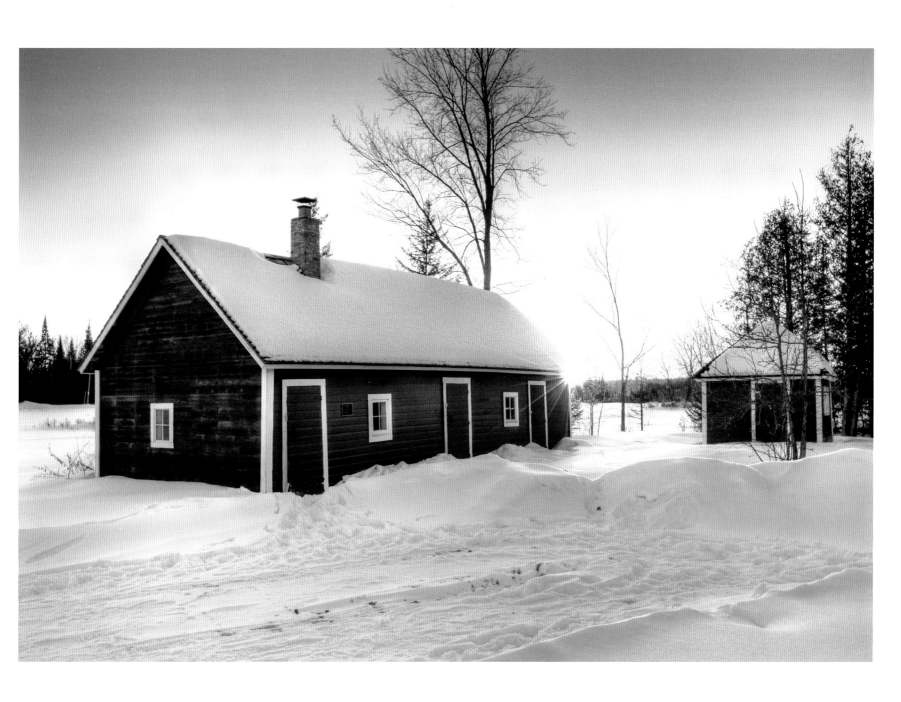

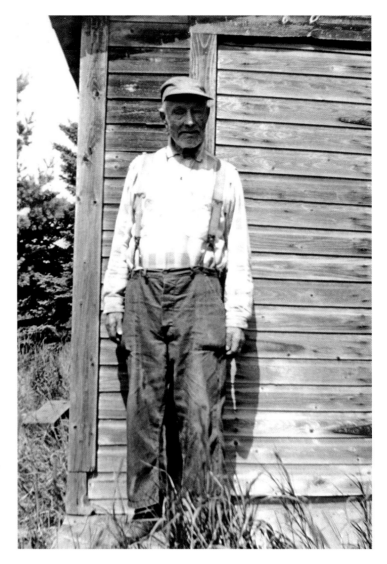

to shake the sauna habit. Sisu Heritage, Inc., a local nonprofit organization, has proven him wrong by saving many invaluable homestead buildings, some of which were being used in earlier decades for practice fires by the local fire department. Their organized tour of important Embarrass sites includes the Nelimark sauna, which is listed on the National Register of Historic Places.

Wirtanen Pioneer Farm

South from Embarrass along the old Vermilion Trail, the annual late-summer gathering at the Wirtanen Pioneer Farm in Markham, Minnesota, honors a sauna site of great importance, which will soon be inherited by a fourth generation of Finnish descendants within the community. But they are not the progeny of the farm's lifelong bachelor resident, Eli Wirtanen.

Wirtanen was an immigrant who lived out his life on the edge of the wilderness in the heart of the Arrowhead. Like most Finnish immigrants who homesteaded at the dawn of the twentieth century, Wirtanen got his foothold in North America by serving in the front lines of resource extraction, cutting pine from the Minnesota winter woods and milling it in the summers. He had first arrived at Port Arthur in Ontario to live with his brother's family on the Kaministiquia flats, but Eli soon moved on in search of work to central St. Louis County in Minnesota. He struck up a close friendship with his boss and took often to the tavern, that ready sinkhole of wages earned. But the boss's wife tamed her mate's wantonness and committed her husband to homestead a forty-acre woodlot in 1904, and Wirtanen anted up as a neighbor.

Markham sits in the wide expanse between the Mesabi Range and Lake Superior, a softer country where terrestrial bones are buried deep beneath gravel deposited as drumlins and eskers by subglacial rivers. Atop this plain of agricultural improvidence, the immigrant Wirtanen staked his claim. He built a savusauna near the road that marked the northern boundary of his forty acres. His

The Wirtanen sauna has seen one hundred winters and warmed thousands of evenings.

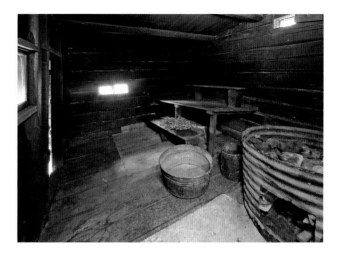

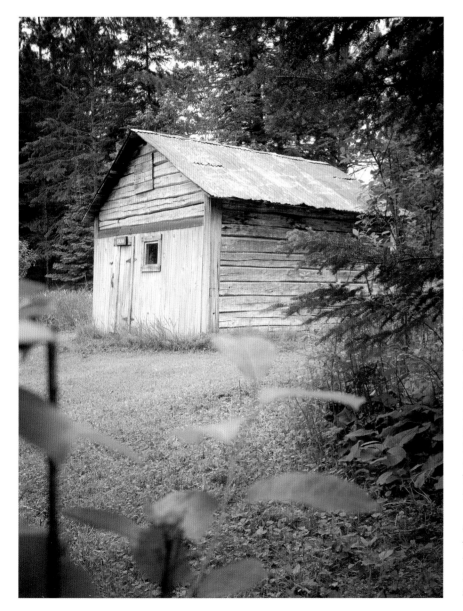

enterprise required much more than simple thrift—it depended almost completely on materials that could be derived from the land around him. The sauna features a small vestibule that opens into a dark room, and Wirtanen's is tightly fitted, exhausting through a hole near the peak of the back wall, the *räppanä*, and taking air in through a chest-high box in a side wall. The structure is simple in its beauty, and decades of functional tweaking are apparent: a culvert section became the hearth; a weathered and reddened metal roof crowns the hand-squared, dovetailed logs. This sauna has seen one hundred winters and warmed thousands of evenings.

After a long week's work in the forest or a day spent teaming his horses for forty cents an hour, Wirtanen would close the week in his savusauna. The room would fill with smoke while the rocks heated, and Eli would stoke the fire with breath held and eyes tight. Only after the fire had died and the smoke cleared would his bath begin, and he would pour water on the kiuas to produce the telltale flash of löyly.

Aside from pure tradition, the Finns' importation of this tradition to the shores and uplands of the Lake Superior basin makes very good sense. The average daily temperature in Markham bottoms out near 0°F in January, and frost is not unthinkable even in July—gardeners in the area are aware of, if not immediately subject to, the limits of Zone 2. (By contrast, the average January

temperature in Wirtanen's native parish of Karstula in Finland is a balmy 16°F.) Sisu, the Finnish essence that simultaneously suggests stubbornness, chutzpah, and Sisyphean grit—"even through a stone wall" is one vivid characterization—must have helped Wirtanen throughout his bachelor life. He carved a wide meadow out of the forest of red pine, white spruce, and tamarack and built a sturdy, modest log house that remains wafer-tight to this day. He raised a few animals, kept a horse team for hire, and worked winters in the woods well into his seventies. Several barns ring the meadow, and the forest still stands respectfully distant more than a half century after his death at eighty-seven in 1957.

But his life also bears witness to the great loneliness that many pioneers endured. Wirtanen's grandniece Martha Stott of Negaunee, Michigan, tracked down and visited Wirtanen's farm in 1952 after following a family rumor that her uncle Oskar had a brother who had ended up in Minnesota. Wirtanen was sleeping inside when they arrived, but Stott knocked persistently on the door while her mother, Saima, and Uncle Oskar stood on the porch. Stott beseeched the awoken man in Finnish: "Elias, it's your relatives from Michigan."

"I don't have any relatives," he called, startled from inside. But he yielded to their persistence, and Stott introduced Oskar as the brother he had left behind in Finland when just an in-

fant. Wirtanen put his head on the table and wept so long that he soaked the front of his clothes and pants, having believed all these years that the baby had died in infancy of an illness along with the next older sibling. Despite living in the same region, he had been separated for decades from his family, aging through an isolated bachelorhood.

Stott marveled at Wirtanen's root cellar—turnips, potatoes, rutabagas, carrots, and jars of venison—but noted that he did not care for corn. When he died a few years later, Wirtanen left the farm to the woman who ran the boardinghouse where he spent his last years. But Mrs. Kainalainen had no need for another farm. Stott recognized its value and suggested that the county historical society take it over. The 1950s were a time of early momentum for Finnish American cultural preservation, and the farm began its history as a community asset, acres devoted to enshrining the skills that had made this marginal land viable.

His legacy is now a historical treasure, thanks to the steady efforts of local descendants and the generous support of successful Markham expatriates who have contributed matching grants for the maintenance fund. The site, held for years by the St. Louis County Historical Society, was acquired in 2001 by the Friends of the Wirtanen Pioneer Farm. These secluded acres are valuable for their ability to explain a simple farmstead economy to visitors,

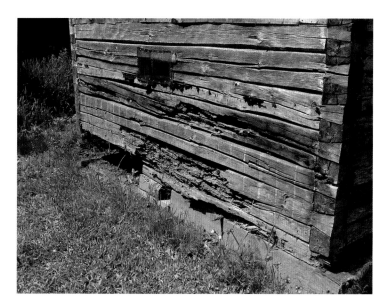
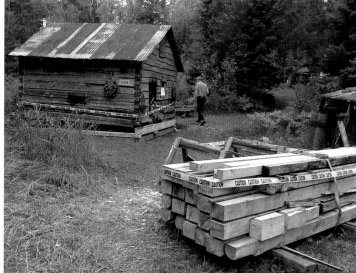

where they can explore a plot that was developed not under the strictures of a contractor's calendar and the power behind a bull-dozer's blade, but rather by the annual fortunes and ambitions of an industrious steward and his reckoning with the land and seasons, all without electricity or internal combustion. But the Wirtanen Farm is precious most of all because of its homestead savu-sauna, a rare relic. Such scorched chambers are understandably prone to destruction every generation or so, and most have disappeared from the Arrowhead woods.

In 2008, the Wirtanen farm organization began a long overdue reconstruction of the sauna. Some work had been done on the foundation in previous decades, but significant rot had converted some of the lower pine logs into soft pulp, and ants were taking advantage everywhere. Local volunteers Harold Johnson and Norm Jarva took on the job, which meant a crash course in dovetailed joinery. "We were scratching our heads," Johnson said as he showed off the progress, sharing that they had recently consulted with local master log builder Martin Mattson, who was once commissioned to build a dovetailed sauna for an exhibition in Washington, D.C., in the 1950s. In the background, accordion music from the annual festival filled the meadow over a bustle of voices that must have been an extreme rarity in Wirtanen's days—this was a day off from volunteer toil. "We intend to do a good job, and that's why we're going so slow."

Jarva had provided several red pines from his property, which were squared at a mill in Palo, saving broadaxe labor, but detail work with drawknives made the new logs appear authentically worked. A passerby stopped to inspect the project and warned Johnson that winter was coming soon. Jarva explained the essential challenge of creating compound dovetail corners: "It makes you have to think in three dimensions at once." He suggested that a Milwaukee Sawzall would make for quicker work, but one was left with the impression that Johnson's commitment to authenticity would win out. He stood back and said he could not imagine putting another tin roof on the old building once the walls were restored. An avid woodworker since his doctor advised him to give up welding and metalwork for his health, Johnson had been setting aside cedar for shakes. He had already learned to manufacture wood shingles with a band saw and claimed that cedar would last three decades in this climate. Unused in a shed nearby was the horsepowered shingle mill Wirtanen long ago showed to his niece.

Even for local residents who did not grow up with one in the family, the sauna is as familiar as a pickup truck. You may not own one yourself; you may never even feel compelled to borrow your neighbor's. But you are accustomed to its proximity and know that severe warmth sometimes comes in handy. Much to the benefit of all, the Palo-Markham community continues to fan the cultural embers.

The Aho sauna on the shores of Wolf Lake in west-central Minnesota was replaced by a basement sauna in the farmhouse in the 1920s, but it is still in use as a playhouse for the original settlers' great-grandchildren.

The Iso Aho Family

Self-sufficiency in the shadow of the mines on small farms was one clear prerogative of Finnish homesteaders in the Lake Superior region. But in communities to the near west of that great watershed—within the Finnish Triangle (according to accordionist Kip Peltoniemi, "the center of the eastern section of the western part of the southern portion of northern Minnesota") roughly bounded by New York Mills to Sebeka and Menahga to Wolf Lake in Otter Tail, Becker, and Wadena counties—immigrants from Finland and migrants from the mining regions practiced agriculture on a broader scale. Some families who have endured on the western fringe of the north woods have expanded their holdings well beyond the typical forty- and eighty-acre spreads of their cousins in the Arrowhead and Copper Country. There were more frequently strong religious motives as well, as Læstadian Apostolic Lutheran pastors exhorted their flocks to depend on the land and break free from the bonds of credit and wage.

No better example of the multigenerational success of a Finnish immigrant farm exists than the one on the northern shore of Wolf Lake (Susijärvi in local parlance) first settled by Jacob and Anna Aho in 1894. Jacob and Anna intended a large family, and he sought a location where "they wouldn't be in anyone's way." With

a fifty-pound sack of flour on his back, and a sharp axe and a gun in his hands, he followed a simple path to inspect the seventy-acre plot where he and Anna would make their future. On first examination of the land, Jacob was pleased by how the open meadows and gentle hills fronting a shallow lake rich with fish evoked his native Alahärmä near Vaasa in Finland.

Jacob was already thirty when he arrived in Minnesota, a devout Læstadian Lutheran who had worked as a foreman in the building trades and helped to build the luxurious Hotel Kämp on Helsinki's main promenade near the harbor. His disavowal of the mammon they built caused him grief among his fellow workers, but he stood steadfast in the belief that one could not depend on earthly riches for lasting security. With the growing threat of Russian conscription closing in, and his savings lost to a friend's betrayal, he left his homeland for America and a shot at independence.

He first found employment as a laborer in Minneapolis and then worked one wheat harvest in North Dakota. But when he learned of the Læstadian Finnish communities of the New York Mills area, he decided that was where he should make his home. There he encountered Anna, twelve years his junior. They marveled to realize that they had known each other in Helsinki, and they were married almost immediately. By the time Jacob left to walk over their chosen acreage, Anna was pregnant.

They purchased the seventy acres for $210.72 and chose a homesite with a view of the lake and a long point of land. They quickly assembled their first home, a shelter of evergreen boughs, and their first son, Uno, was born in August. The log cabin expanded as the family grew, and they quickly upgraded to a frame sauna with a broad brick chimney, which demonstrated Jacob's abilities as a bricklayer acquired in Helsinki. By 1929, Jacob and Anna had brought thirteen children into the world and lost only Uno, at the young age of twenty-four. The Ahos also welcomed many foster children into their ranks. To accommodate the large family, they completed a house so big that Jacob explained to neighbors that "he had wanted it big enough to even hold meetings in, should the church be too small."[13]

The Big House would be described in a local Finnish newspaper as "the size of a hotel in a small town." The house was sixty feet long and forty feet wide, three stories high with twenty-three rooms and long hallways that ran the full width of the building; abundant space was dedicated to storerooms and utility rooms. Most notably, a basement sauna replaced the frame bathhouse down toward the lake, a watershed development for Finnish farmsteads. Jacob and Anna's brood became known in Becker County as the Iso ("Big") Aho family, and their reputation was known well beyond the immediate Wolf Lake community. By the time Jacob

died in 1945, the details of the farm bore witness to a steady progression of success: the hundred-foot main barn had stalls for fifty-three cows, a separate barn housed the calves, and a hog barn held an unknown quantity of piglets—all livestock served by twin silos filled with grain grown on Aho land.

The definitive *History of the Finns in Minnesota* was published in the early 1950s, and it is a comprehensive but mostly prosaic collection of dates, names, and facts. But the author's description of the Iso Aho family provides a vivid and idyllic description of family life in 1954 for thirty persons of three generations under one roof: "The outstanding feature of the Aho farm, however, is the family itself. Although Jacob Aho had died, in 1954 his wife was still living on the farm, together with seven sons, four daughters, three daughters-in-law, two adopted children, twelve grandchildren and one hired man. All of these 30 persons lived under the same roof, ate at the same table, took part in all the farm work, with no distinctions of individual privileges or property rights. Nobody gave orders, for everyone knew what he had to do, had in a sense grown up to whatever had become his responsibility. The young men in the family did not leave home, any more than did the daughters when they married. The sense of unity was so strong that all took part in raising the children, who were looked after by anyone who happened to be on the spot, without asking whose child it was."[14]

The family still owns much of the northern shore of Wolf Lake. Six sons of Jacob and Anna's son Hugo continue to run a dairy farm that has expanded from their grandparents' original farm to 2,700 acres. Wolf Lake is a Minnesota rarity: its ten miles of shoreline are mostly undeveloped because several legacy farms like the Ahos' remain intact. On the Aho property, all of the grandsons have their own homes, and each tends to a particular aspect of the family business: bovine husbandry, equipment maintenance, feed production on the vast acreage, the daily milkings, and that other inevitable daily task, manure management. Among these six families fifty-three great-grandchildren have grown up. Currently their seven hundred cows produce over thirty thousand pounds of milk per day. The new state-of-the-art milking barn includes all essential equipment, including a sauna with electric stove and shower. The main house is currently inhabited upstairs by two older grandsons, but otherwise preserved as a family museum and used for family gatherings. The basement sauna in the farmhouse is a dank relic, and the old outbuilding sauna is now used as a playhouse by the kids, but sauna remains alive among the descendants.

But such continuity is not the rule. Twelve miles to the southeast lies the Ervasti farm near Sebeka. Wes Ervasti was born in 1926. A wiry octogenarian, his frame as windswept as a high-plains fence post, he still has the unassuming confidence of one who com-

mands the acres where he was born. His parents bought an existing farmstead and scratched out a living from the flat, rocky, lakeless pinelands of Wadena and Otter Tail counties, where Finns, the last homesteading wave of European settlers, tried to make the most of marginal farmland. The family mostly raised hay for a milk herd and sold their product to the creamery at Park Rapids. "Finns are the best handlers of cows in the history of the world," said Ervasti, a consistent source of ethnic pride.

He vividly recalled using the sauna to wash off the dust of a day's work in the fields. He recounted the benefit that his family realized from sauna after one of his brothers contracted polio, proudly describing how his tireless and faithful parents treated the boy in the sauna with the Sister Kenny method nearly every day, and how eventually the boy regained use of his legs. Ervasti clearly remembers local cuppers using a clipped cow horn, a small incision, and mouth suction to let blood from willing subjects. "Finns are the smartest people in the history of the world, they are a genius race, but they are prone to high blood pressure. When I was a kid, I asked a guy who did it why, and he said 'I don't know, it feels good.'" Years later, he made a sensible connection before advising a friend: "I told this guy—his doctor says you've got high blood pressure and you've gotta stop it—I says go give blood, and he set the record for giving blood in Menahga."

The most likely reason for a sauna's early destruction was fire from the heat it produced. Photograph courtesy of Rebecca Nieminen Sloan.

Ervasti eventually bought out his parents and made his mark as a rancher after staying in agriculture against his father's caution, breeding Gelbvieh and Braunvieh cattle. He expanded their original farm and now owns over a thousand acres of Wadena and Otter Tail counties, most of which he rents out as pasture. The original longhouse and additions burned in the 1990s, but Ervasti has prospered enough to rebuild in grand fashion. His home is a contemporary tribute to the Finnish homestead, built of logs milled to emulate lap siding. Most of the wood in the house came from groves on his acreage. But a functioning sauna is long gone from his property, and he prefers a hot-water bath, so hot that he almost scalds himself. "My bulls have broken my neck three times," said Ervasti as he moved slowly and gingerly down the stairs to the basement, where he lives below the unsparing splendor of the main floor, a space reserved for visiting deer hunters and other guests.

Given at time to outpourings of cultural pride, Ervasti is a humble man when recalling his herds in the presence of the thousands of trees he has planted over the years as shelterbelts around his fields—"my children and grandchildren" he called the trees and marveled openly at their beauty. The soft green of a long line of balsam fir dissolved into the drizzle and dusk of a May evening, "more beautiful than anything you would ever see in New York City," Ervasti stated with certainty. One legacy of his steady acquisition of his surroundings is the two saunas on the long-vacant Mattson farmstead next door, covered in the dust of disuse. The older log building, a savusauna that Ervasti claimed dates to 1885, has been serving as a shed for possibly as far back as 1936. That is when the newer abandoned sauna was built, and it still shows every evidence of its original purpose and could surely produce abundant heat if put to the test. But all signs suggest that the trees will inherit these buildings in the coming decades. ▪

A typical savusauna and distant *tupa* (tenant house or cabin) in Lempäälä, near Tampere in southern Finland. This photograph was taken at the darkest moment of the shortest night of the year.

Finland's
Sauna Culture

Steadfast old Väinämöinen
Produced honeyed vapour,
Through the glowing stove stones,
He speaks with these words:
"Come now, God, into sauna,
to the warmth, heavenly Father,
healthfulness to bring us,
and the peace secure to us."

Welcome löyly, welcome warmth!
Welcome healing power!
Löyly into the floor and ceiling,
Löyly into the moss in walls,
Löyly to the top of the platform,
Löyly onto the stones of the stove!
Drive the Evil far away,
Far away from under my skin,
From the flesh made by God!

—SAUNA SPELL BASED ON THE
FORTY-FIFTH RUNE OF THE *KALEVALA*

The world from which North America's Finnish immigrants came is a place where the essential importance of sauna is beyond question. In Finland, sauna is fundamental, and no empirical examination could eclipse the simple fact that the entire nation could simultaneously call it a day and every last person find a place on a bench somewhere and indulge in one colossal national wave of löyly. In contemporary Finland most sauna stoves are electric, and such a strain on the grid would idle all other activity. An anecdote demonstrates how tenacious the Finnish people are in defense of the institution, as well as the dark side of sisu. During a recent winter cold snap, the government urged citizens to turn down their saunas to conserve electricity. The next day was a Friday, and by evening the collective response had registered: electrical demand surged to record levels.[1]

But another gauge of sauna's primacy in Finland is perceptible in the culture that was emerging in Helsinki at the time when people like the Barbergs, Ahos, Hankas, Wirtanens, and Palos were leaving their homeland. The latter half of the nineteenth century was a time of national awakening, a movement that would finally ripen into independence in 1917. For Finnish artists of the time, whether they came from Finnish- or Swedish-speaking households, the old stories collected by the wandering philologist Elias

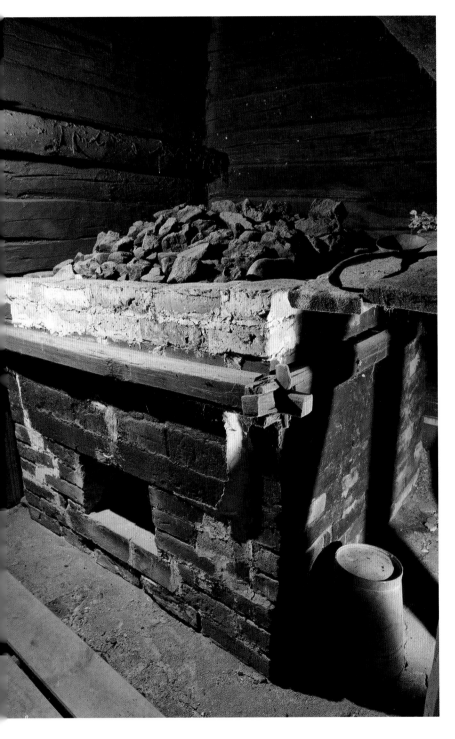

⬅ The kiuas in the Lempäälä savusauna.

➡ An enclosed addition to the original Lempälää savusauna provided a middle ground between sauna and the outdoors. Saunas in the Finnish countryside hosted life events ranging from childbirth to preparation of the dead for burial.

Lönnrot and melded into the epic *Kalevala* in the 1830s could not be ignored. These artists were also compelled to depict sauna and try to capture its essence.

Alexis Kivi's novel *Seitsemän Veljestä* (Seven Brothers) is widely considered a fundamental work of Finnish literature, and he was the first author of his country to write a novel in Finnish rather than Swedish. This wonderful, comical work of literature was dismissed in Kivi's life for its realistic and profane depictions of rural Finns. Once facing a promising literary career, Kivi died at age thirty-eight after a loss of patronage and steady mental decline. But copies of the novel are now as common in Finland as the Bible and the *Kalevala,* and the Jukola brothers could be fairly compared to Tom Sawyer and Huckleberry Finn (no relation). Mostly using dialogue, Kivi documents a decade in the life of Juhani, Tuomas, Aapo, Simeoni, Timo, Lauri, and Eero as they complete their transition from half-feral young men to prosperous, responsible farmers and husbands. The sauna is central to the lives of the Jukola brothers, and throughout the novel characters are birthed, are healed, and die within the bathhouse.

The brothers have lost their father in a death wrestle with a great bear, but the sons have inherited his love for the hunt and his tendency to neglect the agricultural potential of the vast farm. Their mother's whippings and tongue-lashings only serve

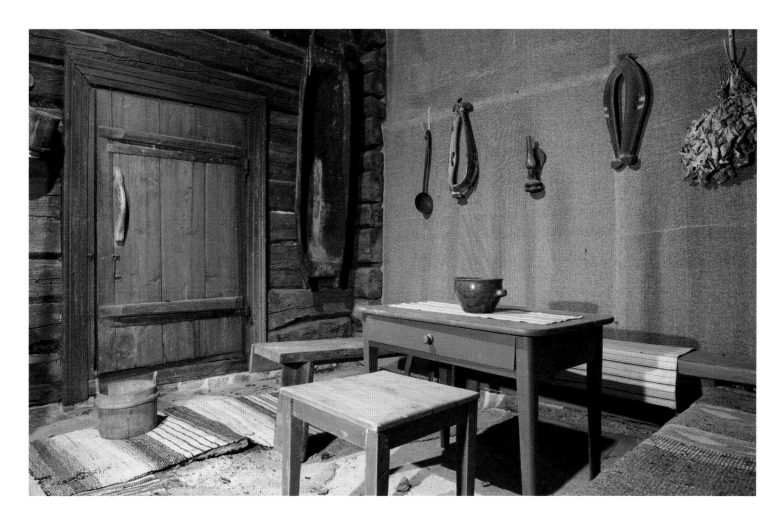

to drive them into the woodland for adventures, where they must be rounded up as truants, and she dies without ever taming her brood. They rove the countryside unbridled by society, bereft of parents, and chafing at their parish's one fundamental Christianizing ritual: that they learn to read.

After they suffer greatly in a brawl with a gang of rivals from nearby Toukola, the brothers return to the Jukola homestead to nurse their wounds in the sauna, which Juhani urges Timo to heat "until the oven rattles," for "hot steam in the sauna, that's the best physic for soul and body."[2] Timo throws water "until the blackened stones . . . cracked with a noise like rifle fire and a cloud of hot steam was wafted round the bath-house." Juhani, the eldest, is the first to relent: "That's enough Timo. Don't throw any more. For Hell's sake stop throwing water on that oven!"

The furious family rhythm of surging löyly and thrashing vihta is upset when Eero blows on Lauri's back, a trick still known to sauna imps everywhere who wish to scorch another bather. While cooling off after a bath that has lasted deep into the night, the prideful Juhani—the real blowhard in the family—suggests that facing the heat of sauna may expiate at least the smaller sins of men. He decides that mortal life is an experience on the porch of Hell, "that everlasting sauna," and he has the mettle to endure its foremost step. Such blasphemy alarms the pious middle son, Simeoni: "Man, remember the furnace of the lost and pray night and day."

Having confronted for the moment their sinful nature, the brothers treat their wounds with a fiery salve of brandy, gunpowder, and pine tar, then retire to bed: "But suddenly the air around Jukola was illumined: the sauna had caught fire. So hot had Timo heated the grey stone oven that after smouldering a while the wall burst into flames. And in deepest peace the building burned to ashes, unseen of a single eye. And when morning dawned, there

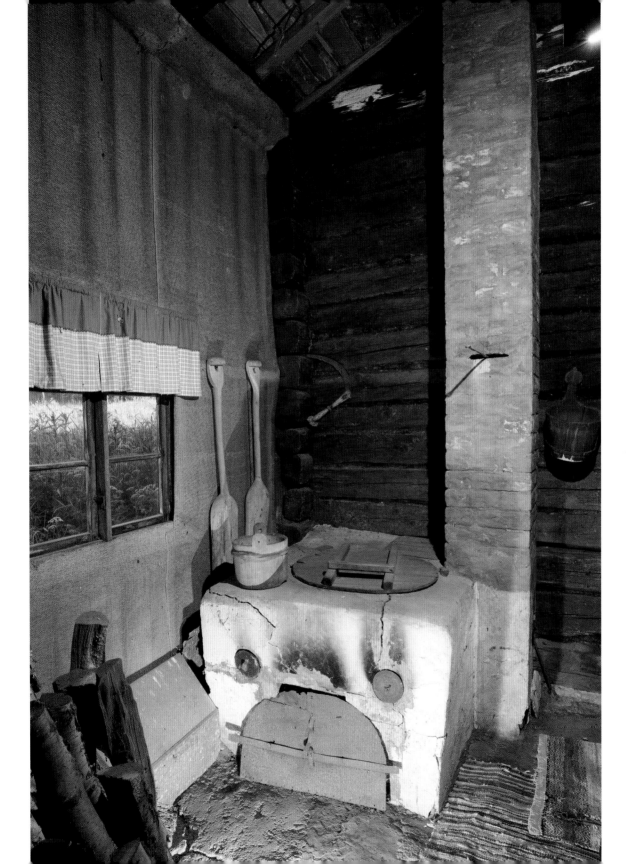

L

was left of the Jukola sauna only a few glowing cinders and the whitehot ruins of the oven." Timo blames Juhani, who responds in kind, but Kivi clearly had force majeure in mind. This setback is the last straw for the Jukola brothers, fate's final encouragement that they leave society for a life in a cabin deep in the forest, for a farm without a sauna is no farm at all.

Irresponsible and undedicated, they lease out the farm for ten years with the condition that the tenant rebuild the sauna, and they depart for the wilderness, unwilling to face the heat as the vicar closes in on their illiterate freedom. The aimless Juhani announces the northward march, and young Eero responds courageously: "I'll follow you even into the deepest cave on Impivaara, where it is said the Old Man of the Mountains boils pitch, with a helmet made of a hundred sheepskins on his head."

Lack of conformity is a proud Finnish tradition, and the brothers Jukola exhibit independence so reckless that it often bites back. In the age-old tradition of Finnish homesteaders, the first structure they build in their exile on Impivaara serves several of their domestic needs: "It was ready at last, the brothers' cabin. Five fathoms was its length and three its breadth [30 feet by 18 feet]; one gable looked eastward, the other westward. Entering through the door at the cabin's eastern end, thou hadst on thy right a large bath-oven, on thy left a manger, built for [their horse] Valko's use

in the winter. From the threshold onward, almost to the middle of the room, a carpet of spruce branches hid the naked earth, but at the back of the room a stout floor had been made of broad planks and above this a roomy gallery. For the new cabin was to serve the brothers both as a dwelling place and sauna."

Almost immediately they burn themselves out of home and sauna after a torch sets the floor afire during another squabble. The source of conflict: Juhani has commanded young Eero to "pour a can of ale on the oven and we'll see what barley juice steam tastes like." Tuomas, who has just bested his older brother at wrestling for the first time, decides to protest the wanton waste. The brothers are left warming their backs to the fire while they stand shoeless in nightshirts as winter's first blast arrives from the north. Fire is a reckless servant in the lives of the brother Jukola, and several subsequent setbacks convince them of the advantages of community.

Kivi's seven brothers are the inheritors of a tradition of quasi-nomadic slash-and-burn agriculture known as *huhta*, by which a field would be felled in the spring, left to dry until midsummer of the third year, burned, and then sown with rye the following year. This practice made settlement of the peninsula's vast forested interior possible by improving the soil, but the drastic method usually produced only one good crop before dropping off quickly.

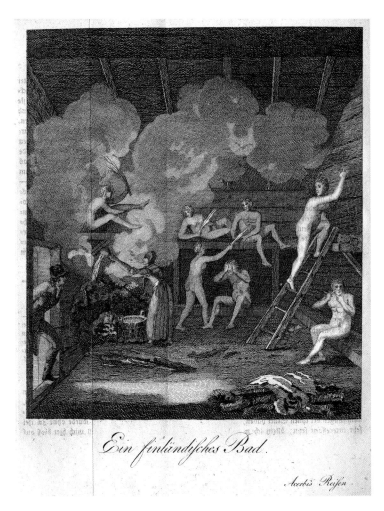

Ein finländisches Bad.

Acerbis Reisen.

These wanderers, known to settled folk as *kirvesmiehet*—"ax-wielders"—moved to a new clearing every few years and exercised squatter's rights. This practice allowed for frontier expansion unprecedented anywhere in the world, according to geographer Matti Kaups, who traced the blazing progress of these people from the stony, forested country near Lake Ladoga, through the lake country of central Finland, into the forests of northwestern Sweden's Värmland province, and across the great ocean in the 1600s as accessories of Nya Sverige, Sweden's colony on the Delaware River. Along with the folk architecture scholar Terry G. Jordan-Bychkov, Kaups theorized in *The American Backwoods Frontier: An Ethnic and Ecological Interpretation* that this Finnish presence in the New World had a fundamental influence on the folk architectural source of the American log cabin. These were the people of Lönnrot's *Kalevala*, "free spirited, boisterous, alcohol-guzzling, party loving backwoods folk,"[3] and the romantic ideal of the great painter Akseli Gallen-Kallela. At each new site, they progressed from an open-faced shanty called an *asento* to the construction of an enclosed *pirtti,* which served as a dwelling, sauna, and grain-drying shed as needed.

When such Finnish peasants were encouraged by the Swedish crown to migrate across the Gulf of Bothnia and settle remote tracts of the kingdom, they established farmsteads in the uplands of Värmland and Dalarna near the current border between Sweden and Norway. The Finns fell out of favor in Sweden for several reasons: poaching game, failing to remain in allotted lands, and above all for the competition that huhta presented to established iron and copper smelters hungry for charcoal. The Forest Law of 1647 condemned those "who come into the forest with a ravenous appetite, without explicit prior permission" and provided that sheriffs should capture them "and, as with other noxious animals, strive to get rid of them."

The first of these people who went to America were exiled to the New World as prisoners. Kaups and Jordan-Bychkov suggest that the notion of punitively sending these "mobile, volatile, disrespectful, and boisterous" Finns to the New World was "a bit like tossing Br'er Rabbit into the brier patch." Plenty of their kin soon petitioned to join the colony abroad on the eastern coast of

Ethnographic photographer Nils Keyland documented folk life during the late nineteenth century in Värmland, a Swedish province with a significant Finnish population. This is a rare view of men and women bathing together. Courtesy of Nordiska Museet, Stockholm.

a vast forest of seemingly infinite potential. The first four Finnish families left around 1640, and two hundred Finns petitioned to emigrate from Värmland in 1649 on the vessels that served the colony: the *Kalmare Nyckel* and *Fågel Grip*. The historical record states that the first gubernatorial mansion on Tinicum Island of Governor Johan Printz featured a sauna, and the accounts of the historian Peter Kalm reveal that almost all of the colonial farms had bathhouses commonly used every Saturday, but by the 1740s the practice had been abandoned.

But many other families stuck it out in the Finnskog, the remote forest that straddles the southern border between Sweden and Norway. Finnish names are common throughout the Finnskog, and the cultural imprint is still evident at homestead museums and other locations near villages such as Gräsmark and Mangskog. The best example is a remote savusauna at Bjurbäcken (Beaver Creek), a remarkable specimen that is over two hundred years old by local account. The sauna has been completely restored, and the highlight is the dry-fitted kiuas, a stone hearth reconstructed with astounding skill. Other features are typical of Finnish woodland building techniques: a spruce shake roof and rain gutters made from slender young trees, split and hollowed into channels. The Swedes of this area, broadly characterized in

the works of Selma Lagerlöf, already occupied the river valleys and lakeshore when Finns arrived, and the Finnskog commands the rockier and pinier ridgelines, where drifts of white moss thinly cover the bedrock.

One important reason for this enduring presence is the efforts of a local named Nils Keyland, who worked for Stockholm's Nordiska Museet in the early twentieth century. His efforts to preserve Sweden's Finnish culture are best shown at Skansen, the oldest museum of its kind, in one of the greatest displays of historical farmsteads and other period buildings in all of Europe. The Finngården (Finn farm) at Skansen comes from the Mangskog area, and on a cool, rainy summer day one can experience firsthand the scent of birch smoke stratified just above head level in a chimneyless cabin. This particular farmstead is notable for the lack of a sauna per se, but it does have a *riihi*—a small drying barn—with a stone hearth, which could also have served as a bathhouse.

The use of separately heated outbuildings was fairly common throughout the Nordic countries into the nineteenth century, but eventually the Swedish *bastu* and Norwegian *torkhus* were used

only for drying flax and animal hides, not for bathing, which had faded with the advent of Christianity. One nonacademic account is the compelling ritual bathing scene in Ingmar Bergman's film *The Virgin Spring,* based on the medieval song "Töre's Daughter in Vänge." Max von Sydow's character, the lord of a remote Swedish farm that has roots in the recent pagan past but also pays tribute to the church, prepares for an act of violent revenge by first sacrificing a lithe young birch tree and then whisking himself furi-

ously in the bathhouse. The Viking archaeological site at Sandnes on Greenland features the obvious footprint of a smoke sauna, and one documented Norwegian tradition provides that a son's return from military service was celebrated by a ritualistic mixed-gender sweat bath. Even the Norse sagas explain the bathing practice of producing steam by dousing hot stones with water. But the precise use of such buildings is not always perfectly known: At Skansen, the Älvros farmstead from northern Sweden, despite Swedish

provenance, has an outbuilding that is identified by the museum as a sauna—not a bastu—but the use is clearly identified by the museum as a place for drying farm products, not bathing.

It is somewhat surprising to find only two saunas at Seura-saari, Finland's answer to Skansen on an island northwest of downtown Helsinki, but that circumstance is related to class distinctions. The farms on the island are almost all the residences of large landholders, and sauna was most common among the

These Finnish postage stamps from 1949 also raised funds for the Red Cross. *Bastu* is the Swedish word for sauna: sauna is the most recognized Finnish word internationally and not otherwise translated, but Finland is constitutionally bilingual in recognition of a small Swedish-speaking minority population. Courtesy of The Finnish Post Museum.

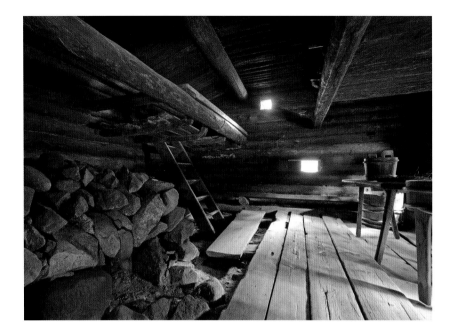

peasantry prior to Finland's national awakening in the nineteenth century. One short bridge connects the mainland to the park, a natural landscape save for the many farmstead buildings relocated from around the country. Seurasaari hosts a tremendous bonfire each midsummer's eve, and the celebration always includes a wedding at the old church on the island. The torch-bearing newlyweds are ferried around the harbor in a longboat by a host of rowers before they are brought to a large evergreen pyramid floating on a barge in Seurasaari cove, accompanied by a thousand Finns on the shores and in boats singing folk songs.

Each farmstead tells an important story, and the farmyards on the island are marvels of productive enclosure. The Niemelä homestead most closely approximates the childhood environment of many immigrants to North America. Most of the farms at Seurasaari belonged to larger landholders, who had a legal legacy to maintain. The Niemelä farm was donated by a landlord who had decided to liquidate the woodlot of a farmstead that had been built by five generations of tenants after evicting the last eighty-year-old survivor. Emigration was an efficient safety valve for the social pressures of the nineteenth century, and for many it presented an alternative to the dead-end continuity of the entrenched landlord-tenancy system. The sort of dispossession that the last Niemelä

The Niemelä farmstead at Seurasaari in Helsinki resembles the tenant farms that many immigrants from central Finland left behind for North America. The savusauna, to the right of the entryway, is attached to the main dwelling. Various platforms within were used for bathing and drying agricultural products.

tenant experienced also helps to explain the friction in Finland that led to its civil war.

The earliest structure on the Niemelä farm, attached to the house by a short breezeway, served as the sauna by the time the farm took its two-hundred-mile journey from Konginkangas, just east of Eli Wirtanen's home parish at Karstula. The sauna had served as the main dwelling for twenty years before a larger log structure was attached to it, and its smooth-worn floors and benches still look inviting.

Sauna became more established among nonpeasants, many of them Swedish speakers, after Elias Lönnrot's epic made sauna a place of virtue and legend. A sympathetic portrait of the Kalevaleic nature can be found in Juhani Aho's "The Old Man of the Peninsula" from 1899. An eccentric bachelor woodsman is granted coveted lakeside land as a reward for dislodging and killing a great bear that had menaced the manor's livestock. The Old Man lives a simple life in a "chimneyless, small cottage, which served also as a sauna and as the threshing floor for grain, yet it was so clean and so inviting that the guests could not praise it enough."[4] He is later dispossessed like the old *karhu* he slew when his site is deemed desirable to a new generation of wealthy sport hunters.

It was these same people that the great Finnish artist Akseli Gallen-Kallela used as the inspiration for many of his best paint-

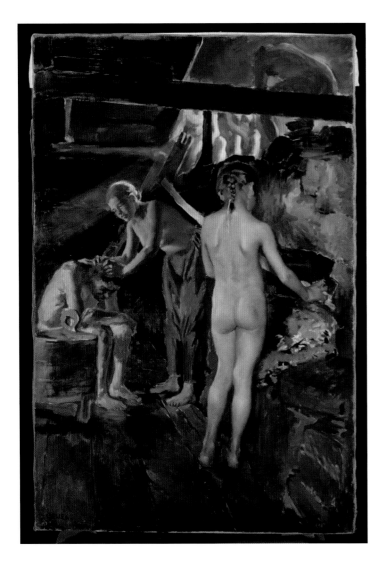

ings. *In the Sauna* from 1889 depicts a Finnish family in the savusauna, a young girl tending the coals, one man getting his hair scrubbed below spectral untanned figures on the upper bench. Aside from the girl in the foreground, the setting is very dark and somewhat crude in the details, much more subdued than the hyperrealism with which Gallen-Kallela later portrayed heroic scenes from the *Kalevala.*

During a summer holiday from his studies in Paris in 1886, Gallen-Kallela had discovered a passion for capturing the heart of the Finnish identity among the backwoodsmen in parishes far from the Baltic coast and any hint of modernity. His first subjects came from near Korpilahti, on Lake Päijänne: "I was looking for virgin landscape, for people of the wilds who lit their fires and built their saunas where they pleased, stuck their spears in the ground by the door and said: 'Here life goes on, wife and children.'" *In the Sauna* comes from Gallen-Kallela's stay at the Ekola croft near Keuruu the following winter, where he took in every detail of "the farm, the household and the wild landscape around it . . . nothing could equal the sauna evenings at Ekola." He and his Swedish companion Count Louis Sparre, a fellow painter, frequently enjoyed the sauna with the rest of the household: "The handsome daughters would take turns throwing water on the stones and sitting on the benches, according to the custom still widespread at that time."[5]

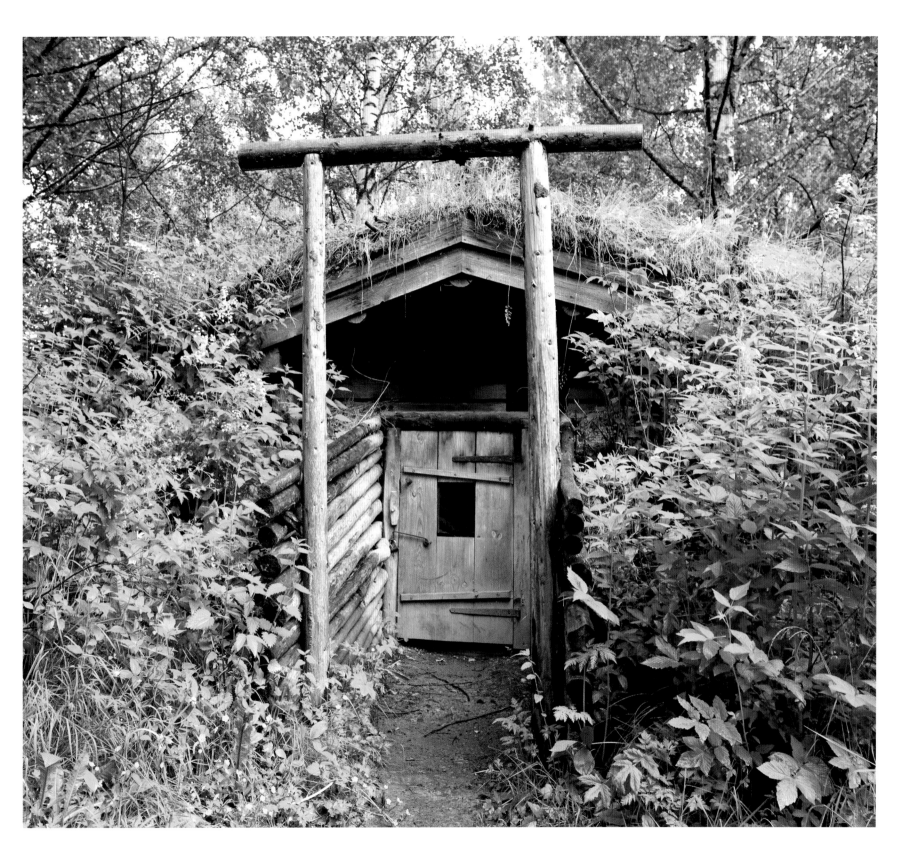

⊡ The Palojärvi sauna is the oldest at Muurame Saunakylä, dating to 1764 according to local legend in its village of origin.

The best collection of preserved saunas in Finland sits not far from Ekola at Muurame Saunakylä, the "sauna village" near Jyväskylä at the northern end of Lake Päijänne. The structures date from as early as 1763 and include a sod-roofed replica of a sauna used in Finland's Winter War of 1939–40 with the Soviet Union over Karelia, a similarly proportioned and roofed sauna from as far north as one can get in Finland, and a replica of a root-cellar sauna of the earliest subterranean form, its low roof covered in midsummer wildflowers. Several savusaunas are still in use and large enough to accommodate large groups, such as a bride's entourage joining in a clarifying steam before nuptials. The museum has so far been dedicated to collecting smoke saunas, and only one installation has a metal stove with a flue. Interpretive displays confirm everything from the regional use of juniper as bath whisks to the fact that saunas at the end of jetties had become a common feature at upper-class vacation properties by the dawn of the twentieth century.

A fine example of the popularization of sauna within the larger culture can be found at Ainola, the villa of Jean Sibelius near Lake Tuusulanjärvi, just twenty miles from downtown Helsinki. The log house itself was designed by architect Lars Sonck in the national Romantic style. But Jean's wife, Aino Järnefelt Sibelius, a talented artist herself who set aside creative ambitions to serve

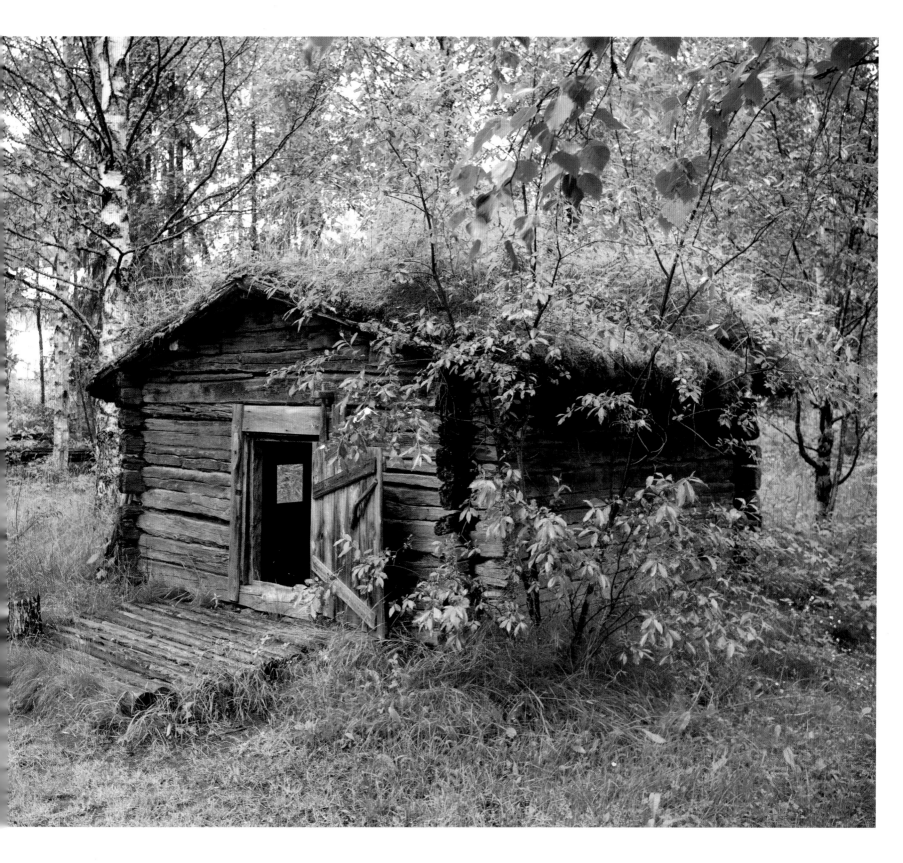

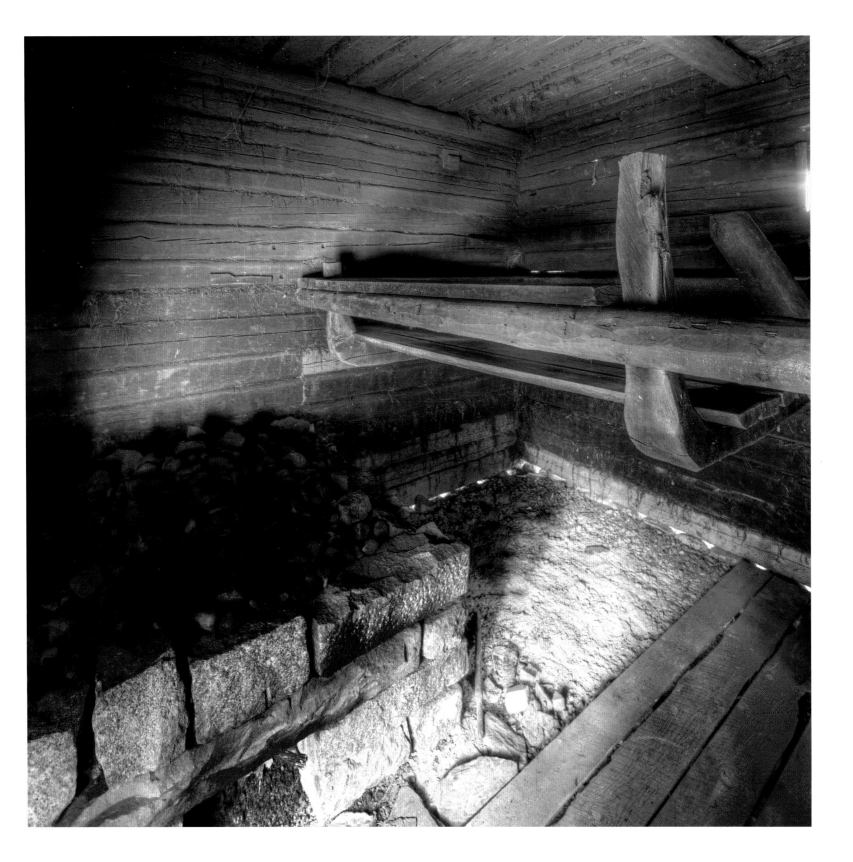

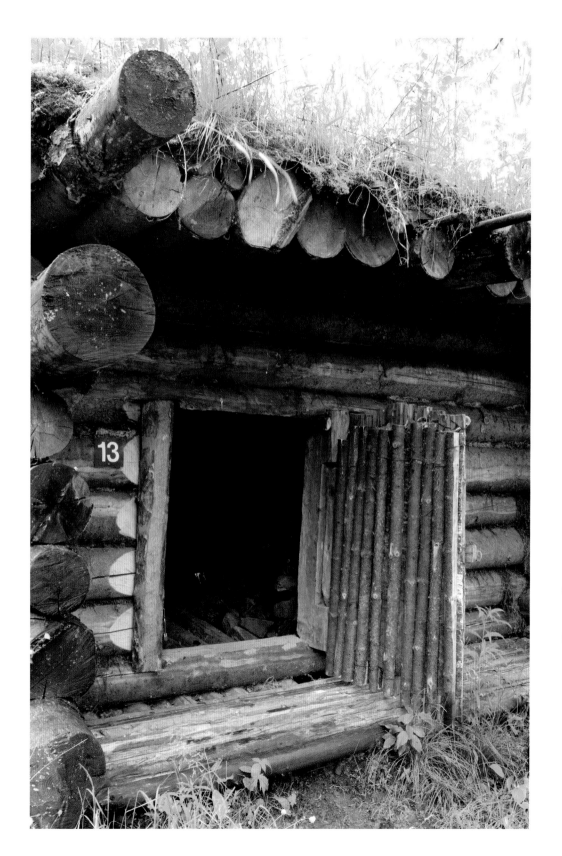

Interior of a vintage savusauna at Muurame Saunakylä that is available for private use.

This sauna is typical of structures built during the war years of 1939 to 1945: soldiers stationed at remote posts constructed them using only the basic tools in their kits.

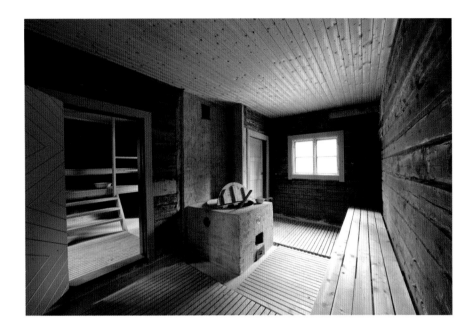

her husband's rise as the first Finnish artist of international renown, designed the sauna. While the sauna's log construction speaks to its roots, the terra cotta roof evokes the house and adds whimsy to the wooded acreage. But the building is also clever and purposeful, the sort of bathhouse that served prosperous farmhouses in the late nineteenth century.

The Ainola sauna was first built in 1905, but burned in the 1920s and was completely replicated. The building has three rooms with unique uses: a sauna, hot-water bath, and laundry. It has three stoves, including a firebox beneath a tank for heating water for the bathtub and laundry tubs, as well as an elegant upright enamel stove typical of Scandinavia—this one heats the room in which the bathtub sits. The heat source in the sauna room is a distinct type that bridges the gap between a savusauna kiuas and later wood-burning stoves. The smoke and fire are enclosed by a brick and mortar firebox, but the rocks are encased within a metal antechamber to the stovepipe, a style sometimes called a *pönttö* (birdhouse) stove. Every unit of heat and soot passes directly through the rock mass as the smoke vents up and out the roof through the broad central brick chimney. While one could enjoy a dry sauna (an oxymoron to most Finns) on the heat of the fire alone, löyly is not available until the fire has died. Then a hatch near the top of

This Kinkomaa sauna, built in 1936 and formerly used by teachers in a village near Muurame, shows the museum's ambition to collect buildings beyond the initial focus on peasant savusaunas.

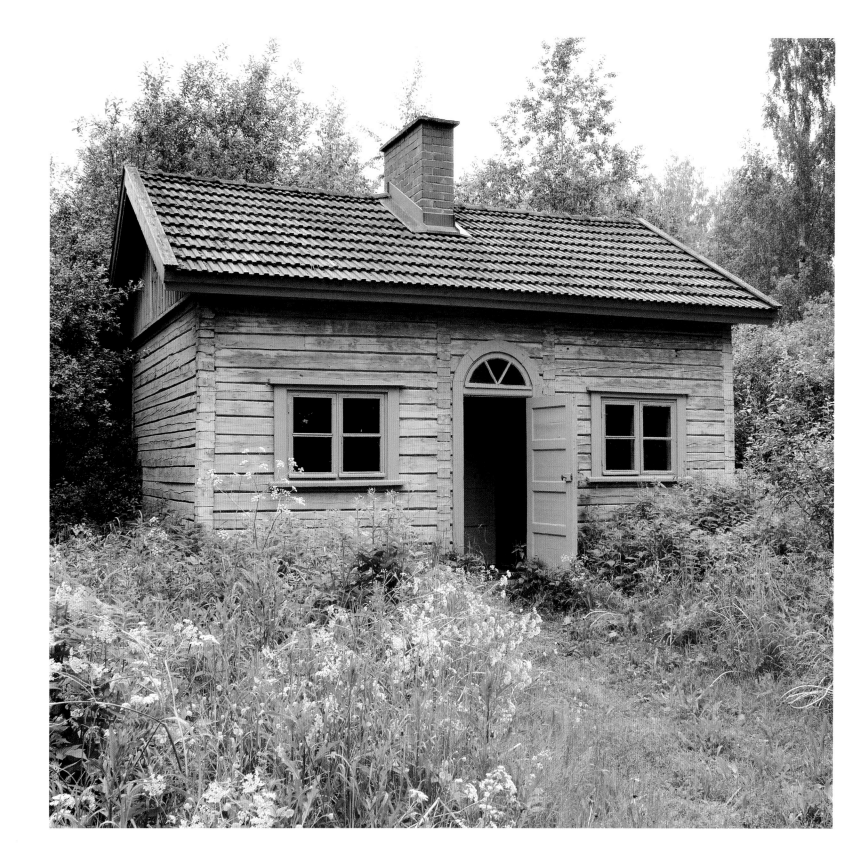

The sauna at Jean Sibelius's villa north of Helsinki was designed by his wife, Aino Järnefelt Sibelius. Water for laundry and bathing was channeled directly from the well to a water heater inside.

the antechamber allows the bather to pour water directly on the rocks and enjoy steam with smoky origins.

Two wells are within close reach of the sauna, including one that has a traditional yoke, arm, and bucket apparatus to expedite the flow. The bucket can easily be dumped into a channel that passes into the laundry room, and on the wall therein hangs a galvanized channel that facilitated precise delivery of water to the proper location inside: sauna or water heater.

Jean Sibelius was an ardent Finnish nationalist, a passion evident well beyond the patriotic strains of "Finlandia." Raised in a Swedish-speaking household, he did not learn Finnish until young adulthood. The Swedish voices in Finland represented the established legacy of earlier colonization, but Finland was homeland to him and his kind, and other influential artists of Swedish background embraced the cultural iconography of the *Kalevala*. He and Aino raised their children in a Finnish-speaking environment, and the home they built with the fruits of his success would naturally feature a sauna. Sibelius opposed the notion of running water in the house, not willing to accept any trickling in the walls that could interfere with the silence he needed to compose. As a Finland Swede who became a stalwart advocate of Finnish nationalism, he no doubt also embraced sauna as a matter of pride. The villa should not be seen as built upon a grandiose rusticity: Ainola also

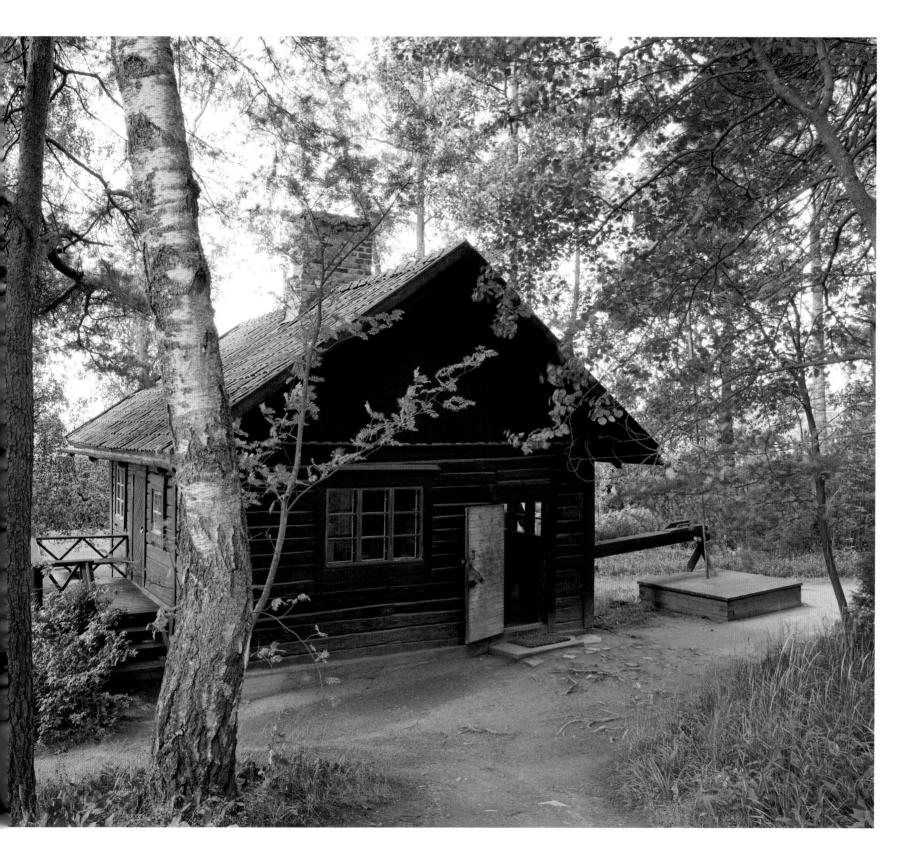

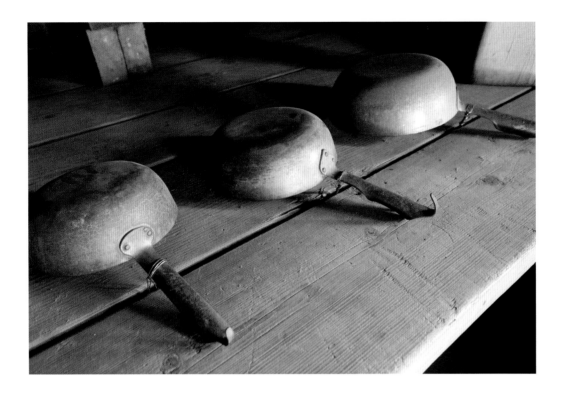

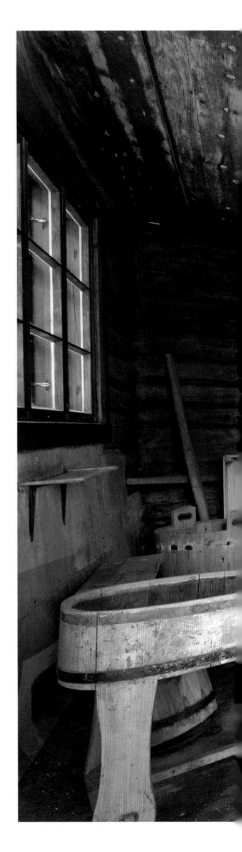

had no electricity until after Sibelius's death despite easy availability. (Indeed, today it may be the only place outside of Finland's roadless wilds without a wireless Internet signal.)

Ainola is right across the road from the estate of Juhani Aho, which transformed this shore of Lake Tuusulanjärvi into an artist colony. An exceptional Finnish bon vivant during the period, Aho was the country's first professional writer, and an early autobiographical novel detailed his passion for Aino Järnefelt, who had already settled on the composer as her future husband. Aho was also a journalist and one of the founders of *Päivälehti*, the predecessor of the largest newspaper in Finland today, *Helsingin Sanomat*. His influence is seen in the *Nuori Suomi* (Young Finland) circle, named for an annual supplement in the newspaper, which featured the works of Akseli Gallen-Kallela, Eino Leino, Eero Järnefelt (brother of Aino Sibelius), Pekka Halonen, and Emil Wikström. One philosophical ideal of the annual publication was the Nietzschean Superman, a concept well served by Finland's homegrown Karelianism, its authentic *Kalevala* culture, and the crucible of sauna.

⬆ ➡ The Sibelius sauna has three rooms, including a laundry. The sauna proper can be seen through the doorway to the right.

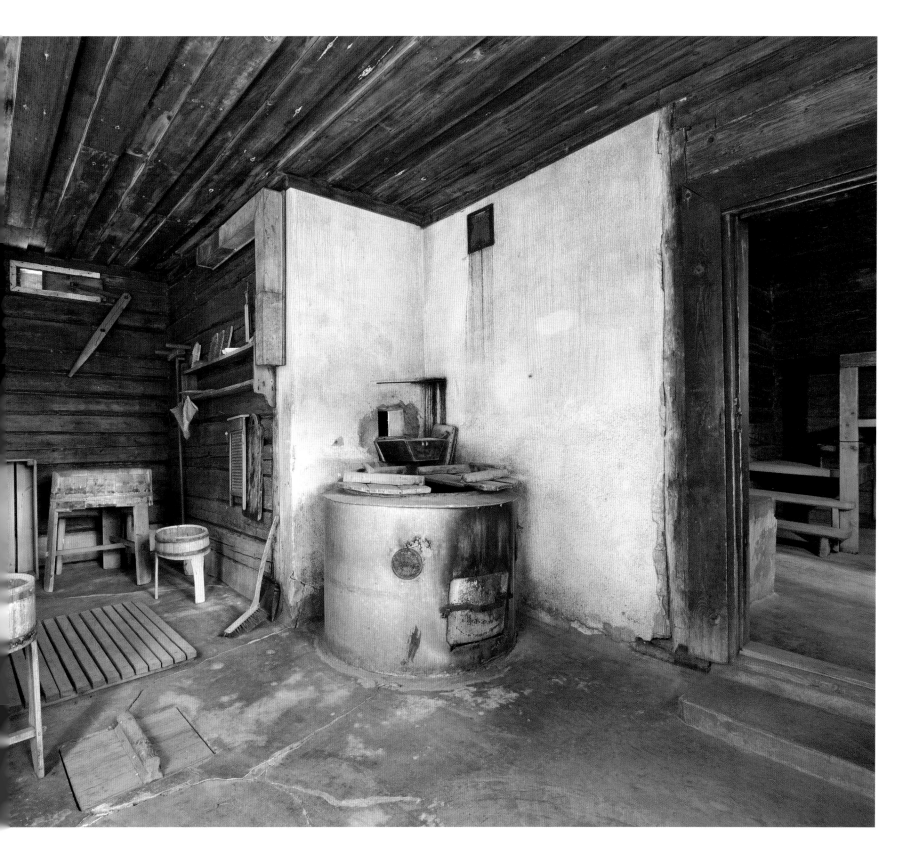

The artists of Tuusula had a short train ride into the thriving national capital, where Aho had made his mark in Finnish-language literature with stories like "A Visit to a Sauna" from 1892, a depiction of the urban sauna of the late nineteenth century as the latest frontier of national pride, boldly declaring that because sauna is their sole invention, "the Finnish people know how to bathe better than any other people." The narrator observes his companion's prodigious appetite for sauna and tremendous endurance. Like Aho, who grew up in a Swede-Finn household and had changed his surname from Brofeldt, the narrator describes this spectacle of authentic Finnishness as an awed outsider. Prior to seeing him in the sauna, the Finnish companion "was nothing much. Fat, lazy, dull, slow of speech, with no interests, no zeal . . . unless one would consider his talents the fact that he liked to sleep and that he sometimes went to Kamppi's Restaurant specifically to eat beef." But in the sauna, the locus of his genius becomes apparent: "There are some bodies which appear at their best with clothes on. . . . Sasu Punanen's limbs and body were built so that only in a sauna did they seem to come into their rightful surroundings." The narrator is driven out when the stones begin to hiss like "a hundred spitting cats, and I feel that in an instant they will assault me with their sharp claws and tear me to pieces." The attendant flails Sasu with birch whisks until even she complains that "the

Sauna novelties, including felt sauna hats, are unique to Finnish tourist shops.

stones can no longer take this without splitting." Finally taking a break for beer, Sasu looks "like a skinned seal as he stands under the ice-cold shower."[6]

Such commercial saunas are rare these days. The Kotiharjun Sauna is one of the last of three in Helsinki, where there were once as many as 150. It still serves a steady clientele in the Kallio neighborhood, a bohemian and working-class district of Helsinki, where even the older patrons have abundant tattoos and cool on sidewalk benches as steady traffic buzzes past. But the disappearance of this subspecies of sauna is countered by its ubiquity elsewhere in Helsinki. Saunas are mandated in any housing project, and even the cheapest hostels in the city give the visitor a chance to enjoy löyly. At the high end, a sauna is included with the six-room Mannerheim Suite at the Hotel Kämp, overlooking Esplanadi Park in the waterfront heart of Helsinki. But even regular guests can enjoy a deluxe sauna in the hotel for a supplementary forty euros per half hour, and alternate to a humid grotto and Turkish bath. Wolf Lake, Minnesota, immigrant Jacob Aho, who fled the increasing affluence of the city he helped build for an American homestead of pious prosperity, clearly saw the future coming. At the other extreme of

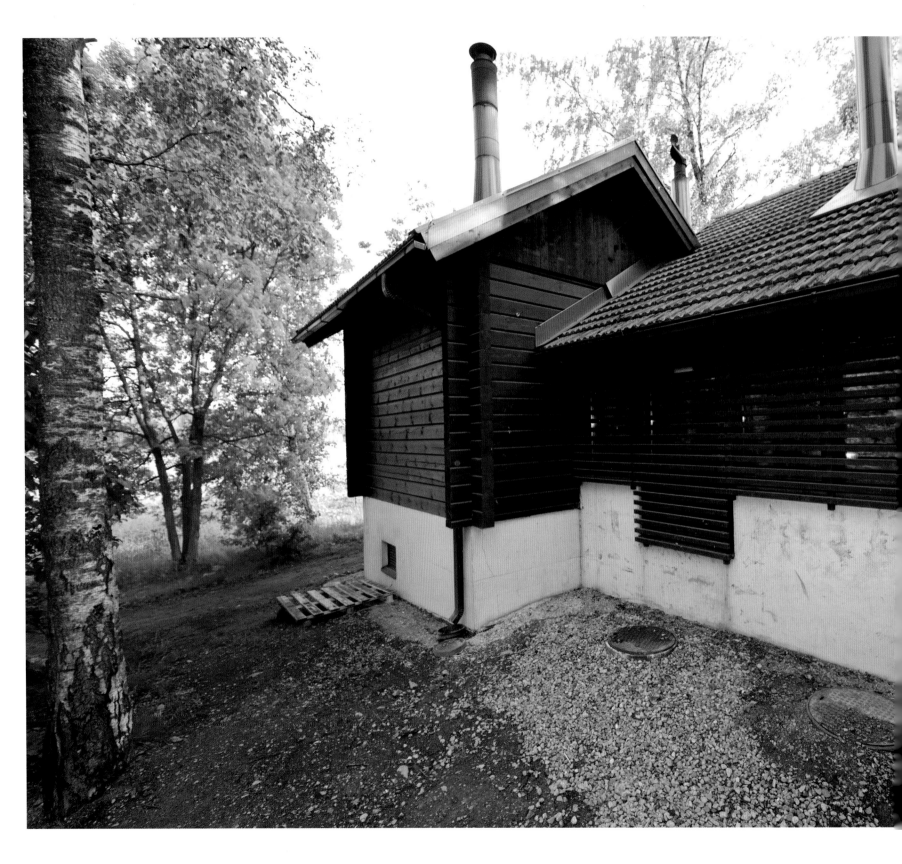

Chimneys indicate several distinct wood-fired saunas at the Finnish Sauna Society's facilities in Helsinki.

public accommodation is Finland's largest sauna, built for the Naval Academy near the island fortress of Suomenlinna and designed to simultaneously accommodate seventy rank-and-file cadets.

A standout among Helsinki's saunas is the facilities of the Finnish Sauna Society, on the island of Lauttasaari just west of downtown. The society is the equivalent of a country club for sauna enthusiasts, and if that is the measure, it is Finland's Augusta. Hidden in the woods on a dead-end suburban street, the grounds slope to a chilly Baltic cove. The dock provides a broad view of the islands of the western Helsinki harbor. Members have their choice of six saunas: three savusaunas, two with wood-fired stoves, and one electric. The greatest of the smoke saunas seethes with a thermal mass of over a thousand kilograms of stones, which are heated every day until afternoon, when the saunas are opened for use. While these rooms are all under one roof with the rest of the complex, they are separately vented and fill with smoke as the kiuas is heated. The wood is fed into large stoves in the basement, and birch is the exclusive fuel. The polite custom is for one bather to ask first before pouring water very slowly over the rocks for a long even breath of steam.

The patrons range from sage elders to Nokia executives to NHL defensemen, but the most notorious are a group of young Jukolas who frequently dominate the hottest savusauna when it is

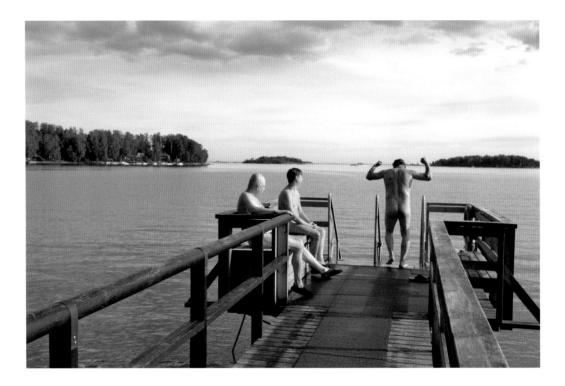

 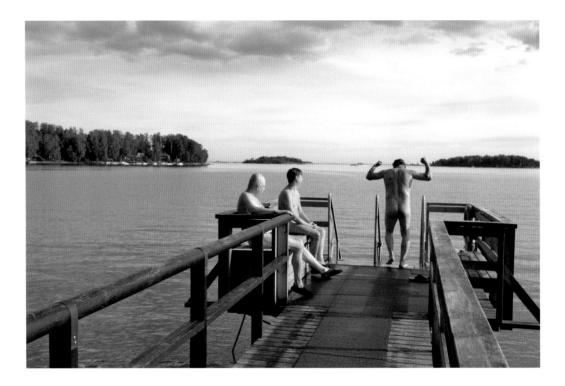 The invigorating midsummer temperature of the nearby Gulf of Finland (equivalent to 59°F) is clearly displayed for bathers.

first opened for the day. Other members grumble somewhat about this group's need to push the limits of sauna endurance, and tell tales of some who have suffered burns to their backs from the löyly onslaught. These adventurers are known for wearing wool sauna hats that protect the most vulnerable thin skin of the skull and ears. Reports of 160°C (320°F) in this sauna seem uncanny—the participants in the annual Sauna World Championships in Heinola must endure a starting temperature of 110°C (230°F) with a half liter of water thrown on the rocks every thirty seconds. Sustaining the slightest breath of löyly from a 320°F start would seem to be superhuman indeed.

The society is open every day but Sunday, and the facilities are not coed. The membership is over two-thirds male, and they control an even larger share of the calendar, as only Thursdays and the first Saturday of every month are available to the female membership. Vihta, or *vasta* (the term used in eastern provinces and

Karelia), is available to the members for seven euros per bundled birch whisk, which are packaged in plastic and kept in a freezer in the lobby, then soaked in "hand-warm" water. The best effect comes if you lie prone on the bench and let someone else flay you. Reanimated, these desiccated twigs leave an oily residue on the skin along with the fresh scent of the previous midsummer. Even on a slow day before that holiday, over a hundred members enjoyed sauna and subsequently the abundant spread of cold meats, beer, and other specialties. The Baltic provided a brisk alternative to the heat at 15°C (59°F) in late June.

As compelling as any of these settings might be, the essential sauna experience in Finland must be affiliated with one of the multitude of private cottages (*huvilas*) along the thousands of miles of Finnish shoreline. No lake better represents this possibility than Lake Päijänne, the second largest lake in Finland. With a winding length of seventy-five miles north to south, and as much

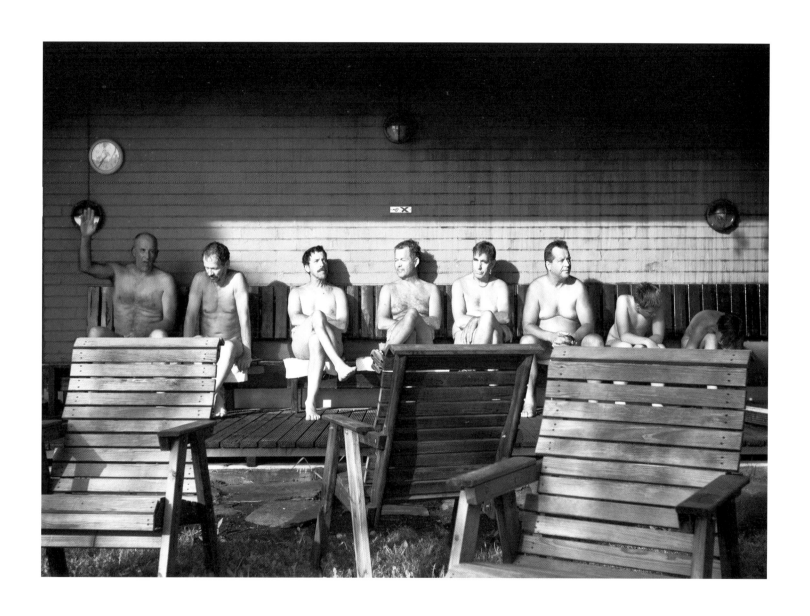

◱ ◳ The facilities at the Finnish
Sauna Society encourage quiet
relaxation and contemplation
after sauna.

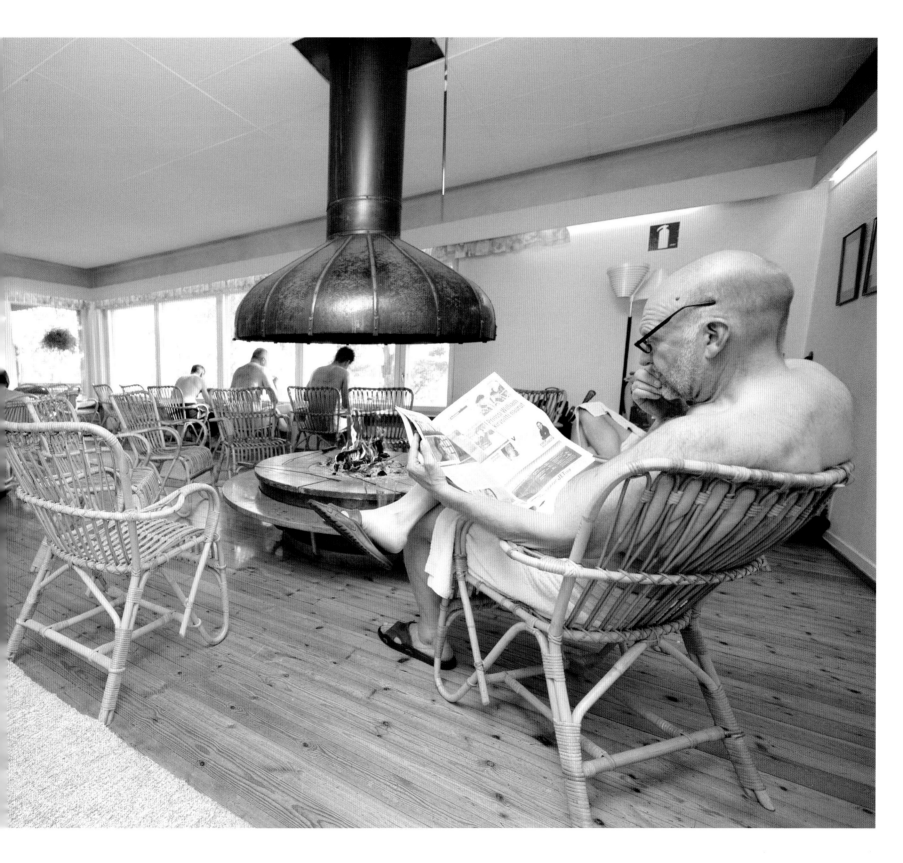

↖ The essential sauna experience in Finland can be found at any of the private cottages along the country's thousands of miles of freshwater shoreline.

↱ The savusauna that accompanies the architect Alvar Aalto's Experimental House on Lake Päijänne was built in 1954.

as fourteen miles wide, Päijänne knifes and sprawls south from Jyväskylä along over thirteen hundred miles of forested shoreline, two-thirds as much coastline as Lake Superior. Its glacier-carved granite and schist shores and nearly one thousand islands host over thirty thousand vacation properties. Päijänne is also the deepest lake in Finland—three hundred feet in spots—and this immense resource provides the municipal water for Helsinki via an underground aqueduct that is as long as the lake itself.

None of the many sites on Päijänne can far outdo the spot chosen by the architect and designer Alvar Aalto for the savusauna that accompanies his villa at Muuratsalo. Aalto's sauna, completed in 1954, sits near the edge of a cove and commands a view of the bedrock point that fronts the house, as beautiful a view as graces any Boundary Waters, Chequamegon, Keweenaw, or Quetico shore in the Lake Superior region. One might expect Aalto's savusauna to make a proportionally grand statement in the vein of the soaring asymmetry of his Finlandia Hall in Helsinki, or to boldly express the modernist innovation of the Experimental House itself nearby, but Aalto's own interpretation of the larger site suggested otherwise: "The building complex at Muuratsalo is meant to become a kind of synthesis between a protected architectural studio and an experimental center . . . where the proximity to nature can give fresh inspiration both in terms of form and construction.

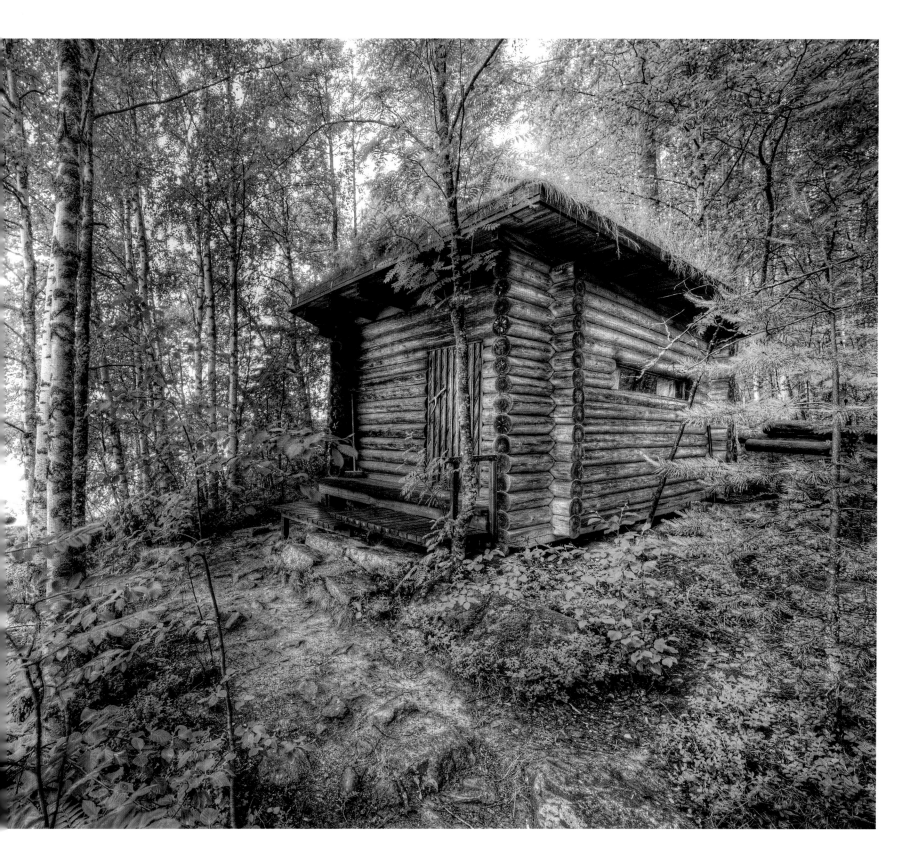

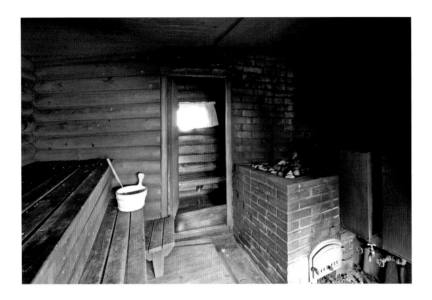

Alvar Aalto's savusauna reveals his respect for traditional forms as well as the demands of the site.

The bathhouse conceived by the artist and children's author Tove Jansson and constructed at the Moomin World theme park in Naantali evokes fanciful shoreside swimming houses of the past, such as this scene from a villa on Lake Päijänne. Drawing from *Moominland Midwinter* (Farrar, Straus and Giroux, 1958); drawing copyright Moomin Characters™. Historical photograph by G. A. Stoore; courtesy of the Museum of Central Finland.

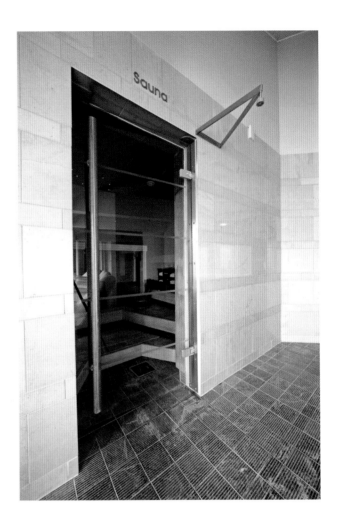

Perhaps it will be possible there to find the specific character of architectural detail that our northern climate requires."[7]

The log sauna at Muuratsalo would stand out little in the landscape of any Finnish farmstead of an earlier century. The form is strikingly similar to the most primitive saunas at the Muurame Sauna Museum, just three miles away, or the authentically appointed buildings of Savutuvan Apaja at Haapaniemi, several more miles up the lake. Only on slow inspection does one notice the architect's hand. The logs on the side walls are milled to taper toward the back, thus providing the pitch of the roof. And while from most perspectives it seems to be a simple square building with a shed roof, the heart of the building is the trapezoidal sauna room itself, which focuses the bather's attention on the kiuas. The trapezoid is an adept accommodation of the four naturally located boulders on which the sauna sits, and the kiuas roosts on the largest of these boulders without being relegated to the corner of the room. But the overall impression is that Aalto found little to improve upon in the essential form of a Finnish lake-country savusauna. Nature has volunteered a rowan (the close kin of our mountain ash) just beside the door, a good omen in any Finnish yard.

There is probably no less purposeful sauna in Finland than the whimsical bathhouse with a pointed roof at the end of a jetty near the lovely seaside town of Naantali. The imagination of the

The sauna facilities at Hotel Kämp are open to all visitors for a fee, but the renowned Mannerheim Suite has its own sauna.

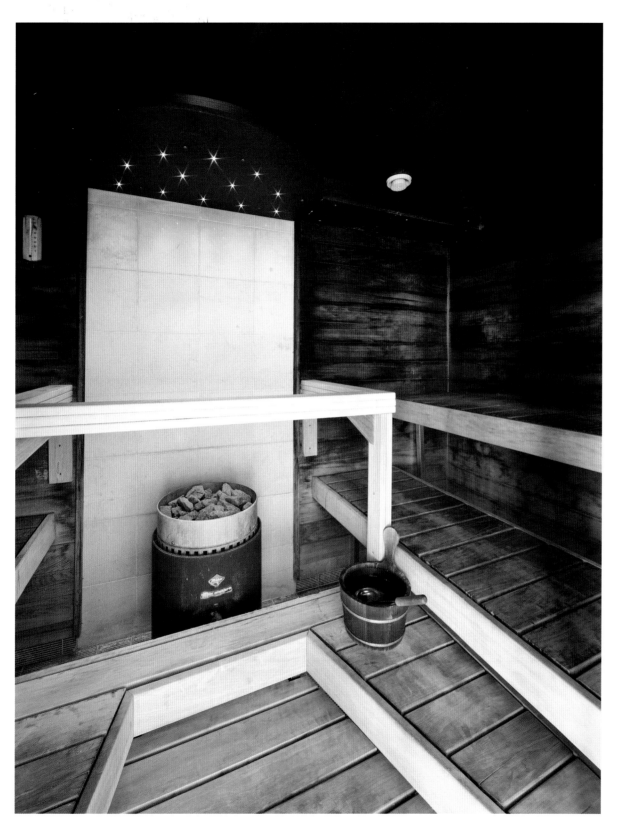

beloved children's author Tove Jansson inspired this and all other buildings in Moomin World, more than twenty acres of island theme park dedicated to her magically mundane tales and drawings of the Finn Family Moomintroll and their diversely odd, wise, and neurotic Moominvalley neighbors. Jansson's most memorable use of the sauna in her stories was not as a scene of bathing but rather as a refuge from fierce arctic cold as personified by the beautiful Lady of the Cold in *Moominland Midwinter*.

Because the Moomins themselves hibernate in the winter, the bathhouse has been occupied by a winter stranger, introduced in chapter 2, "about the bewitched bathing-house," who gathers plenty of firewood in advance of the front and invites the other winter folk inside to weather the deadly cold. They venture outside one last time to see if they can yet spot the Lady advancing across the ice: "The evening sky was green all over, and all the world seemed to be made of thin glass. . . . It was terribly cold." They watch her approach through the green and red window panes. "Perhaps she did cast an eye through the window, because an icy draught suddenly swept through the room and darkened the red-hot stove for a moment." But this iciest, darkest moment of winter passes, and the promise of spring is renewed. ▪

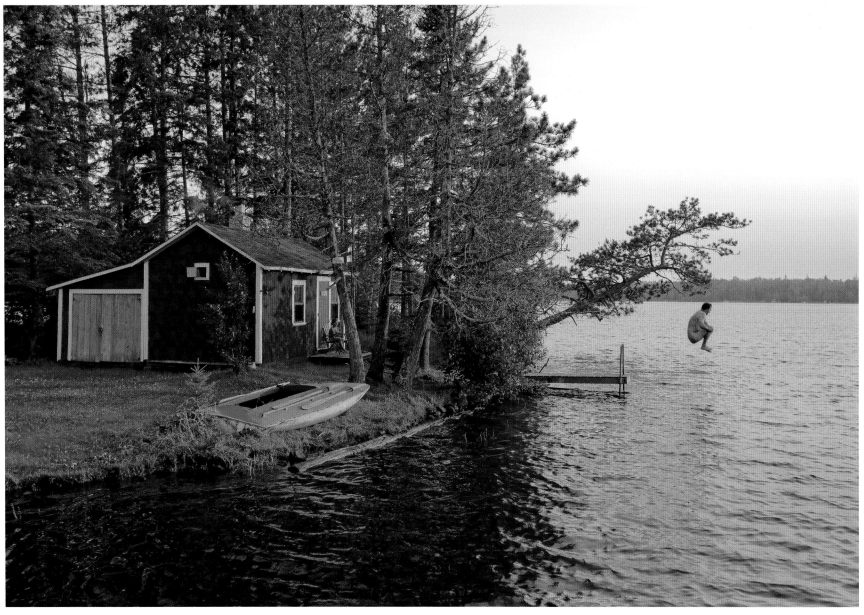

 The Ollila sauna in Brimson, Minnesota, is one of many on the shores of a spring-fed lake developed by a group of Finnish American families who built recreational retreats here in the 1930s and 1940s. The sauna is on property still owned by a family member.

The North
American Lakeside Tradition

The decade of the 1930s does not seem a likely time for immigrant families of any origin to be expanding their holdings, especially those who were not foreclosers but wage earners. The Great Depression brought crushing unemployment to regions like the Copper Country of Michigan and

Minnesota's Iron Range, as the demand for metals plummeted along with the slack national economy. But if cutover farmsteads had been a bargain for Finnish immigrants a generation earlier, the same was true for lakeside parcels that had been owned by logging and mining companies. In 1939, six families drew lots and legally platted a forty-acre parcel they had jointly purchased on a clear lake near Brimson in Minnesota's Arrowhead, the previous site of a logging camp for the extensive white pine resource that had towered above a deep foundation of glacial till.

These families resided in the Finnish neighborhood on South Avenue in Two Harbors, Minnesota's original iron ore port on Lake Superior. (To this day you can pick out several old back-lot saunas in the neighborhood, though most have been converted to other purposes.) That these couples had resources to devote to a vacation property during this period is a testament to their thrift and commitment. Among these enterprising couples were Wilho and Fanni Puikkonen, who set about building a family retreat on their parcel amid the Moisio, Ollila, Wirt, Jalonen, and Salo families. Wilho, who had been born in Finland in 1895, worked for the Duluth, Missabe, and Iron Range Railroad, which hauled iron ore from the deep mines near Lake Vermilion to the massive docks at Agate Bay. His job at that booming waterfront was just a short walk from the Puikkonen home. Approaching middle age, Wilho may have had enough seniority at the DM&IR to hold on to his job through lean times.

Other Finns soon purchased parcels in the next section up the shore, and by the end of World War II eight of nine consecutive lots were owned by Finnish families (the sole interlopers being a family named Callahan). Each of the Finnish families built a sauna on their lot that endures to the present day, and half of these are still owned by descendants of the proprietors of what came to be known as "the Finn Shore." Unburdened by the limits of contemporary land-use regulation, the saunas all sit within a few yards of the lake, and their basic similarity is balanced by many indications

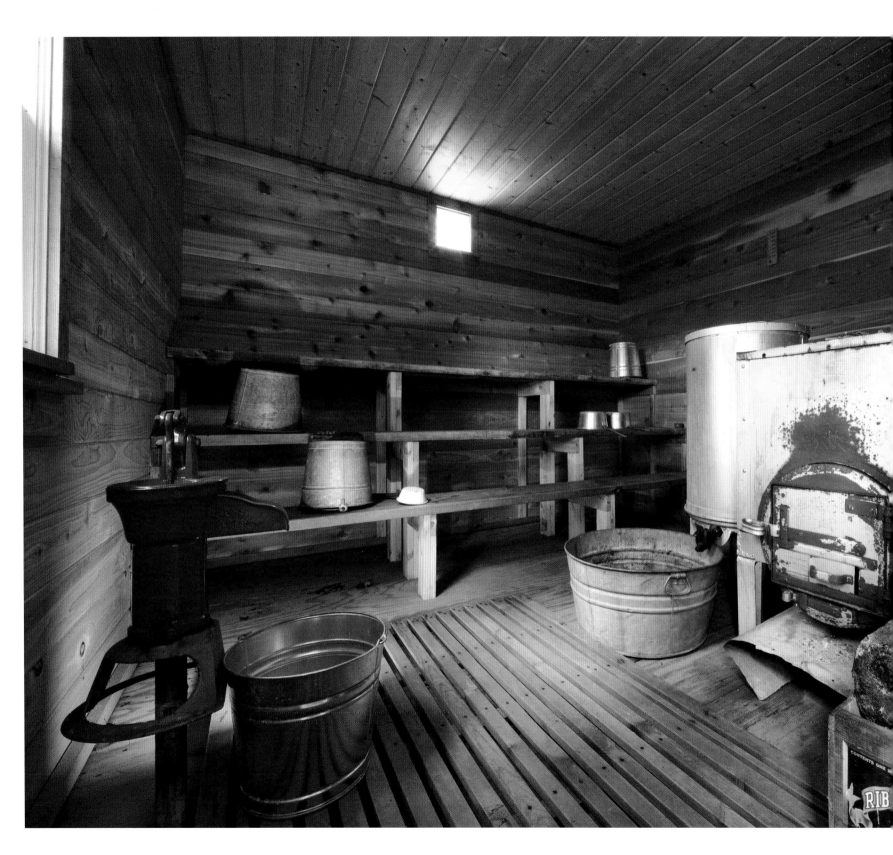

The updated interior of the Ollila sauna features elements common to the original, such as a locally manufactured stove with an attached bucket-filled water heater and a hand pump that draws water directly from the lake.

of individual charm. Collectively, they bear evidence of the great rewards that immigrants were able to achieve in their new land.

University of Wisconsin–Madison professor Arnold Alanen has a deep scholarly interest in Finnish buildings and cultural landscapes. In addition to many published papers about the Finnish American imprint on the region, his lasting legacy is an ongoing survey of Finnish buildings throughout North America. In the past few decades, he has driven well out of his way on cross-country trips at the mere hint of a sauna or *riihi* (drying shed) at a distant crossroads. He rejects the environmental determinism of early scholars like Eugene Van Cleef, who suggested that Finns gravitated to the north woods because of the similarity to their

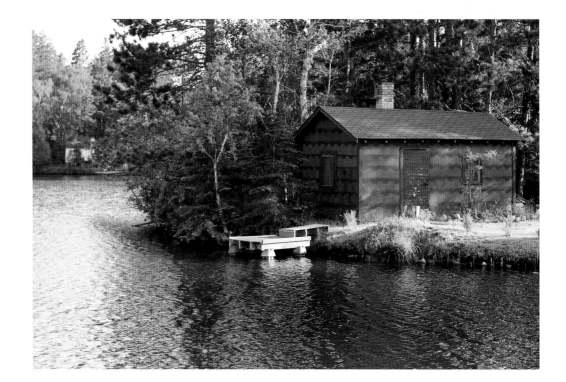

→ The vividly colored Moisio sauna seems to have absorbed the landscape over the decades. Such proximity to the water is not allowed for new construction, but the shoreland ordinance for St. Louis County unusually codifies saunas as a distinct permitted use.

↘ Serious heat.

homeland. But he recognizes that once they were here, they were culturally preadapted to settle the Lake Superior watershed, and the built environment bears witness to that. In Alanen's words, Finnishness is equal to saunaness.

Inspecting the shore with a measuring tape and notebook in hand, Alanen recognized immediately the common aspects of saunas with chimneys all around the region from the period: frame and board buildings roughly ten feet by twenty feet with two rooms of nearly equal size. "The saunas individually are very typical. What's unique about the collection is that you have six or seven of them adjacent to each other, all owned by different families. You certainly find examples of that elsewhere, but in so many cases there are usually one or two missing, or not that many were built." To his eye, any distinctions are secondary: "You certainly are beginning to see some Americanized interpretation, but there are some very strong Finnish elements—the vents, kiuas, and two rooms are very similar to twentieth-century examples in Finland."

But he identified the Puikkonen sauna as an anomaly in this group. Unlike the other saunas, Wilho and Fanni's bathhouse is a log building, expertly handcrafted of cedar logs. It seems unlikely that even someone with the skills to create a log building on this site would have done so when the neighbors were all using milled

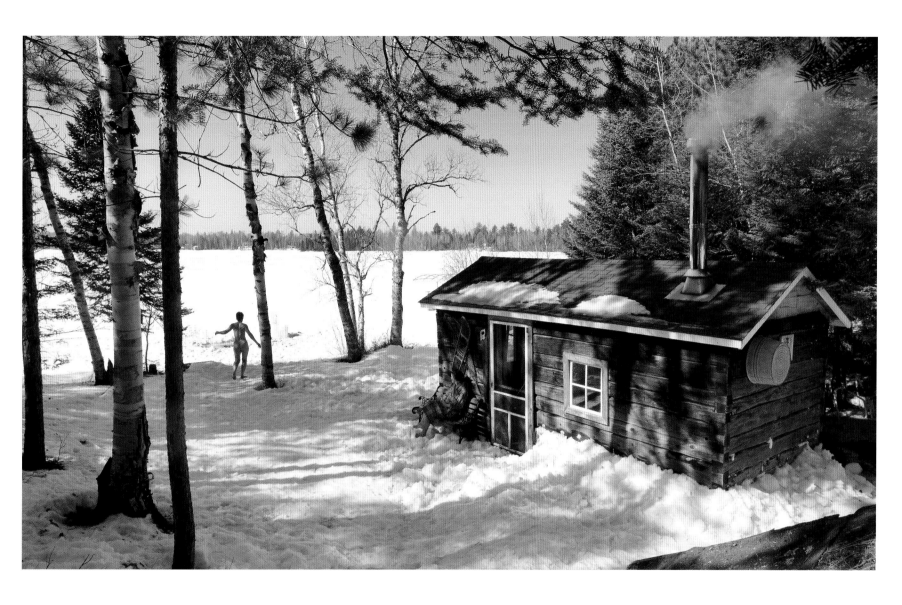

The Puikkonen sauna is the only log sauna on the lake. Constructed of dovetailed cedar, its logs were likely salvaged from a nearby farm.

lumber. One possibility is that the sauna was a part of the earlier logging camp on the site. Though Fanni was born to Finnish parents in Two Harbors, Wilho was born in Mikkeli, Finland, and last resided in Toivakka, just east of Jyväskylä, before emigrating in 1914 at age eighteen, so it is not unlikely that he had the skills necessary to erect a log building. He worked for the St. Croix Lumber Co. on Fall Lake in northern Lake County, which logged much of the current Boundary Waters Canoe Area Wilderness, before landing a job with the DM&IR, so he was familiar with the Arrowhead woods. But there is not a lot of cedar near the site, and Alanen detected a clue in the logs themselves.

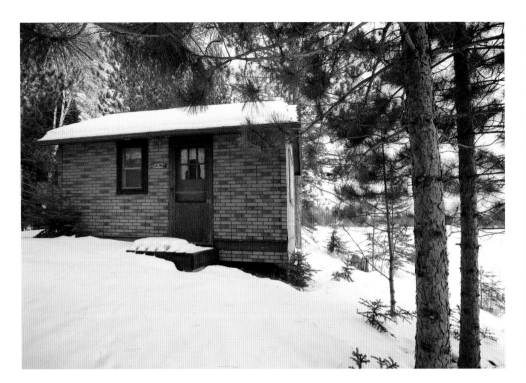
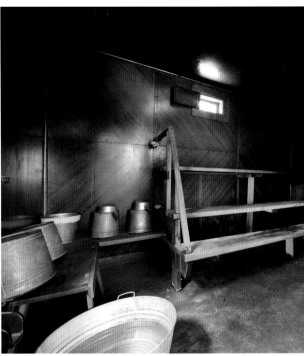

On both faces of each corner, the logs feature one-inch bores even deeper than they are wide. Alanen immediately recognized this as a feature of multistory buildings: these holes held up scaffolding to allow the builders to lift logs above ground level for a structure that rose above a single story. If this theory is true, this sauna was repurposed from another building in the area that had been abandoned. Many of the farmsteads of the Brimson-Toimi area endure to this day, but whether a farm failed or updated, dovetailed logs could easily be reused elsewhere. Cedar log structures were more typical of Michigan's Copper Country, but the species was locally abundant in Minnesota as well, especially on the bog edges between Brimson and Toimi. What better way to create a lakeside sauna than to haul logs on a Model T across bumpy corduroy, then refit and reassemble them on-site?

The other saunas all exhibit their individuality in other ways. Several have asphalt shingle siding that evokes the ghost weave of Pendleton woolens, each in its own color scheme. Two of the saunas also house a boat shed, another obvious use for a solid shelter near the shore. One is covered in faux-brick shingle siding that almost seems intended to hide its inner charm. While the order of construction on the other properties is no longer known, this sauna was the first building on its site. Jussi Aalto, the step-grandfather of the current owners, built the sauna in 1944 and 1945 during summer visits from Brooklyn, New York, to the adopted lake country of so many of his extended family. He built a kids' bench safely away from the stove for his granddaughters, and the dressing room once had bunk beds where the girls might sleep on braver nights. Another two generations have enjoyed the sauna that Aalto built, but these days the only little ones within proximity are the weekend resident cats, Heikki and Helmi.

Aalto's granddaughters grew up in Duluth, and they recall that the Kamarainens next door strongly encouraged their father to buy the parcel with its lovely point because they were very interested in securing Finnish neighbors. But shared saunas with the neighbors were not as pleasant when the Kamarainens hosted, because their benches and walls were painted and very hot to the touch. Lauri and Kati Kamarainen also ran one of several public saunas on South Avenue in Two Harbors, and one can only speculate that they had too much concern about hygiene, for such benches and walls truly miss the point—untreated wood absorbs humidity rather than fostering condensation.

The girls were the lone children along the Finn Shore at this time, as the other owners were a generation older than their parents. They were not thrilled with every aspect of sauna, such as an imported bottle of pine tar–based löyly additive on the shelf that their father enjoyed. But they continue to use the sauna almost

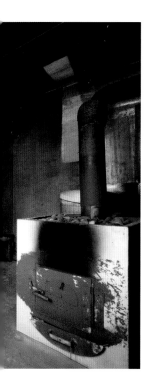
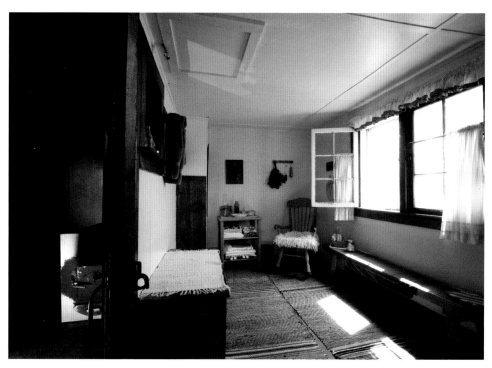

Jussi Aalto of Brooklyn, New York, built this sauna for his stepdaughter's family during long summer stays in northern Minnesota in the 1940s. He constructed a special junior bench for his granddaughters, who still enjoy lakeside baths throughout the summer. The family occupied the sauna on weekends while building their cabin.

Serious cold. A sauna beside a winter shore can tempt the adventurous.

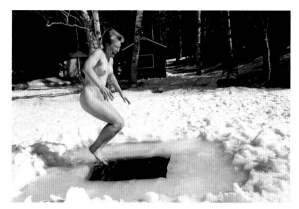
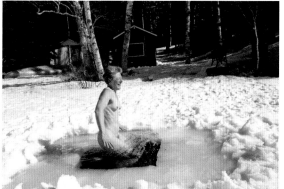

every week during the summer months, and the old hand pump still brings lake water right into the sauna room. The pioneers of this recreational enclave would doubtless be pleased to witness this continuity.

Aside from the beauty of the buildings and the setting, the most striking aspect of this string of saunas is the collective effort behind it. From cooperatives to unions to temperance societies, Finnish immigrants had a strong reputation for sticking together as well as remaining apart. It is hard to imagine a group of contemporary American families banding together for reasons of ethnicity rather than religion or a shared economic goal. An even more concentrated example of such efforts is Mesaba Park near Hibbing, Minnesota, which recently celebrated its eightieth anniversary.

During the 1920s the foreign-born Finnish population of St. Louis County peaked at over seventeen thousand. Due in part to the labor struggles that Finns endured, the Superior, Wisconsin, Finnish-language newspaper *Työmies Eteenpäin* promoted the notion that the working class could employ cooperatives as a way to correct great imbalances of power. The economic activity of Iron Range cooperatives doubled during the decade—not just cooperative stores but also creameries and a regional oil distributor. From the late 1880s on, Minnesota was home to more Finns than any other state except Michigan. Finns had become the largest ethnic group on the Iron Range by 1895, and they made up 40 percent or more of the foreign population in a dozen towns and villages.

World War I brought on a trying time for Finns, who endured the death of a logger and dockworker named Olli Kuikkonen, who was tarred, feathered, and lynched for opposing the war and renouncing his application for citizenship. The *Duluth Herald* headline read "Knights of Liberty Tar and Feather Slacker" but reported the death as a suicide. Bachelor Finnish loggers came to be called "jackpine savages," and some taverns were balanced in their discrimination: "No Indians or Finns allowed." Finns who resisted the political mainstream were dismissed as anarchists and Reds, and many were sufficiently motivated by ideology to relocate in the 1930s to Soviet Karelia, the *Kalevala* homeland. As recently as 1908, a federal district court in Duluth had considered the issue of whether Finns were Mongols and thus ineligible for citizenship as a colored people under the 1882 immigration act, commonly known as the Chinese Exclusion Act. Judge William A. Cant rejected the government's position, finding the Finns to be the most fair-skinned of Europeans. While this decision was met with loud approval in much of the Finnish community, some Finnish socialist newspapers dismissed the decision on the basis that such nationalist ambitions were purely bourgeois.

In 1928, the Mesaba Range Finnish Workers Federation re-

solved to obtain a common festival and campground somewhere on the Range, a site that would emphasize ties of kinship and ethnicity. Citizens who sought a better way against the conditions they had faced in the mines also felt a need for a separate gathering place, and they found one by buying up the shore of a fifty-two-acre uncharted lake for twelve dollars per acre. Finns who had logged the section remembered a spring-fed lake with only a marsh for an outlet, and its small size and distance from the county road had left it unknown. Volunteer labor built an access road, and soon facilities were in place to feed the workers. A contest provided the official name, Mesaba Range Co-operative Park, over such alternatives as "Red Star Park."

The first structure was built to house a caretaker and the staff of a children's summer camp. A pavilion arose near the lake, and on June 29, 1930, the membership celebrated with a dance, the first of a long tradition of frequent summer dances that would continue into the 1980s. The newspaper *Työmies* celebrated the event: "We celebrate heartily! For the last time at the mercy of others!" The park had no electricity during the early years, and members filled a shed during an annual winter "ice lifting bee," packing the ice in sawdust for keeping food cool in the summer. But the membership also took into account the need for the other extreme in temperature and soon built a sauna on the edge of the lake.

In its first decade, Mesaba Park hosted a major festival every summer around Independence Day in the tradition of Finnish *Juhannus*, celebrated at the solstice, when the daylight is at its longest and the sauna is fired well into the night alongside a mighty bonfire. (American bosses would not recognize such a holiday so close to the annual patriotic occasion.) A tide of progressive politics had settled over Minnesota during the Depression, still evident in the enduring "Farmer-Labor" designation in the official name of the state's Democratic Party, which later absorbed the party of that name. In 1936, the park attracted as many as ten thousand people—one of the largest gatherings ever held on the Iron Range—to a rally for party candidates for Minnesota governor and the U.S. House of Representatives. Elmer Benson and John T. Bernard both won large victories that fall, and the ticket took nearly every statewide office. Among the labor activists who were active in the park's early history was Gus Hall, the Iron Range native who went on to run four times for president as the American Communist Party nominee.

The lakeside sauna survived into the 1960s, and the circumstances of its demise are only rumored, though the foundation is still in place. It is hard to imagine that a lakeside sauna in this setting would ever fall from use, and of course they burn down for many innocent reasons. But during the Red scare, the park was

sometimes vandalized by vigilantes, fueled by the anticommunist
rhetoric of Wisconsin Senator Joe McCarthy. FBI agents intimi-
dated arrivals at the people's park, parking outside the gates and
taking down license plate numbers. The co-op movement's mo-
mentum had dwindled, and Mesaba Park lost the ready organiza-
tional support on which it depended. Private membership helped
the park persist through a decline in populist activism, and in the
1970s a new generation of progressives revitalized the park's mis-
sion of promoting the values of the labor, peace, and environmen-
tal movements.

By the mid-1990s the park's membership recognized that part
of its heart was missing. While it could no longer be considered a
Finnish cultural organization, the members recognized that a
lakeside northwoods camp on a spring-fed lake without a sauna
was a lost opportunity for fellowship. In the 1980s the group began
to raise funds to pay for a new sauna. The current sauna was built
in 1996, and to ensure its preservation, visitors are not allowed to
use it unless they can explain their familiarity with a wood-fired
bath. Certain members assert that the new sauna can achieve
180°F within an hour of firing. The proportions reflect its use:
the dressing room is twice as big as the sauna, which seats about
twelve comfortably. One of its most pleasing features is a thick
cedar sauna door salvaged from a project at Lutsen Resort, and the

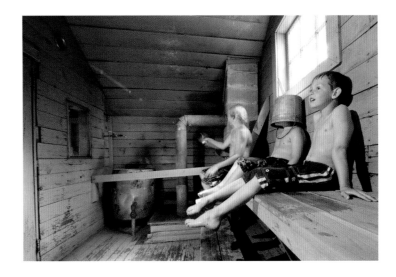

Nothing serves better as a porch for a traditional wood-fired sauna than a dock out the front door.

walls are rough-cut sanded local cedar. Among the many Finnish socialist community halls of the pre-Depression era, Mesaba Park has endured with its roots intact.

A sauna was a natural for any Finnish organization that established regular gatherings on a prominent point or backwater bay of one of the region's tens of thousands of lakes. The Knights and Ladies of Kaleva, a society dedicated to Finnish cultural preservation that arose out of the temperance movement, built recreational sites throughout the region that hosted society functions. A dozen miles east of Mesaba Park, the Virginia Kalevans, who met for more formal activities at Virginia's storied Kaleva Hall, built a lovely white sauna with blue trim evoking the Finnish flag on Long Lake near Eveleth. In 1938, the Ishpeming, Marquette, and Negaunee, Michigan, lodges of the Kaleva Society established a camp at nearby Three Lakes, and the sauna was the first structure built and dedicated. (For those who left for jobs in Motor City, the Finnish American Club of Detroit maintained a sauna along with facilities for swimming and boating on Walnut Lake, among the many lakes of Oakland County near Pontiac, Michigan.) Martha Stott, the oldest member of the Ladies of Kaleva in 2008, celebrated her seventieth anniversary with the society with a visit to Sampo Beach on Little Grand Lake near Duluth, a site that features twin saunas, one to serve the Duluth

lodge and another belonging to a Finnish group from Carlton County. Stott shared a story from early in her membership about a visit by a Finnish men's chorus who emerged nude from the sauna and were discreetly escorted from the lake in towels by valiant and prudent Knights—one sign of how Americans were adapting sauna culture.

The region also features summer camps where many midwestern children get their first exposure to löyly, some of which have no particular Finnish affiliation. Prominent among recent efforts to integrate sauna into a site for fellowship is Salolampi, the Finnish language camp at the Concordia Language Villages on Turtle River Lake near Bemidji, Minnesota. Contrary to the geography of the Nordic countries, at Concordia, Suomi's Salolampi is nestled *between* Norge's Skogfjorden and Sverige's Sjölunden. The camp hosts children and adults for weeklong cultural programs and language immersion, and the sense of foreignness is enhanced by the remarkable central hall, a replica of the old-world railway station that once served Jyväskylä in the heart of Finland's sauna country.

The sauna at Salolampi provides an even deeper sense of removal and immersion—the visitor must walk over three hundred paces from the nearest dormitory on a simple path through maple, birch, and balsam. But the sauna itself is not a product of domestic

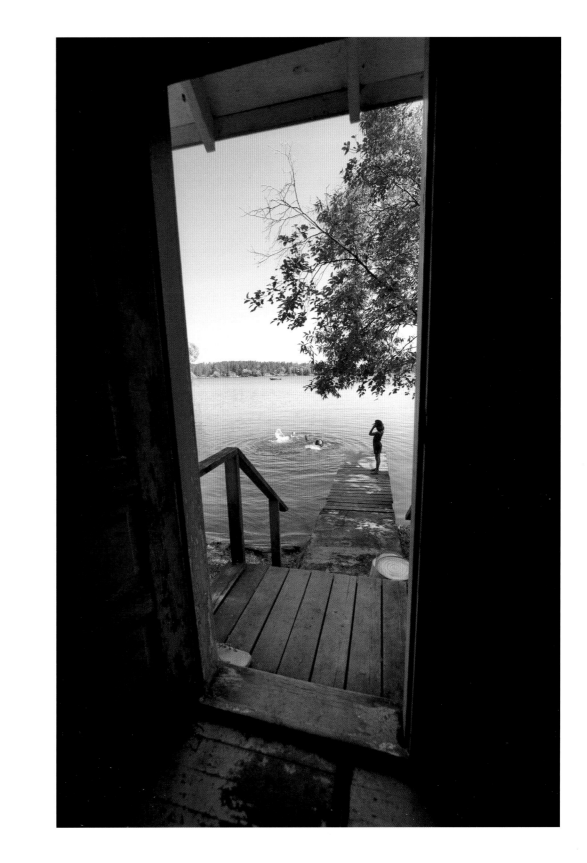

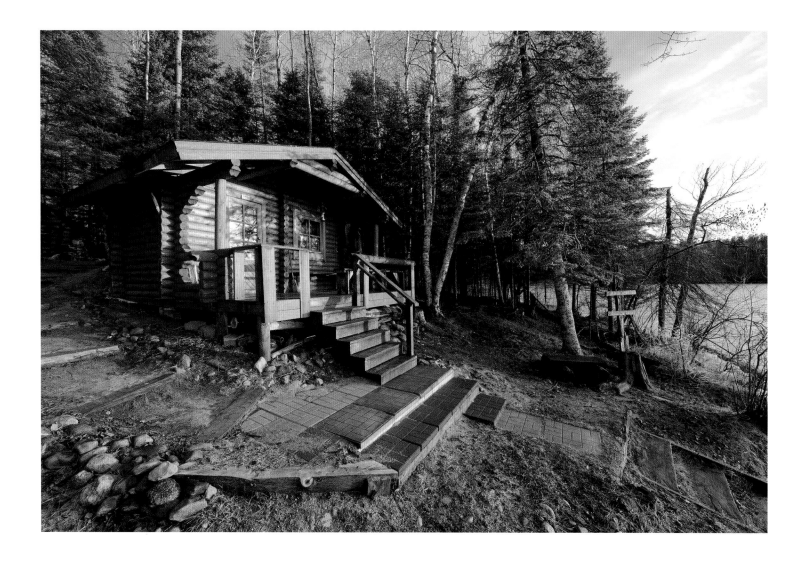

forests: it is a kit log building imported from Finland as an exhibition piece for a downtown Minneapolis bank lobby during the first FinnFest in 1983. The sauna finally found its proper home when the language camp moved from ambition to reality. Even before a road was completed and the final layout of the other buildings was settled, the logs and lumber were hauled across the ice and installed fifteen feet from the cool waters nigh upon the Norwegian frontier, the most suitable location on the Salolampi coast. But one must assume that even without this valuable gift, the camp would have been fine: Director Larry Saukko was once profiled in the *Finnish American Reporter*'s Sauna of the Month feature for his unique wood-fired trailer sauna, a somewhat top-heavy unit that can be pulled slowly to any beach or backyard.

The bathers on one particularly cold and sleety Saturday evening in early May—during one of those rare fishing openers when the walleye fishing fleet on the largest lakes, wearing parkas, had to negotiate ice floes through horizontal snow—were a group of volunteers who contribute a weekend every year to clear away the

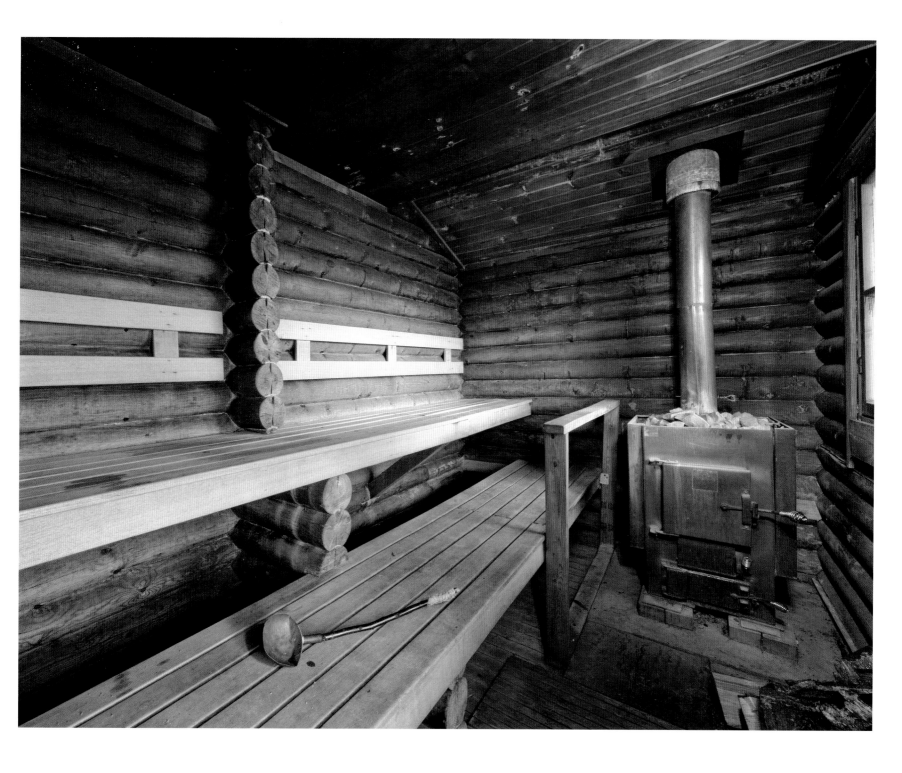

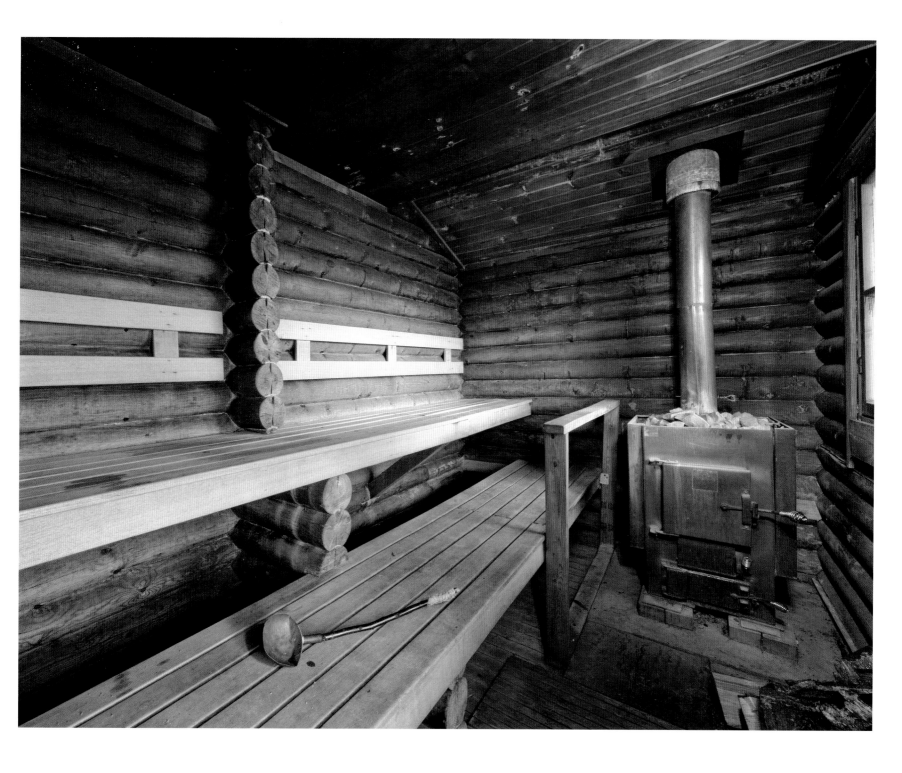 Concordia College of Moorhead, Minnesota, runs several popular language camps near Bemidji, Minnesota. The sauna at the Finnish language camp, Salolampi, is an imported kit building from Finland.

Sauna etiquette sometimes requires explanation: Maplelag Resort in Callaway, Minnesota, a popular cross-country skiing destination, offers guests a choice between "suit" and "no suit" saunas.

branches and confront the accumulated chores of another long winter. An anecdote from Salolampi's Web site illustrates the level of dedication that maintaining authenticity demands:

> The Finnish ambassador, during a visit to Salolampi, commented that the flagpole near Jyringin Talo (the large central hall) would not be proper in Finland because it was not higher than the highest building on the grounds. Oiva Ylönen took that as a personal challenge to get a proper flagpole. He calculated how tall a tree it would take and then cut down a tree on his own property. He peeled it and then painted it white. Jack Rajala loaned him a trailer to haul the pole about 100 miles to Salolampi. It was quite a proud moment for the volunteers to put up a "proper" flagpole with a Finnish flag in the right proportion to the pole.

With winter hanging on just six weeks before midsummer, the sauna was of particular benefit to tired backs, and several volunteers enjoyed a quick swim in the recently thawed arm of Turtle River Lake. Just before sunset, light streamed under the clouds, promising a clear, cold night, but it warmly illuminated the plaque above the door, dedicated to "Salolammen Raivaajat"—Salolampi's pioneers.

If fellowship is the goal, sauna can provide the lure. Such was the theory at Eden-on-the-Bay Lutheran Church in Munising,

Michigan, likely the only church in the country designed to house a sauna. A local Finnish congregation had been absorbed by the Swedish Lutherans in 1965, and when architect Eino Kainlauri of Ann Arbor, a native of Finland, gained the commission for a new church, he asked the congregation for ideas. A non-Finn suggested a sauna, and the architect willingly included it in his plans for the new building, completed in 1973. Soon thereafter, a resident pastor estimated that at least a third of the new members had joined

REMEMBER

1. USE ONLY ½ PIPPER of WATER on the ROCKS. TOO MUCH WATER COOLS the ROCKS and LOWERS the TEMP. It KILLS the STEAM.
2. REFILL the WATER TANK when you LEAVE.
3. CLOSE all the DOORS TIGHTLY!
4. DO NOT OVERFIRE the SAUNA STOVE. It MAKES A FIRE HAZARD, and it BURNS OUT the STOVE. TEMP should be around 180°.
5. PLEASE PUT SOME WOOD in the STOVE when you LEAVE.
6. FINALLY - REMEMBER* NOT TOO MUCH WATER on the ROCKS and Don't OVERFIRE. Enjoy! · Thank You.

in one year because of the availability of the sauna. "Talk about a better mouse trap in parish evangelism," he wrote enthusiastically to a colleague, adding that he "was known to retire from his office, at closing time, to the sauna to melt away the cares of the day in his work."

By 2009, Pastor Lynn Hubbard was the only person who still regularly used the sauna, taking time every Saturday night to sweat out burdens and pray for his congregation within. Hubbard, no

Finn himself, is no stranger to such traditions: he regularly serves as keeper of the rocks at Lakota sweat lodge rituals during sojourns to the near west. In Hubbard's view of human spiritual traditions, Christianity has absolved us of suffering, but his experiences with earth-based tribal spiritual traditions have shown him how healing can come from enduring spiritual and physical rites of purification. He knows that the momentary suffering of exposure to searing heat can prepare one to help loved ones face life's burdens. He has had

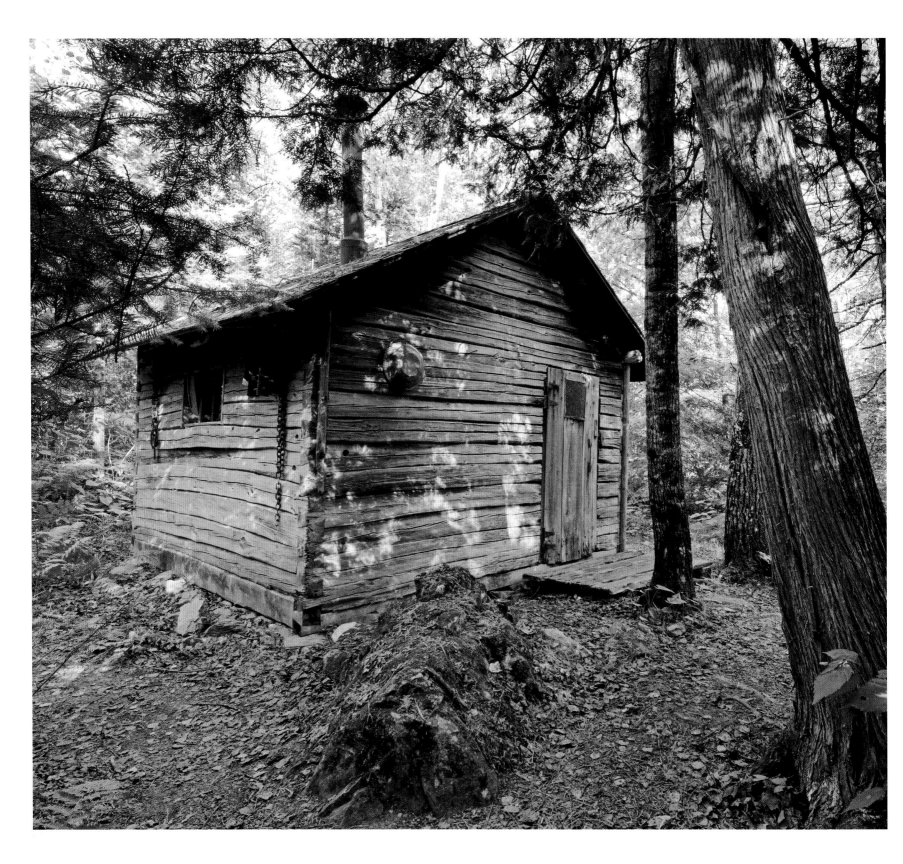

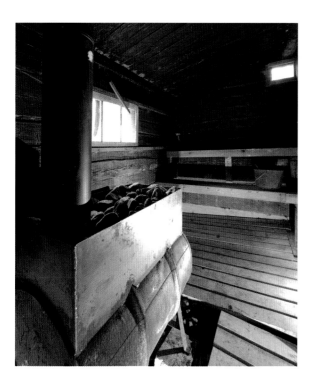

revelatory experiences in sauna during cross-cultural ministerial training for graduate-level seminarians, watching while individuals from indigenous American, African, and Asian tribal traditions melded into a ritual that was punctuated by a great burst of heat from the rocks, referred to as "grandfathers."

Listening Point

The conservationist Sigurd Olson provided clear evidence of his passion for sauna. His 1958 book *Listening Point* documents his patient observations from a bedrock point on Burntside Lake near Ely, Minnesota. Olson describes the slow process he and his wife, Elizabeth, undertook to build a humble lakeside retreat that would provide the convenience of a simple cabin but also much the same experience as some of his favorite campsites in the Boundary Waters and Quetico country. *Listening Point* provides an excellent template for anyone who aspires to tread lightly while developing a shoreline parcel of land, and the reader cringes along with the author as he follows on foot behind the bulldozer that executes the one act of major surgery on the landscape: the construction of a half mile of road, which pushed aside boulders and disturbed centuries of slow accumulation of forest duff.

The Olsons took into account many factors in choosing the right place for a cabin—seasonal winds and sunlight, respect for a huge granite boulder on the point, keeping a humble distance from the water—but they knew from the start that they would not build a new structure. Their inspiration was all around them in the forests of northern St. Louis County: log buildings derived from generations of northern European necessity:

> We wanted a cabin that blended into its surroundings, a cabin as gray as the rocks themselves. The north country is full of old cabins built by the original Finnish and Scandinavian settlers when they first moved in. Many are now falling apart and being replaced by modern homes, but all of them have weathered a silvery gray, for none have ever known paint or varnish.
>
> If we could find one of these cabins back in the clearings below the canoe country, one that was still sound, we would buy it, take it down log by log, and bring it to the point. Built of tamarack, jackpine, or cedar, with dovetailed corners, these cabins are so expertly hewn and the logs fit so closely together that little chinking is ever required. The result of centuries of building in Europe's north, they were designed to keep out the bitter winds. The new settlers brought their broadaxes with them, and, more than that, skills perfected by necessity. Such a cabin, it seemed to us, would fit the point, for it would have tradition behind it, and in its soft grayness there would be no jarring note.

We began to explore the countryside, drove down old logging roads into abandoned clearings, always watching for the telltale gray of old cabins and barns. We looked at many around Ely and in the Little Fork country to the northwest, but invariably the roofs were fallen in and the corners soft with decay. One day we found one built of jackpine and in excellent condition, but the owner refused to sell.

"That cabin has no price," he said. "I was born there; my father built it, and there it will stand until I die."

That we understood.

Then in the Bear Island River country to the south, seven miles from home, we found exactly what we wanted, a cabin that had not been used for many years, with the roof still sound and the logs silvery gray. It was large enough, and I pictured it sitting next to the pines with the warm slope just below it. I approached the owner with caution, but, to my joy, there was only one question: "Why should anyone want to bother with an old-fashioned building like that?" I tried to explain, and that day came into my possession of a cabin that met all of our requirements.

The natural perfection of this building for the site is still evident in its masterful compound dovetail corners and the weighty stone fireplace that dominates the inland gabled end. The book does not mention a sauna as part of the plan for Listening Point, but Olson clearly revealed his affinity several years later in *Runes of the North*

from 1963. The sauna at Listening Point is another log building transported from a nearby farm, a structure that he describes as "primitive, one step removed from the first [saunas], excavations in the hillsides of Finland." The building is a mere twelve by twelve feet, separated by Olson into two rooms arranged on either side of the ridgeline rather than front to back. The stove's placement in the bathing room seems irregular—it does not strike one as a sauna designed by a Finn. But it is clearly a lovingly used bathhouse. Set about a hundred feet back from the lake, the building is now deeply hidden in the cedars and aspen that Olson describes, though he maintained some visibility of the lake during his years of active use. Midsummer foliage on the brush obscures the nearby shore, but a short dash down the trail is rewarded: the simple dock serves a quiet cove with a soft sandy bottom and a gradual shallows. The view from the swimmer's entry to the cabin is precisely the shore so well portrayed on the cover of *Listening Point* by the artist Francis Lee Jaques. The sauna is a full 150 paces from the cabin. Even in August, as if the forest were still leaving tributes to a great and curious ecologist, the cedar bog path from the dock featured the last hair and bone remains of a wolf-strewn deer.

In *Runes of the North*, Olson reveals the importance of sauna to his family by sharing the story of his adult son Bob's return to Ely from work in the Foreign Service abroad, and detailing the

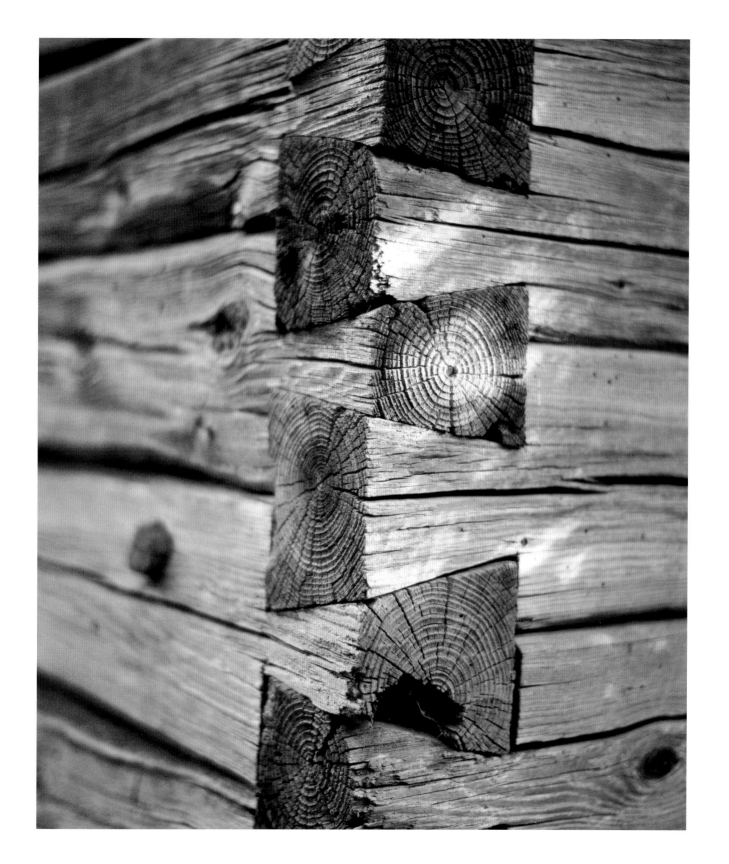

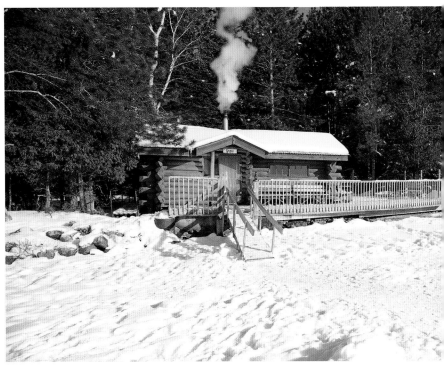

family ritual. One might expect that Olson, the son of a Swedish Baptist minister, may not have had much early experience with the sweat bath—Swedes who emigrated due to persecution by the Lutheran church had little empathy for the state religion's relative tolerance of residual pagan practices and its blind eye toward the evils of drink. But he did grow up in proximity to Finnish communities: When Olson was ten years old, his father moved the family to Prentice, Wisconsin, to serve congregations in the area. The town's sawmill heyday was waning, and Finns from the Michigan mines were homesteading the barren cutover lands of Price County (several buildings, including a sauna, are preserved at the Knox Creek Heritage Center in Brantwood).

Two years later, the family moved north to the Lake Superior port of Ashland, Wisconsin, the midpoint of the Highway 2 corridor of northern Wisconsin, with many Finnish communities lying between Superior and Hurley. Olson cultivated his love of the outdoors during this time and stayed on in Ashland as a student at Northland College, where his brother spoke out against the anti-immigrant sentiments that took root during World War I, a movement that had cast a particularly suspicious eye toward Finns. Olson's father had emigrated from Dalarna, a Swedish province with a notable Finnish presence, and his first host in the United States was an uncle who worked at a steam bath in Alexandria, Minnesota, at a

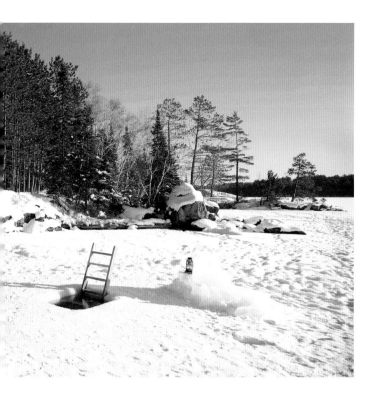

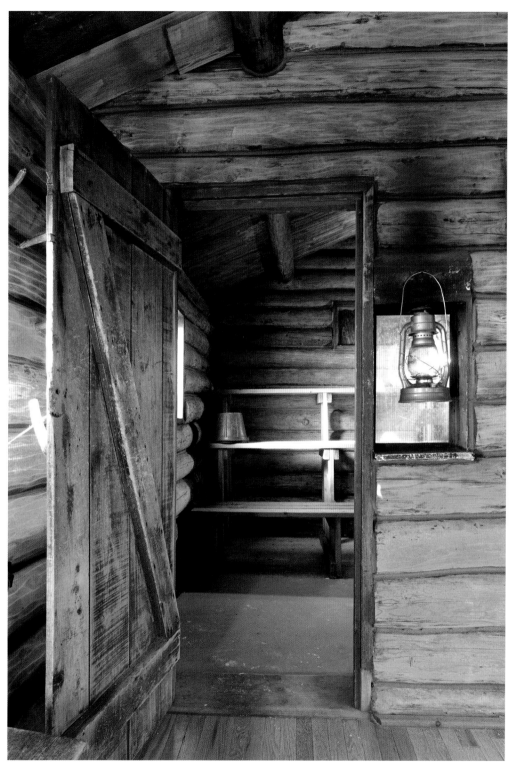

The saunas at the YMCA's Camp du Nord on the north end of Burntside Lake have given visitors an excellent and authentic introduction to sauna for a half century.

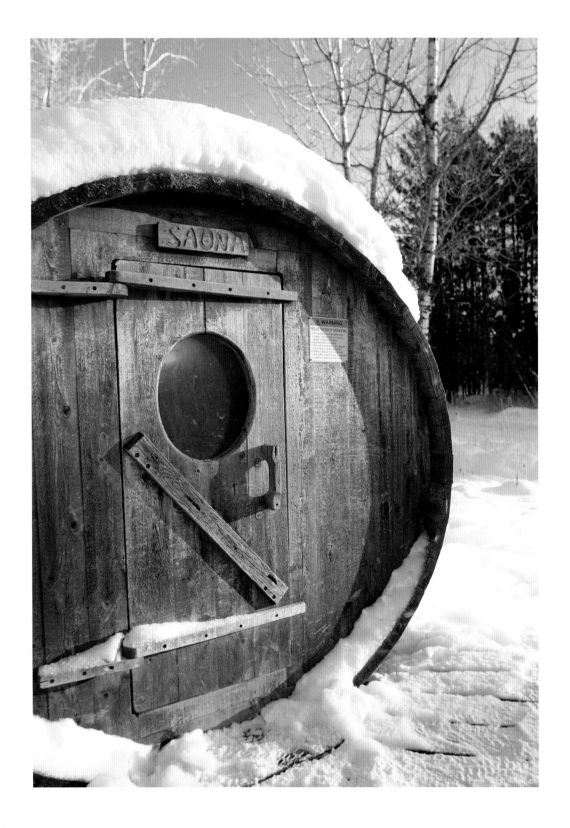

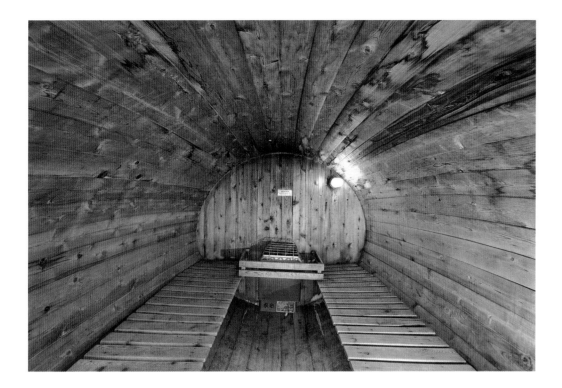

The barrel sauna at Camp du Nord is built of bent-stave cedar using traditional cooperage techniques. Its economical form allows the space to heat up quickly and favors a compact electric stove, but some manufacturers also offer wood-burning options with external chimneys. Such saunas can be delivered fully assembled to a desired site.

time when Finnish settlements were taking hold in nearby Holmes City and just to the north at New York Mills. Olson would have had a thorough understanding of sauna practice long before he arrived to teach in the Finnish stronghold of Ely, Minnesota.

The details of Olson's sauna practice bear this out, and his descriptions of the preparation of the momentous sauna for the prodigal son are thoroughly authentic:

> Only the finest spruce was to be burned that day, for this was a great event for us both. Two cedar switches were prepared. We picked them carefully, only the softest and finest from the lower branches of a tree that grew close to the water. The cabin was swept and clean, and a hand woven rug of many colors was laid out smoothly for our feet. Buckets were filled from the lake, two placed on the rocks above the stove, two on the bench before it.
>
> As preparation, we spend several hours at the woodpile, hauling logs of birch, aspen, spruce, sawing them into proper lengths, splitting them to size, and piling them neatly. While we labored with axe and saw, the smoke curled high above us, the rocks became hotter and hotter until they hissed and spat when the water was sprinkled on them.
>
> Toward evening all was in readiness. We opened the door and the bathhouse smelled as it should, rich with the pungence of burning, the odors of hot logs and of many saunas of the past. We stripped and took our places on the lower bench.

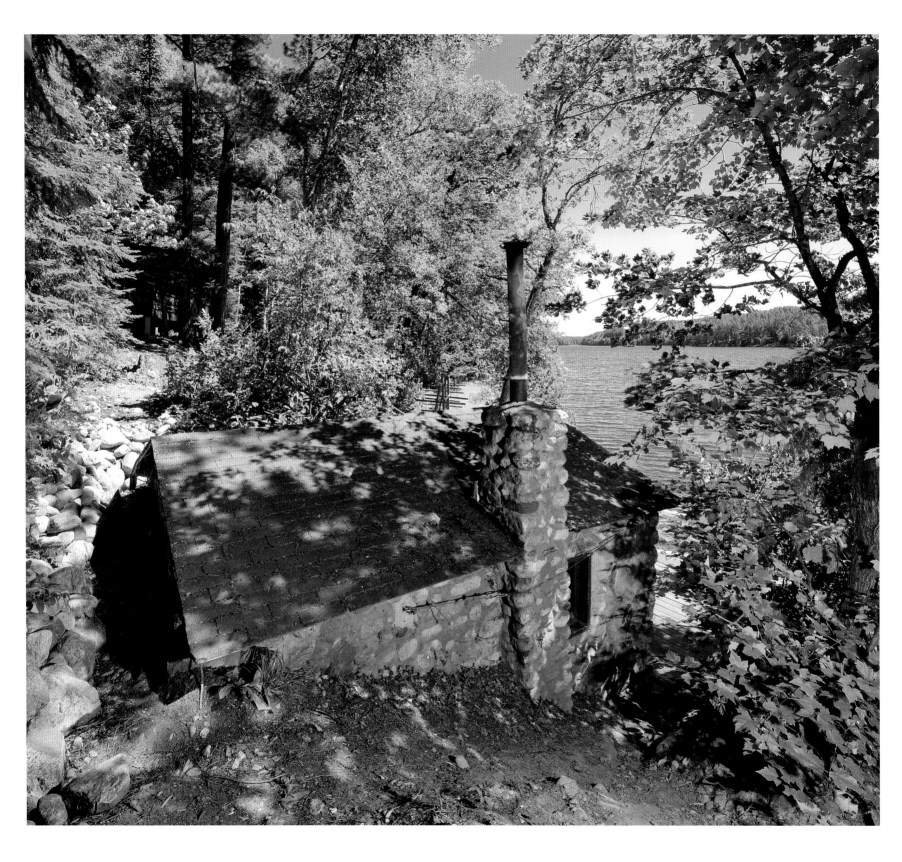

A dipperful of water tossed onto the rocks all but exploded, instantly filling the cabin with steam. Then more water, again and again, until the steam began to penetrate our bodies. When we had become accustomed to the heat, we moved to the upper bench where it was more intense. As we sat there, we became one with the rising vapors and the crackling spruce in the stove.

"Dip your cedar switch," I said, "dip it in your bucket and sprinkle the stones."

Bob did so, and the air was full of fragrance.

"Hold it to your face," I told him, "hold it close and breathe deeply."

The oil of cedar went into the passageways of our lungs, scoured and renovated them until they were clean and fresh. The moist warmth caressed us and filled us with a lassitude that dispelled all thoughts, and had we not been faithful to the ritual, we might have been tempted to stay and miss one of the greatest thrills of the sauna, the exhilarating plunge into the cold waters of the lake. Watching Bob, and knowing myself, I felt we could wait no longer. The time had come.

"Let's go," I said.

Heated through and through, we dashed down the trail, splashed into the bay, swam furiously for a moment, then returned. How good to feel the warm steam again, and now the perspiration literally rolled off our bodies until we shone and gleamed in the firelight.

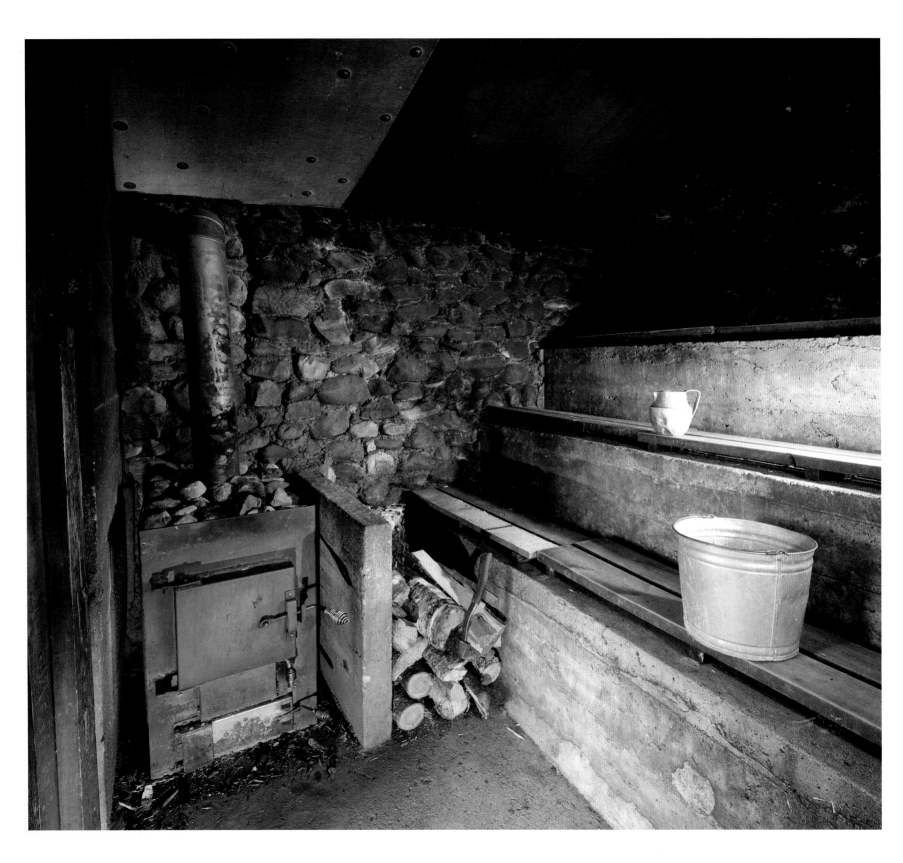

⊏ The stone and mortar textures of the Rock Ridge Camp sauna are a rare precursor to David Salmela'a Emerson Sauna (pp. 143–47)

Robert Olson remembers many such sauna sessions and recalls that his family took saunas at the Ely Steam Bath (still operated as Ely Steam Sauna) long before his parents purchased the lakeside parcel. To him, the use of a Finnish building was an essential expression of his father's philosophy and pursuit of oneness with the living land—a "hallmark of an ancient adjustment between humans and their environment." In Robert's recollection, vihta usage was not some stab at authenticity; it was common knowledge of the way things were done. "The sauna came soon after the cabin, and then it all made sense—my father didn't care for big architectural expressions of Americana or formal gardens." But simplicity, the potential for solitude, and proximity to cool, clean waters mattered deeply. ▪

The Value of Heat

As iconic as lakeside saunas or dedicated bathhouses on pioneer farmsteads may be, most immigrant Finns enjoyed their first American saunas in public accommodations of some sort. In any town that had a mine, dock, or mill that employed a fair number of Finns, a public sauna would

soon open to serve them. In Calumet, the earliest saunas were opened under the names Lamppa and Murto; in Duluth, St. Croix Avenue on the waterfront hosted several saunas that served residents of nearby boardinghouses. A high percentage of early immigrants were single men who found employment in forest camps far from these amenities, and sometimes they made their own accommodations, mimicking the wigwam architecture of Ojibwa sweat lodges to ensure a good steam after a week of felling, skidding, and driving white pine or peeled spruce from the Lake Superior region.

As research for his never-finished book about Finnish saunas in the New World, geographer Matti Kaups interviewed Paul Buffalo, an Ojibwa veteran of logging camps in the Deer River–Ball Club area of northern Minnesota. Buffalo referred to a variety of benefits of "sweatbaths" in camp, including treatment of cold, flu, and rheumatism. In his view, the Finns "were very much like Indians . . . they loved the Indian way of life." They told him: "We heard

in our country that you need help, and we come to help you," and he shared an eagerness with them to learn each other's language. In the summer, "they chopped up the sod and planted crops at the edge of swamps and grew big cabbages and carrots."

A good employer would recognize the importance of sauna as an amenity, and a fine example is Fred Hall, who earned his living from a variety of northwoods logging operations and other endeavors that required close contact with the land. Hall grew up in Toimi, Minnesota, one among several sprawling rural townships collectively known as Brimson that were settled largely by Finns at the wilderness intersection of two railroads, one to haul iron ore from the Iron Range to Two Harbors and the other, long abandoned, to bring timber to the mills of Cloquet on the St. Louis River. Toimi is a community with such a Finnish cast that the first post office operated out of Kalle Ranta's sauna.[1] Hall still lives on the farmstead his parents purchased in 1912, which included the previous owner's farmhouse, sauna, and two small barns.

This establishment in Biwabik, Minnesota, still sells cold beer but no longer offers public sauna.

The Algoma Steam Bath in Thunder Bay, Ontario, was one of eight public baths that served the Port Arthur and Fort William communities over the years. Courtesy of Lakehead University Library Archives and the Canadian Finnish Historical Society Collection.

Most immigrant Finns enjoyed their first American sauna in public accommodations like Salon Sauna in Superior, Wisconsin, open Wednesdays, Fridays, and Saturdays from 1:00 p.m. until midnight. The name is the genitive form in Finnish of the proprietor's last name, Salo. Courtesy of the Immigration History Research Center, University of Minnesota.

Finnish fishermen on Michigan's Keweenaw Peninsula built saunas as an integral part of their cold and strenuous life on Lake Superior. These saunas are on Lac La Belle.

Hall was born in 1915, delivered by local midwife Minnie Ranta, but not in the sauna, as was sometimes the local practice. In the fall of the first year, when he was only five months old, the three-room farmhouse burned down, and the young family of five spent the winter living in their sauna until father Arvid built a new house in summer 1916. After Hall's father died young, his mother sold milk and buttermilk on the output of eight good dairy cows.

The Hall farmstead sat on the edge of a vast marshy wilderness in the heart of the Arrowhead, stretching north across the Hundred Mile Swamp to the bogs that feed the Hudson Bay watershed via the Kawishiwi River. While the upland white pine was all cutover by this point, a new market for pulpwood had emerged, and the moist country to the north had marketable spruce that could be made into paper. Hall quit school after the tenth grade to start working the woods with his stepfather, Jake Hakala.

Soon, Hall began to run the operation himself, as he would throughout the 1930s. Major hauling could only be carried out on ice roads in the winter, and the buildings had to be relocated every two or three years on skids to the next camp. The 120-by-24-foot tar paper bunkhouse had to be broken into sections to be moved, but the 27-by-16-foot sauna could be skidded in one piece. Most of the workers, aside from one Swede and one Dane, were immigrant Finns who came back year after year throughout the Great Depression. According to Hall, "you couldn't break a nickel loose from anywhere during those years." The presence of a sauna in camp was taken for granted, and Hall later saw the benefits when working for other backwoods operations: "I worked for Northwest Paper Company as a forester as far away as Orr in camps that didn't have saunas. One of the good parts of the sauna, it kept away the bedbugs that a guy might have picked up along the way."

The camp housed dozens of men during peak operations, and delousing was important, if not critical, to keeping a crew healthy and productive. "We had a very good bull cook, he stayed with us for many years, and when a new man came in, he checked him out right away to see if he had any passengers, then he made sure he was in the sauna cleaned up. Then the clothes would get a sauna, too."

Harvesting spruce for pulp was difficult work. "The crew, they peeled anywhere from twelve thousand to fourteen thousand cords in a season." According to Hall's recollection, a very large tree might produce a cord all by itself, but most were much smaller, and the process of providing peeled pulpwood to the paper companies was labor intensive. While the road building and hauling were done with the benefit of internal combustion, the felling, cutting, and peeling were all done with crosscut saws, bucksaws, and other hand implements; and the skidding, with

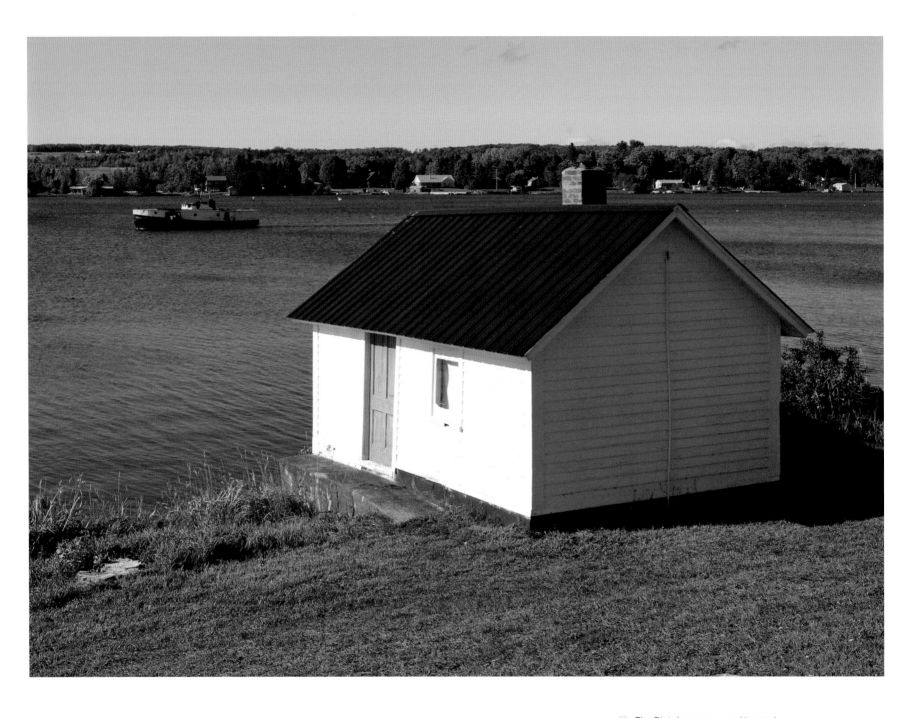

⊡ The Rintala sauna, near Hancock, Michigan, and the Upper Peninsula's Portage Canal, lies a short sail from Lake Superior's frigid fishery.

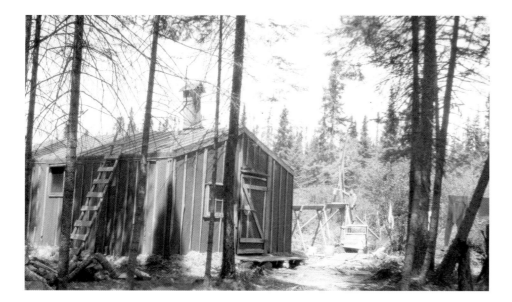

This sauna, built on skids for eventual portability, served several spruce logging camps run by Fred Hall in the 1930s north of Toimi, Minnesota, in the boggy Arrowhead region. The sauna was always parked near a creek so water could be easily conveyed for bathing, laundry, and steam fumigation of each new hire's clothing. Courtesy of Fred Hall and Evelyn Thompson.

horses.[2] Viable chain saws were still a decade away, and the camp was hungry for wood beyond its commercial value, as the cookhouse, bunkhouse, and garage all demanded at least as much firewood as the sauna.

The sauna was fired every day and served as both bathhouse and laundry, so one priority for each successive campsite was a nearby water source. To keep the water flowing, an elevated trough was built so that buckets could be dumped at the creek and run into a barrel in the sauna, a minor challenge compared with the water conveyance demands of twelve miles of ice roads. Trucks pulling wooden cribs full of water worked like urgent Zambonis to build up roadbeds and keep the logs moving during the frozen months. Naturally, sauna stoves were made from spent copper gasoline barrels, not the best metal for the job but no rarity in camp because of the trucks and Cats.

Hall still takes a sauna every Wednesday and Saturday evening in the farm's third sauna, aiming for around 170°F to start. And he still relocates saunas. The original homestead savusauna was filled with hay when it was struck by lightning in 1936 and burned for three days, because the burning grass was impermeable even to gas-powered water pumps. The second sauna he built upon his return to Toimi in 1947, after being enlisted to run a logging operation in Canada during World War II. The 1980 model features an insulated concrete foundation, a trick he picked up on a trip to Finland.

He also assembled and welded his own stove, recalling that as a child his whole family bathed together to make the most of the first hot clouds of steam produced by a savusauna, and that the initial blast would be smoky and sting the eyes. "And some had the bad luck of the sauna burning down," he added. The fact that Hall made his own sauna stove is not uncommon—period saunas throughout the region frequently feature one-off kiuas with certain central elements in common: a frame for cradling the rocks above the stove, and frequently an attached water tank with a closed loop that passes through the firebox to produce hot water. Hall remembers a variety of skilled local makers, including one he recalls only by the name Ikka, who was about four feet tall and was known for his stout barrel stoves made from truck rims that he had welded together.

Hall has learned that tamarack burns the hottest of any locally available firewood. With a practical familiarity born of a youth in the woods, which ripened into a career as a major construction superintendent for a mining company, he must be as practically familiar with the engineering properties of the boreal ground, from ice roads to tailings ponds, as anyone. When it comes to stones producing steam, "there's nothing better than Lake

Superior rock—waves have washed all the softness out of them and they don't crack like the ones you get out of the glacial till up here in Toimi."

Savusauna usage, with its chimneyless hearths and lesser convenience, mostly disappeared from the region in the 1920s, and many existing bathhouses were converted. Every area had its local Ilmarinen, the legendary smith and inventor of the *Kalevala*. One whose name would never achieve widespread recognition was Tauno Ainasoja of Wawina, Minnesota, a master welder who produced sauna stoves with a 16-by-24-inch firebox of $3/16$-inch plate steel that was a strong match for a 12-by-8-foot room.[3]

But for true iconic status, none can surpass Leo Nippa, who started manufacturing stoves in Bruce Crossing, Michigan, in 1930, and later brought his sons into the business. The Nippas would eventually sell thousands of stoves to buyers from as far away as Alaska and Hawaii. Building on years of experience working with metals, Nippa developed techniques that promoted strength and durability by minimizing the extent of welds, and also employed a baffle system to transfer more of the hot exhaust to the rocks. Among the more notorious locations of a Nippa stove is the Upper Peninsula's annual Heikinpäivä Ice Sauna (*jääsauna*) (Heikinpäivä is St. Henrik's Day, the midway point of winter, when the bear turns over in his den). The last stove manufactured

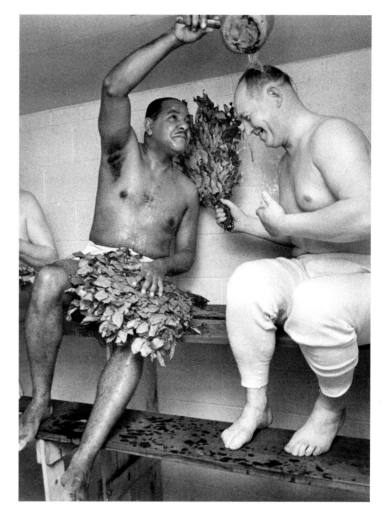

in Bruce Crossing in 2005 resides in Hancock's city hall, but the brand is still manufactured in Michigan's Lower Peninsula. Nippa's granite gravestone in a cemetery east of Bruce Crossing is engraved with a depiction of a stove door.

During Nippa's history as a stove manufacturer, sauna became known and practiced throughout the country, particularly during the 1950s and early 1960s, after the 1952 Helsinki Olympics, Finnish President Urho Kekkonen's 1961 visit to the White House during the Berlin crisis, and a flock of articles in magazines and newspapers promoting the exotic healthful practice. In 1962, a *Wall Street Journal* headline confidently announced, "Relaxing Sauna Baths' Growing Popularity Lifts Equipment Sales." In early 1963, *Life* proclaimed, "U.S. Takes Up Sauna Bake-bath: A Hot Fad from Finland."

Some Finns of the Lake Superior region saw a clear opportunity to assert their authentic claim as a local source of sauna supplies. In March 1963, John F. Kennedy's newly appointed U.S. ambassador to Finland, Carl Rowan, was invited to the Iron Range and presented with an electric sauna stove locally manufactured by Ronald Lahti for delivery to President Kekkonen. With U.S. Senators Hubert Humphrey and Eugene McCarthy in attendance, the Iron Range marked Carl T. Rowan Day in honor of the first African American to reach the highest echelons of national diplo-

macy. Rowan experienced his first sauna at the residence of Mr. and Mrs. Wayne Luopa of Virginia, and gamely shared that "there are people in Washington waiting for a report on this." The new ambassador was offered a birch vihta but cautiously responded, "I don't intend to join any Birch Society." The *Mesabi Daily News* reported the next day that Rowan had lost four pounds during his initiation.

The mechanics of transferring heat from fire to stone to steam is quite simple, but the qualities of the heat at every stage are distinct. Everyone instinctively appreciates the heat of fire, and the heat of stone is as familiar as bare feet on bedrock on a sunny summer day. But the best means of understanding the heat of löyly is

explained by the late writer, welder, and professional engineer Pertti Räty, an immigrant from northern Karelia to Thunder Bay. Räty developed an analogy to help explain to disbelievers how a 240°F sauna was not unbearable. Exposed long enough in such an oven, water obviously has 28° of rolling boil behind it. But Räty explains that considering temperature as one would voltage in an electrical context provides insight. Hot dry sauna air is analogous to the tiny sparks of lightning that you see under a synthetic blanket at night—"since there is hardly any current or 'amps' involved, this high voltage is benign. Similarly, the heat transfer from sauna air, or current in electrical terms, is very low and the seemingly high air temperatures are quite tolerable. It is the high heat transfer rate from boiling water—having an energy density over 3000 times higher than that of air—that does the damage, not the temperature per se."[4] The wall of vapor that emanates from a sauna stove after water is tossed on the rocks does not bring a great increase in temperature. But the surge in humidity, or "amperage," bridges the gap and brings the heat with the quality of a swift slap. For the uninitiated, a soft wood room at 240°F is a briefly tolerable roast; löyly at that temperature is an experience best endured by true believers.

Ever striving to improve on this heat transfer, local stove manufacture in the region continues at both Spartan Sauna Heat-ers near Eveleth and Kuuma Stoves of Tower in Minnesota's Arrowhead, which both produce more than two hundred units every year, including wood-burning stoves.

Spartan's Scott Heikkinen represents the third generation of his family's sauna stove enterprise, launched in 1953. His shop is a former barn on his great-grandparent's farmstead in Sparta, but the 1925 log sauna still standing on the site was long ago committed to storage—the current family sauna is in the basement, powered by a Spartan electric unit. His father, Jack, and grandfather, Ted, built the family business from scratch on the family farm, and Scott started out painting, bending sheet metal, and wiring electric heaters when he was twelve or thirteen. He recalls his grandfather as a hard teacher, someone he could never please, but learned later in life that Ted always hoped Scott would carry on the business when the time came. His father, a welding instructor at a local vocational-technical institute, taught him how to build the wood-burning stoves. Scott acknowledges that the deep connection with the men who immediately preceded him provides a comforting presence in the shop—"I always feel there's a part of them

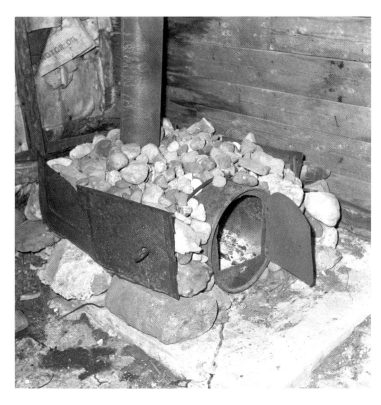

around, helping me out"—as though the hiss and spit of his father's torch has never left the room.

Scott admits, "I always thought of my dad more as an artist than out to make money," less interested in marketing than metallurgy and pride in craft. But legacy customers and word of mouth seem to take care of demand. Scott recalls how the business had a growing order list for fully fitted sauna buildings that would be relocated to a chosen site, but his grandfather balked at the high cost, believing that sauna should not require such a large expense, and ceased that specialty. While his grandfather was always ready to barter a sauna stove for basic needs, he could not bring himself to submit a bid if he found that a particular custom installation would be too expensive. He was always resistant to any potential for growth that would remove quality control from family hands. Scott's son has started to follow his way into the business, a development that Scott accepts with the constant reminder that he was not interested in perpetuating the business at the same age. Now he accepts the burdens of a small businessman who is committed to the benefits his product provides: he has helped customers load up their sauna heaters on the verge of midnight—his close contact with local buyers often leads to pickups—and he filled an order on the day that Jack Heikkinen succumbed to a long bout with cancer.

Daryl Lamppa is another third-generation stove manufacturer, producing Kuuma Stoves in Tower, Minnesota, which take their name from the Finnish word for hot. He is not himself the most avid sauna participant: "Once a week is enough for me, I'm not real big on sauna." His business has its origins in the many sauna stoves his grandfather Richard, a former blacksmith and shipyard welder, made for Finnish Americans on the Iron Range seventy years ago. Daryl's father, Herb, recalls the family's metalwork legacy, remembering "clearly how many hours I had to stand there cranking the handle of the blower of the coal-fired forge. He had straps of iron that had to be heated 'til they were red hot so he could then hammer them in the shape needed to form the legs of the stove." Herb took his father's basic knowledge to develop a line of high-efficiency wood-burning stoves for both home heating and sauna usage, as well as electric sauna stoves. The Lamppas' focus on wood burning has resulted in the only UL-listed wood-burning sauna stove, a $20,000 business investment that has made Kuuma wood sauna stove usage insurable.

The key to an efficient wood-burning sauna stove, according to Lamppa, is ensuring that it fully consumes the gases using a

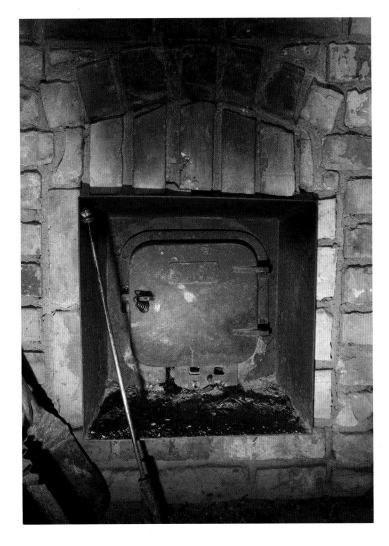

baffle system to promote secondary burning. He points out how the designs of his grandfather's generation often produce an excess of uncombusted smoke, and by using a patented wood-burning process called gasification, heat production is vastly increased, and creosote buildup is minimized. The Lamppas learned as they developed their business to use heavier steel—at least $3/16$-inch plate—to ensure that a stove endures. He proudly and confidently claims that a medium-sized Kuuma sauna stove can heat a tight 10-by-10-foot room to 200°F in just over an hour. Two-thirds of their sauna stoves are wood burners. "Most of our sales are upper Midwest, but we sell saunas all over—Canada, Washington State, Colorado—and people call to tell us how you can control the sauna fire so well."

◰ Maplelag stove, at the Maplelag Resort in Callaway, Minnesota, manufactured by Spartan Sauna Heaters of Eveleth, Minnesota.

⊡ Salolampi stove, at the Concordia Finnish language camp near Bemidji, Minnesota, manufactured by Kuuma Stoves of Tower, Minnesota.

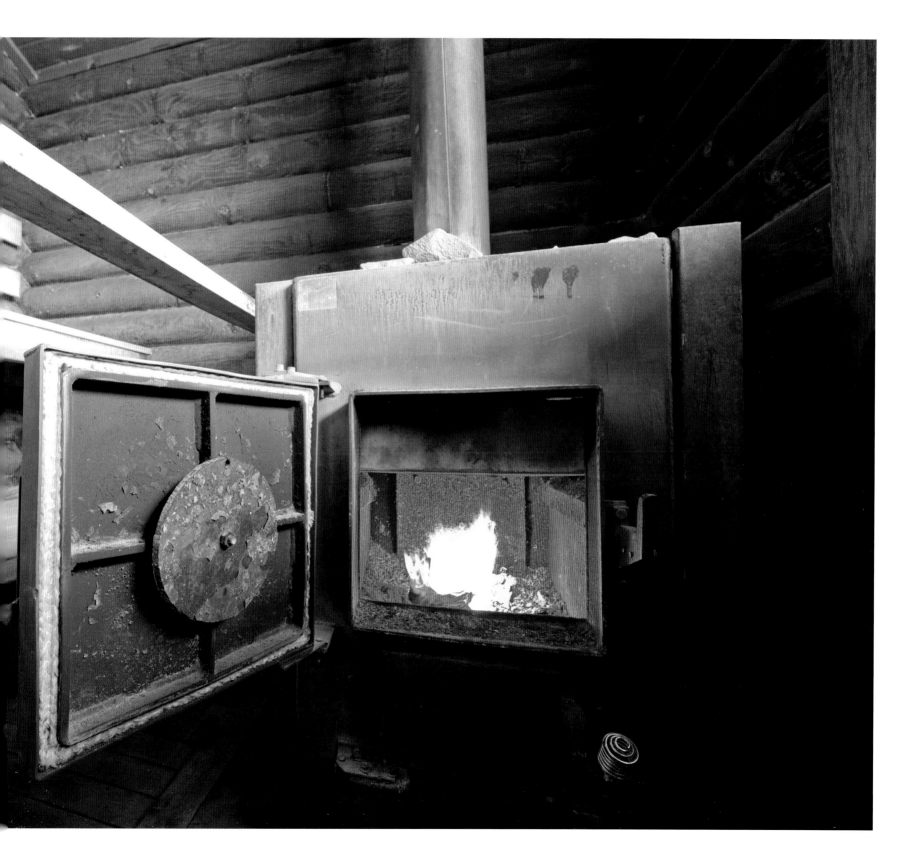

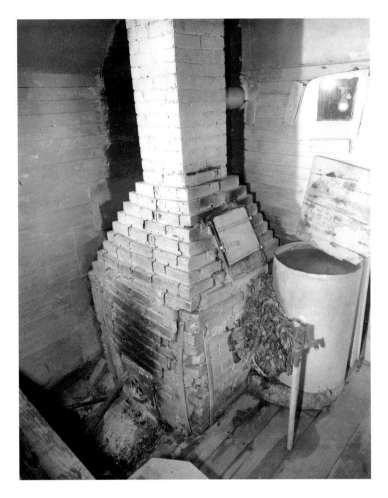

The unusual brick oven of Hoikka stove, Annandale, Minnesota, provided both the means of heat and the steam-producing mass.

Stove sales remain steady—along with a few employees, he is able to ship about two hundred sauna stoves a year—but Lamppa acknowledges the hard work of running such a specialized small business. He predicts that he will be the last of his family to produce sauna stoves. Yet he would be eager for a real opportunity to prove the mettle of his wood-fired and electric stoves to Finnish consumers: "I see no reason in the world why people need to import a sauna stove from Finland, because the ones made over there are not made as good as ours are."

While not a manufacturer of stoves, Saunatec Inc. in Cokato, Minnesota, is the largest seller of sauna equipment and materials in North America. They cut and package custom sauna rooms to accompany imported Finnish stoves and stone, all from a facility situated less than three miles as the crow flies from the oldest sauna in North America. The company employs a hundred people at its headquarters and production facility in Cokato, and the business has had a knack for gaining ground in tough economic times. Keith Raisanen, president of Saunatec, now supplies a nationwide sauna distribution network of a thousand dealers from the edge of a largely agricultural community with deep Finnish roots. Cokato's Finnish legacy is most in evidence at Temperance Corner, with its old temperance hall, one-room school, and the 1867 pioneer savusauna.

Raisanen did not come to the sauna business by first ambition. He studied plant pathology at the University of Minnesota before attaining a graduate degree in agronomy, then landed his dream job as county extension director in Houghton County, Michigan. Born and raised in Cokato's rich agricultural economy, he was eager to work with the mostly Finnish American farmers who were making a living on the fringes of the Copper Country. After a bout of wanderlust satisfied by a global bike ride, he returned to work for his father's company in Cokato, which installed agricultural ventilation systems. A representative from Finland's Finnleo company, scanning for Finnish names in a business directory, found the Raisanens and badgered them into signing on as the new central U.S. distributor of their products, buying out the inventory of Peterson Sauna in Duluth.

Keith Raisanen took over the company himself after two years, converted a roller-skating rink on Cokato Lake into a warehouse, and quickly became the exclusive distributor of the company's

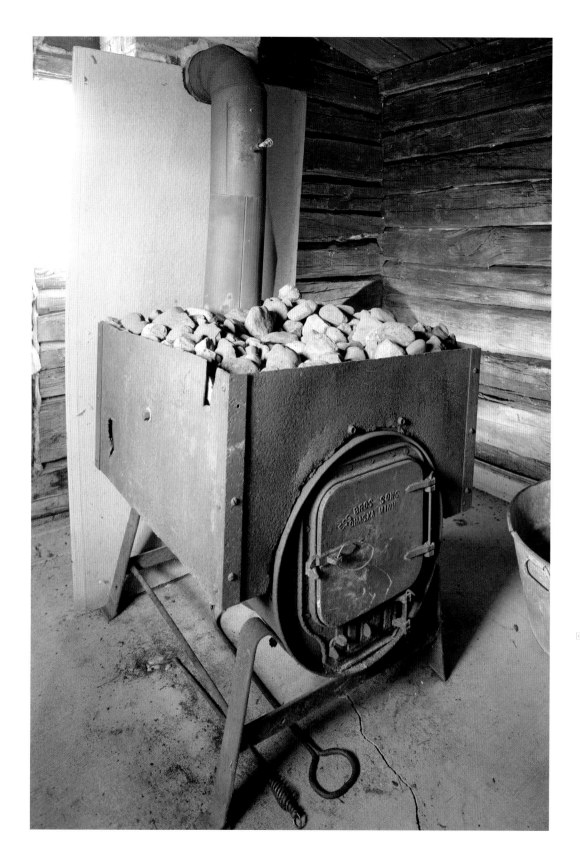

Waahto stove, Brantwood, Wisconsin, is a classic example of custom sauna stove manufacture.

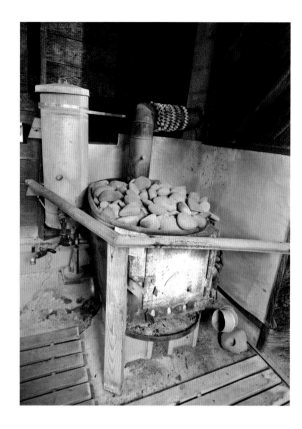

products in North America. He used the proceeds to develop an affiliated line of modular kits and materials packages for custom on-site installations. The Finns appreciated his ability to translate sauna to a North American market, and they acquired a controlling interest in the company in the 1990s. Cokato now hosts the American headquarters of Saunatec Inc., "the world's largest corporation in the sauna and steam bath business," and Raisanen is confident that his company fills the orders of at least half of his estimate of 12,500 to 15,000 units sold yearly in the United States. The vast majority of those projects—over 97 percent—involve indoor installations and electric stoves, but he states that the wood-fired business recently doubled.

The one dramatic change he has noted, and one that he is very grateful for, is that sauna is no longer an "ethnic product" but rather a "lifestyle product." Whereas twenty years ago you could overlay a map of his sales and see it almost perfectly coincide with areas of strong Scandinavian heritage and colder climates, today's sales are even across the map, aside from the impenetrability of the Deep South. But Tennessee is now one of Saunatec's strongest growth areas. "Tell me," Raisanen says, "is that sauna country?"

The latest development in sauna stove technology is an always-on, superinsulated stove that holds two hundred pounds of stone, capped with a lid when not in use. Raisanen claims that

Barberg stove, Cokato, Minnesota, adapts a washtub and serves the successor to the oldest sauna in North America, which has remained in the original family.

Kaleva Island stove, Eveleth, Minnesota, a wood-fired sauna stove.

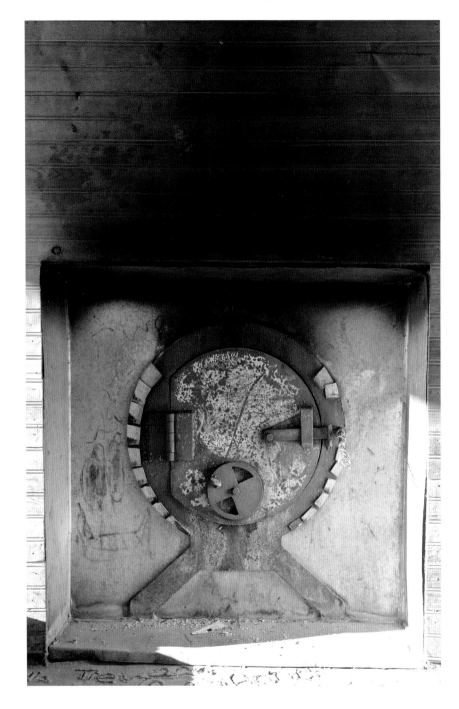

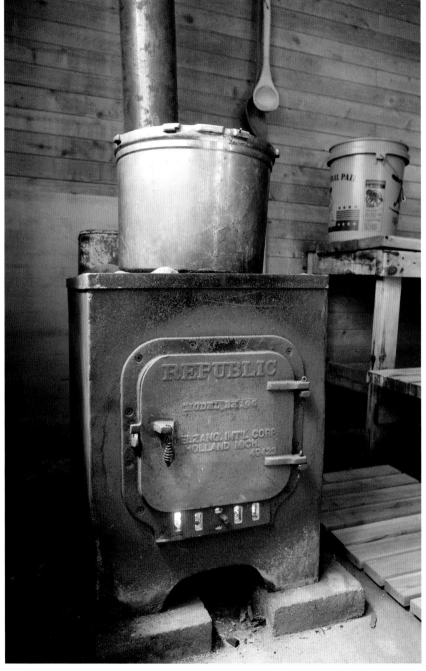

Thompson Island stove, Thunder Bay, Ontario. A regular American visitor to a Canadian wilderness harbor sauna on Lake Superior contributed this sauna stove.

Water heats on the rocks on the Winter-moon stove, Brimson, Minnesota, for a Saturday night sauna after a long day of mushing dogs through the boreal forest.

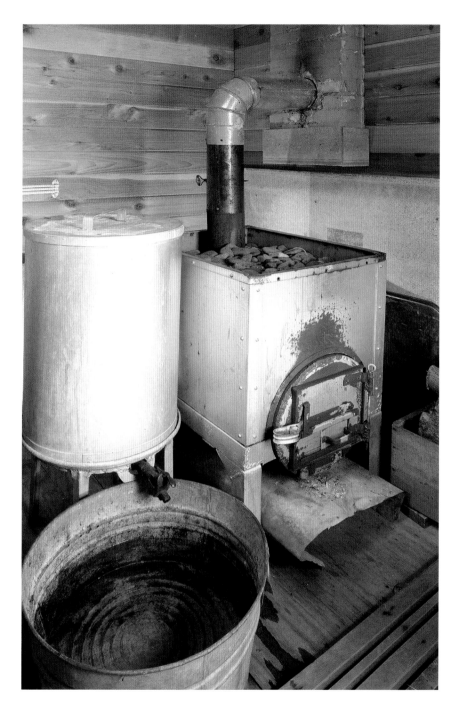

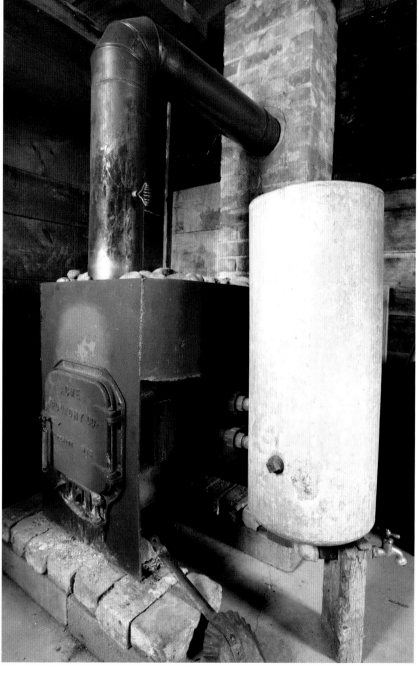

↑ A brick chimney rests on an internal wall near the Ollila stove, Brimson, Minnesota, a common feature of vintage Finnish saunas in the region.

↗ The pipes that pass from the water heater into the firebox of the Palo stove, Oulu, Wisconsin, can bring a large volume of water to the boiling point in just a few hours.

The modestly clever Niemi stove, Lempäälä, Finland, heats a small sauna within an old tupa that has been converted to a guesthouse.

Stove at the Naval Academy on Pikku Mustasaari Island, Suomenlinna, Helsinki, Finland. Photograph by Ari Saarto; courtesy of the Governing Body of Suomenlinna.

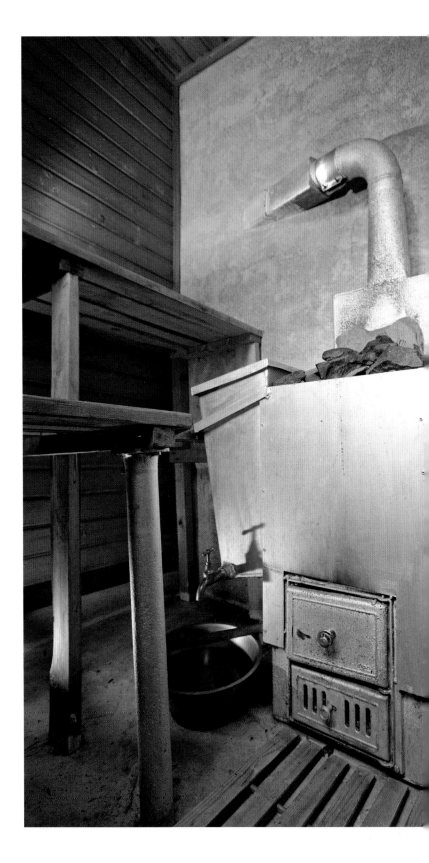

this technology is more efficient than heating from scratch for someone who takes a few saunas every week. For UL listing, his imported electric stoves must be sold with the rock with which they are originally tested—in this case peridotite, a coarse-grained igneous rock from quarries in central Finland that has excellent heat retention and durability.

But Raisanen maintains that even the farmers of distant Cokato would seek out Lake Superior stones when possible, though most used local field stones that had the right quality. Mikkel Aaland, the author of the 1978 classic *Sweat,* a comprehensive examination of various hot bathing practices, has recommended the following test for anyone choosing local stones for a sauna: "Thoroughly heat a sample for two hours or more. Drop it into a pail of cold water then look for cracks. When the rock is cool, test it further by hitting it with a hammer or against another rock. If the rock cracks or makes a soft grinding sound when rubbed against another rock, discard it. If it survives, you have a safe sauna rock."[5]

Which is not to say that stones are the only way to produce steam for sauna. At the 2008 FinnFest in Duluth, a Finnish scholar told of productive research on the use of ceramic stones, and the longest-lived commercial saunas in America from the immigrant period produced steam by throwing water on radiators heated by a central furnace. A fine example of this is the Virginia sauna

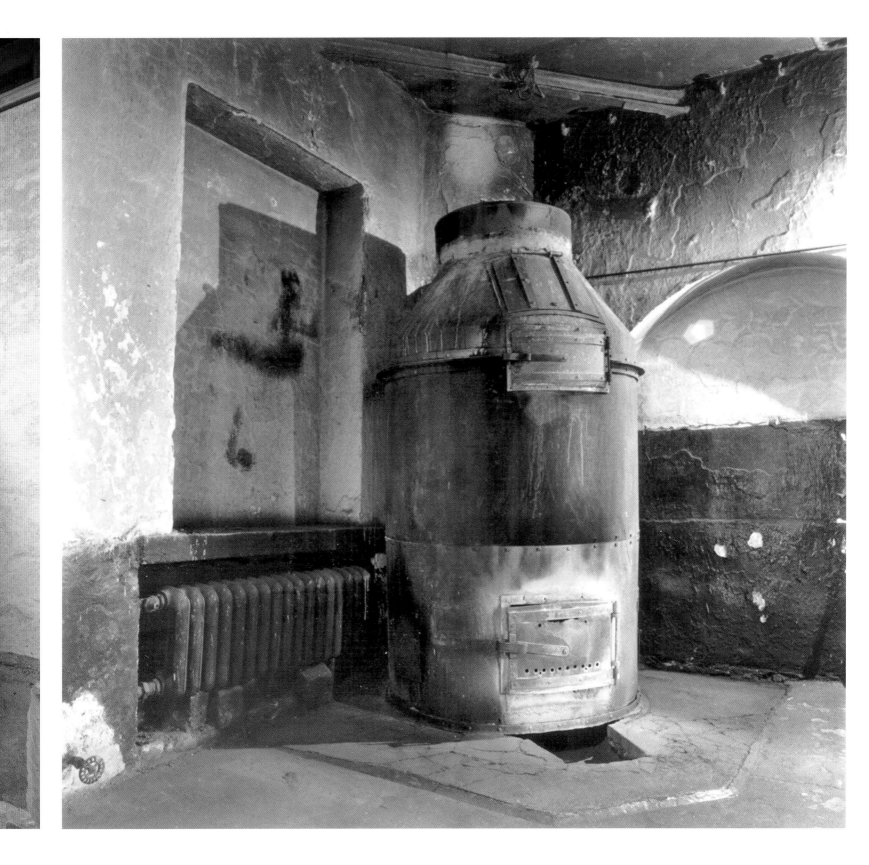

Platforms

Common Sauna

Storage

Common Shower and Washing Room

Common Dressing Area

Dressing Room

Sauna

Dressing Room

Dressing Room

Dressing Room

Sauna

Sauna

Dressing Room

Dressing Room

Sauna

Sauna

Dressing Room

Dressing Room

Sauna

Sauna

Dressing Room

Dressing Room

Supplies

Cashier

Storage

Lobby

Vestibule

0 4
FEET

MK

The floor plan of the Virginia Steam Bath in Virginia, Minnesota (no longer in operation), reveals a variety of accommodations for bathers. Drawing by Matti Kaups. Courtesy of the Immigration History Research Center, University of Minnesota.

The public sauna on First Avenue East in Duluth continues to serve a diverse community long after it opened in the city's primary Finnish neighborhood in 1923. Photograph courtesy of Herbert G. Jensen, Duluth Family Sauna.

described by University of Minnesota Duluth geographer Matti Kaups in "From Savusaunas to Contemporary Saunas: A Century of Sauna Traditions in Minnesota, Michigan, and Wisconsin." Kaups had grown up in an Estonian community that had a deep sauna tradition. As a graduate student in America, he was not impressed with the quality of steam that he once experienced at the now-defunct Glenwood Avenue sauna in Minneapolis: "missing was the expected heating apparatus consisting of a stove equipped with loose rocks on top of the fire chamber. In its place heat emanated from old-fashioned, piping-hot plain radiators lining the walls. In our quest for löyly, we had to turn on the hose provided so as to get water on to the radiators, and in return got plenty of foul steam, of an odor reminiscent of an automobile's overheated engine."

Such a public sauna still serves its original purpose in Ely, Minnesota, which could safely promote itself as the sauna capital of North America. The Saturday night regulars at the Ely Steam Sauna, some of whom have been coming every Saturday for forty years, are very familiar with this same means of drawing steam from metal. The room never attains the stark dry heat of a wood-fired sauna, but it does produce an intensely humidly hot environment. Outdoors it was 5°F on a darkening February Saturday evening, but in the bull pen—the men's public sauna room—regular

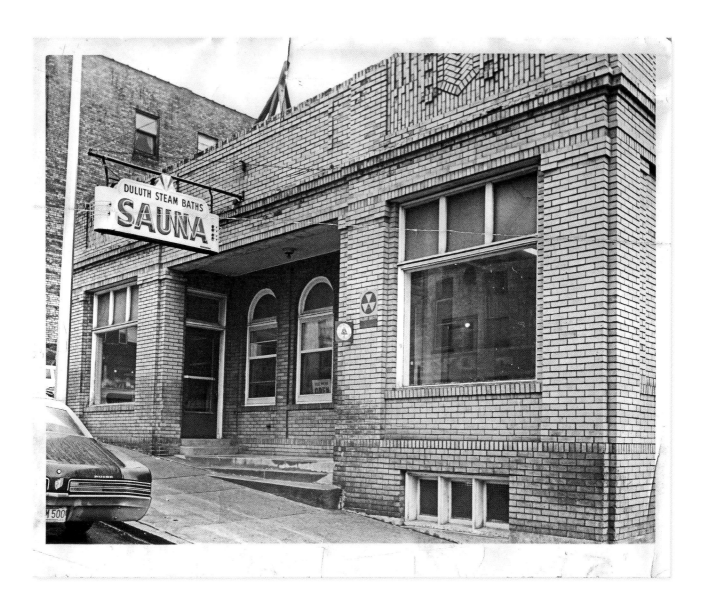

waves of steam lapped the paneled walls as a host of old-timers took their weekly breather.

Emil Ahola started the business as the Ely Steam Bath in 1915, and it stayed in the Ahola family for almost ninety years. Emil's son Toimi, a longtime St. Louis County commissioner, took over in the 1950s. His daughter Judy Mackie grew up in the Ahola house next door, had her regular Saturday night sauna there throughout her childhood, and worked there with her sisters and brother as teenagers, admitting customers and selling pop on the Wednesday, Friday, and Saturday schedule that continues under current own-ership. She recalled that before the 1950s many people still did not have a proper bath at home, and even many non-Finnish Elyites came at least once a week. But the business remained a vital part of the community even after home baths proliferated, and the good utilitarian bath began to serve an increasing number of Boy Scout troops and other campers emerging from Ely's wilderness hinter-land. But "the bull pen was much more popular" at that point, she said, as sauna became more of a social ritual for men from town. Still, the bull pen's counterpart, the henhouse, endures, along with several private sauna rooms.

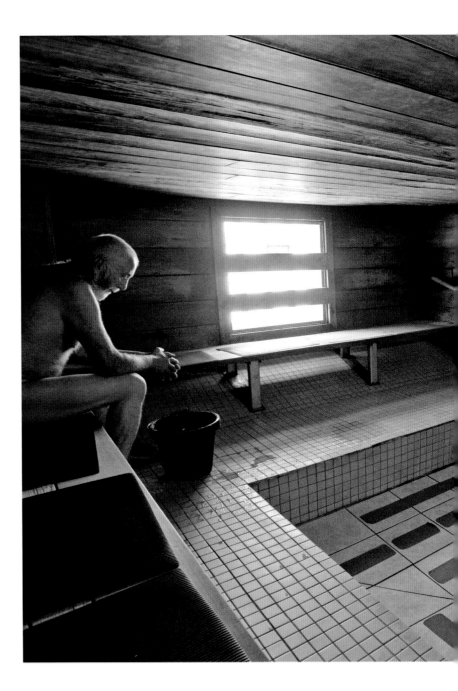

Sauna etiquette is simple and traditional. Nudity is not enforced, but swimming trunks will invite something between indignation and ridicule from some bull-pen stalwarts—towels provide a layer of discretion and hygiene. The dressing room is ringed with benches and hooks, and conversations endured long there while the men sipped beverages between sessions in the sauna. In between is an ample shower room where one can rinse and fill a bucket of water for dips of relief in the sauna proper. The main attraction is handsomely paneled, and the lower stages are tiled, leading up to a wooden top bench. The wall to the left of the entrance takes the full brunt of the waves of steam from the radiator, produced by a twist of a self-closing spigot on the wall in the corner farthest from the hearth. One could quickly pick out the regulars by their ability to draw breath and speak soon after the wave had passed.

The patrons who frequented the bull pen in deep winter ran the gamut from dedicated regulars in their eighties to a bearded father and his two young sons, off-the-grid residents of distant

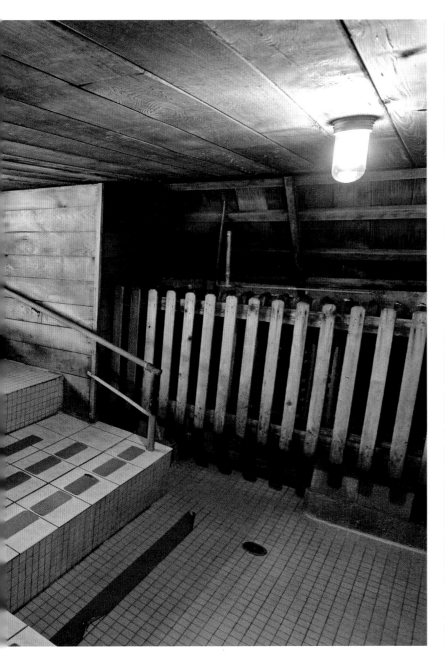

Started by Emil Ahola as the Ely Steam Bath in 1915, the business stayed in the Ahola family for almost ninety years and still serves an array of customers from Finnish American regulars to Boundary Waters canoe campers.

outskirts, who peeled off layers of flannel and long underwear in anticipation of their weekly winter bath. Many are more likely to sauna near a lake in the summer. A man in his mid-fifties grew up a few doors down and recalled how his father used to send him and his brother home after sauna in fresh pajamas, while he returned to the bull pen for headier steam and conversation. A few bachelor acolytes studied how to be old, wise, and Finnish by listening keenly to a brutally funny and ribald mountain of an octogenarian who closely resembled Urho Kekkonen—if the Finnish statesman had the bulk and swagger of a man who spent his life working in the northern Minnesota woods. The local Urho's best legend revolved around his encounter with a tragically curious male black bear and its future prospects for reproduction.

But conversation also turned to addressing practical matters of various importance: a firefighting forester's secrets for an effective backcountry sauna using a tent and rocks heated on a Coleman stove; a miner's protracted dispute with his union over benefits; a rural semihibernator's fury at the government's ineptitude in delivering digital television to the sticks; and a roundtable of wisdom about bears, guns, Internet connection speeds, and wolves—never take the wolf's side in any story, an offense worse than wearing a bathing suit. ▣

Kangas Sauna is the only public sauna still in operation in Thunder Bay, Ontario. It was established in 1965 and has eighteen separate private saunas available.

The public sauna at the intersection of Second Street and College Avenue in Marquette, Michigan, was built in 1926 and now features four newly remodeled sauna rooms still heated by a central boiler. Photograph courtesy of Jack Deo.

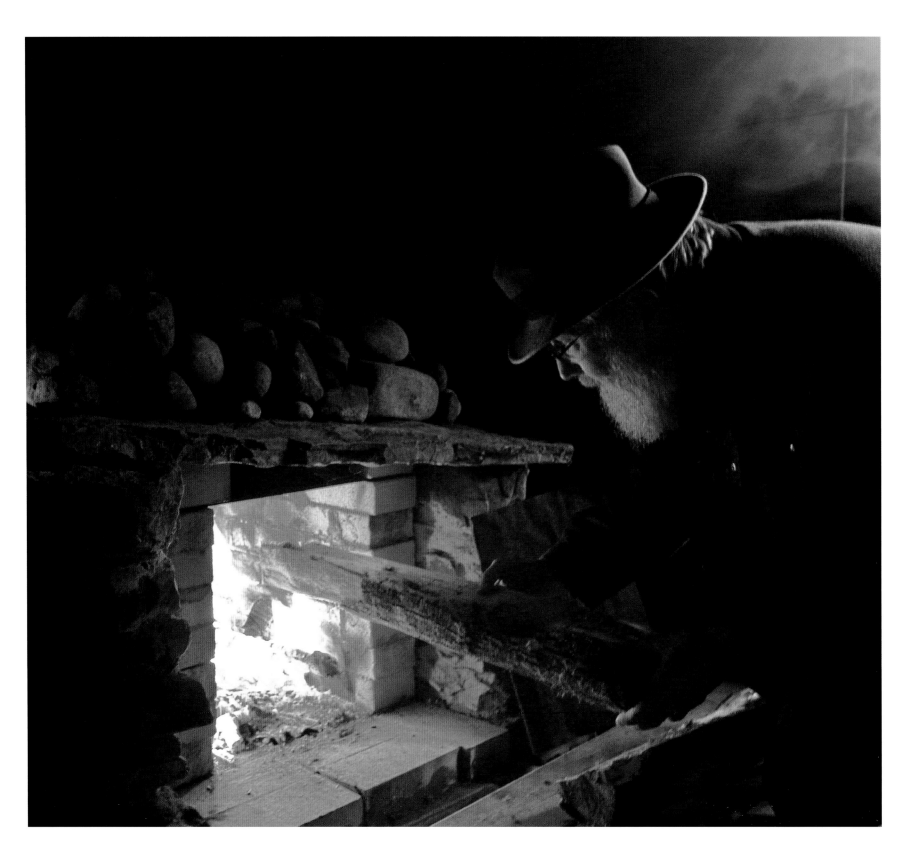

Keeping the Wood-Fired Sauna Tradition Alive

A century past the peak of Finnish immigration to North America, sauna is now the one word of Finnish that, depending on the pronunciation, most Americans and Canadians would recognize (too much authentic "ah-oo" and you lose plenty). Any debate over whether it is a healthful

practice should succumb to that very fact. Finnish immigration did not fuel this widespread popularity as much as the Helsinki Olympics in the 1950s, the dawning awareness of the commercial potential of wellness in the 1960s, and the sprawling basement prosperity of the subsequent decades. Saunas became popular across most of the continent due more to *Life* magazine and home-and-garden shows than Finnish ancestry. They are a standard feature in any health club that dares to put an umlaut on its name, and they sprout near hotel pools like cedar seeds in hothouse soil. But the sauna as a distinct building in the landscape is still a largely regional phenomenon, and the fact that the foremost architect of this distinct form lives within clear sight of Lake Superior is fitting.

That architect, David Salmela, is a native of Sebeka in Minnesota's Wadena County, where the north woods dissipate into a lakeless upland that marks the easternmost point of the Finnish Triangle: "the center of the eastern section of the western part of the southern portion of northern Minnesota."[1] Salmela's father

had tried his hand near Lake Vermilion in the scintillating lake country near Ely, but then opted for the relative stability of a farm among the townships between New York Mills, Wolf Lake, and Menahga, which drew dense pockets of Finnish settlement and resettlement and a chance at agricultural prosperity. Like other farmhouses in the area, the home that Salmela grew up in had no bathtub. The family bathed using a sauna and shower in the big basement. "My mother's home had an original outdoor sauna, but our house in the country built in 1917 had an indoor sauna. After milking the cows, you bathed in the basement sauna."

Salmela saw in his immediate environment much of the inspiration for his future as an award-winning architect: he saw beauty in the functional imprint his farmer neighbors made on the landscape, "how the fields were cut, the rows of trees planted for windbreak, the buildings placed in an order of function."[2] A defining feature of many of his projects is the dialogue among the various structures on the site, an influence he openly credits to the scale

Jon Saari of Marquette, Michigan, keeps the savusauna tradition alive in North America. He must add three to four split logs every half hour for about nine hours to achieve 200°F on the upper bench of the log savusauna he salvaged from a nearby farm and restored on his backwoods camp.

The sauna as a distinct building in the landscape remains a regional phenomenon. The sauna designed by David Salmela for Pete and Cindy Emerson plays with the traditional form of a Finnish sauna while keeping its essential layout and purpose intact.

and dimensions of the Finnish homestead courtyard. After years of relatively rootless modernism, he realized the benefit of the use of familiar forms to satisfy clients' local tastes, and in his practice quite frequently that means the rooflines of farm buildings and outsized hay bales, groupings that enclose outdoor spaces in the landscape. He realized that his influences could be inspired by the vernacular forms that he had always admired.

Still, he freely credits the influence of several important distinctions attributable to Finnish and Nordic architecture: a sense of organization that plans to the site, deferring to trees and existing contours; frugality and sensitive use of land, in contrast to the formal devastation of a site like Versailles; and social relevance, that is, design on a comfortable scale. "Finland has the finest public and private buildings in the world per capita." Before he found his footing as an architect, he felt that he could make Minnesota into Finland.

Salmela is rare among architects for having designed a large number of saunas, an important component in over two dozen of his projects. He is by his own estimation *the* architect of saunas in North America, a statement issued not as a boast but as a simple factual claim of uniqueness. Most notable among his designs is the Emerson Sauna near Duluth, Minnesota, which received an Honor Award from the American Institute of Architects Minne-

sota in 2003. It also received a North American Wood Design Merit Award in recognition of projects that employ wood elements for exemplary architectural design and building craft. The jury praised Salmela's "skillful use of basic geometric shapes that intersect to make a strong building with textures of wood, brick, glass, and sod roof." The unacknowledged irony in their judgment of praise in what is foremost a wood design competition is that the Emerson Sauna departs perhaps as far as one could materially from the traditional Finnish sauna, a devotedly wooden structure, while keeping its essential layout and purpose intact. "I don't even know in Finland if a sauna has won a national award," Salmela states to underscore the project's singularity. This success is all the more remarkable for Salmela's lack of formal training—he apprenticed into his profession by working with Finnish American architect Eino "Jerry" Jyring, among others.

In conversation, Salmela makes a casual distinction about saunas that most architects would never utter. He describes a client who desired more of a "Norwegian" sauna, recognizing subtle preferences within the Nordic aesthetic among his clients, many of whom are the grandchildren of northern European immigrants. "I don't have that many Finnish clients, but a lot of Scandinavian Americans. I don't force the idea of saunas on people, but people that come to me have that mind-set." The challenge of adding a

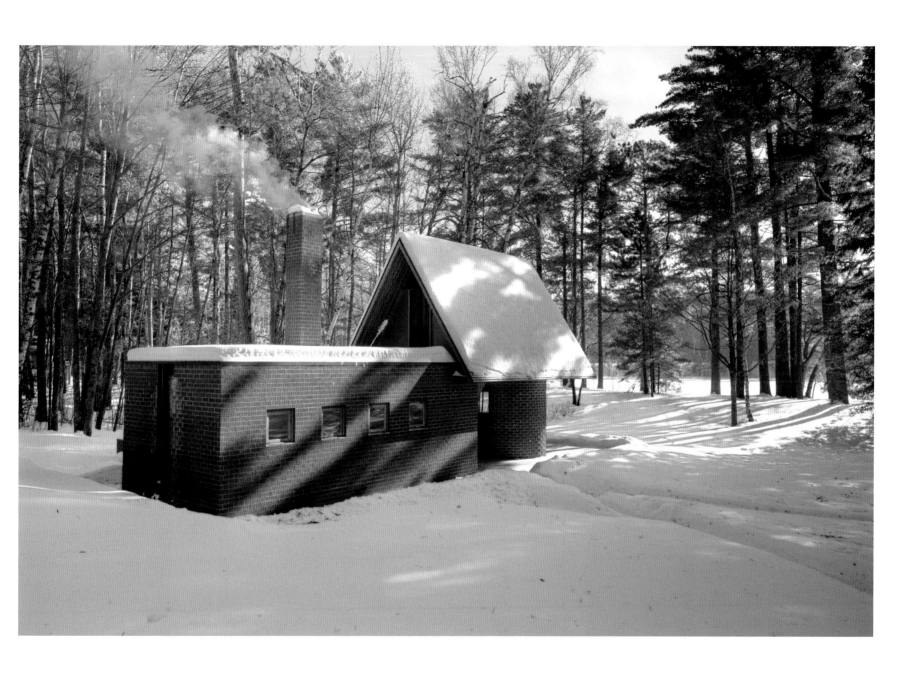

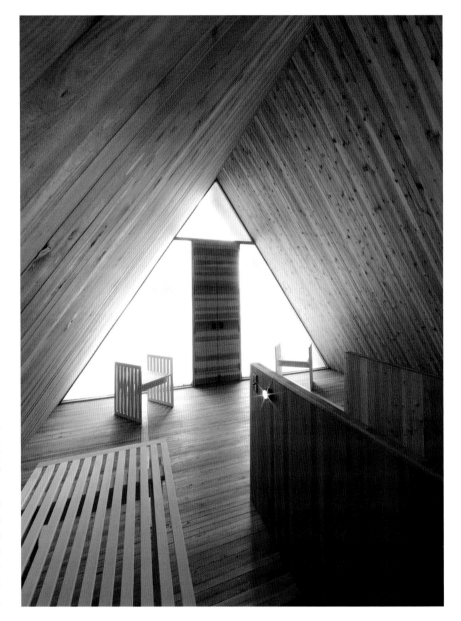

The interior of the Emerson Sauna has unique adaptations, including a second-level cooling porch that shelters an outdoor shower. The owners choose to forgo the traditional stovetop rocks and use the brick wall to generate löyly.

building to the landscape is a welcome opportunity given his expressed admiration and tribute to Alvar Aalto's Villa Mairea, with its poolside sauna, as "the finest house of the twentieth century." In America, he sees the sauna as a particularly midwestern building type, a building with a unique identity. To that end, Pete and Cindy Emerson were ideal clients. They are both natives of the Duluth area and met in high school in nearby Two Harbors. Pete, whose father grew up in the Finnish community in nearby Brimson, is avid about sauna from a lifetime of regular use, and the sauna is most frequently used in winter after skiing with friends on a series of cross-country trails that he maintains on his property. Cindy far prefers a hot bath, but she understands her husband's love of a good scalding in the hard oven in their side yard. Between the two, they claim Swedish, Norwegian, and Danish ancestry.

The Emersons' home, also designed by Salmela, was built five or six years before the sauna. They first considered converting an existing lakeside guest cabin into a bathhouse, but decided to go with a design that their architect had already completed and was looking to employ. At first approach, the building is something of a mystery. Shifted shapes throw one off the internal function, and reconciling its original forms helps one get oriented: rectangular floor plan, gable roof, and chimney. The shift of the "roof" and the slightly larger scale foster an elevated screen porch, in the sauna context functional as a place for participants to cool off, which in turn shelters an outdoor shower below in a public space. (Due to zoning setbacks, the building had to be built a hundred feet from the lake.) Pete comments on Salmela's design: "I lobbied early on—why is that room so juxtaposed, why don't we move that roof back—but now I appreciate how the elements in those exterior geometric shapes that you get by having it cantilevered off the top of the sauna add interest." The triangular wood truss, a strong elevated shape

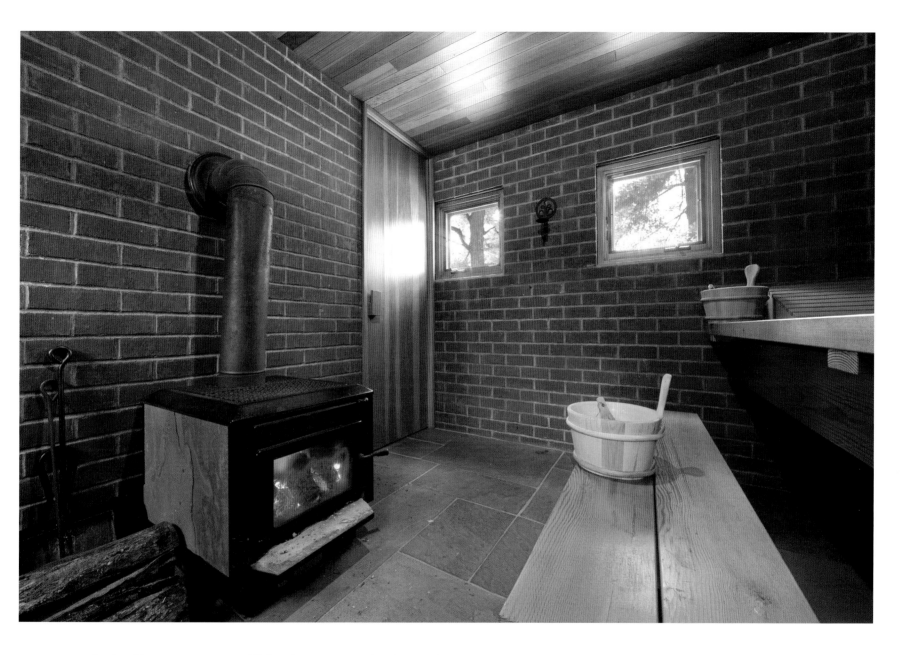

that is wide-open, serves an additional purpose as a sleeping porch in the summer. The Emersons have noticed that from certain distances on the lake, it appears similar to a tent on the grass.

That this seemingly playful, avant-garde disassembly of a beloved form actually has a rational payoff is Salmela's nod to architect Aldo Rossi, whom Salmela praises for his conceptions that translated pure forms into a classical order. Pete Emerson says that as a pure conception envisioned by an architect without a client

in mind, his sauna is perhaps "the most David" of Salmela's buildings. The architect himself is very pleased with the outcome of the Emerson Sauna, and he says that the material departure of mostly brick interior walls gives the bath more of an ovenlike quality: a starkly silent inner sanctum. A run of small windows provides a visual connection to the large pines on the property. Emerson has declined the traditional use of rocks cradled above the stove and douses the bricks of the proximate wall, deeply heated by the wood

⊡ The cooling porch of the Emerson Sauna
is a structural triangle, an elegant shape
enhanced by the warm wood interior finish.

fire, to produce löyly. Salmela defines the Emerson Sauna as ex-
perimental for its departure from the use of wood interior walls,
and claims that the brick interior produces an all-consuming heat
within which 150°F feels like 180°—a development that has caused
Salmela to wonder if he has upstaged the Finns. Emerson prefers
a sauna of 155° to 160°: three hours and two stove loads of birch or
maple. Salmela is confident that Aalto would never have designed
such a sauna, nor would Rossi or contemporary Finns. The build-
ing is a native of northern Minnesota, the only place where it could
occur, but describing the way the elevated porch catches the lake
breeze, he acknowledges that the theme might bear repetition.

The house that Salmela designed for himself and his wife,
Gladys, in Duluth is a rational and transparent structure an-
chored in the bedrock with a view of Lake Superior bellied to the
horizon. It features a sauna that in one fundamental way also
renders classical order by tweaking tradition. Similarly propor-
tioned and equipped as any contemporary basement sauna, the
sauna is on the building's utmost level, attendant to a guest bed-
room and bath, and the best seat provides a sweeping view of the
Zenith City's downtown spires, grain elevators, signature Aerial
Bridge, and the thousand-foot rust-red ore boats that carry ship-
loads of Minnesota earth to the steel cities on the lower lakes. He
has chosen not to ignore, even while taking his weekly sauna, the

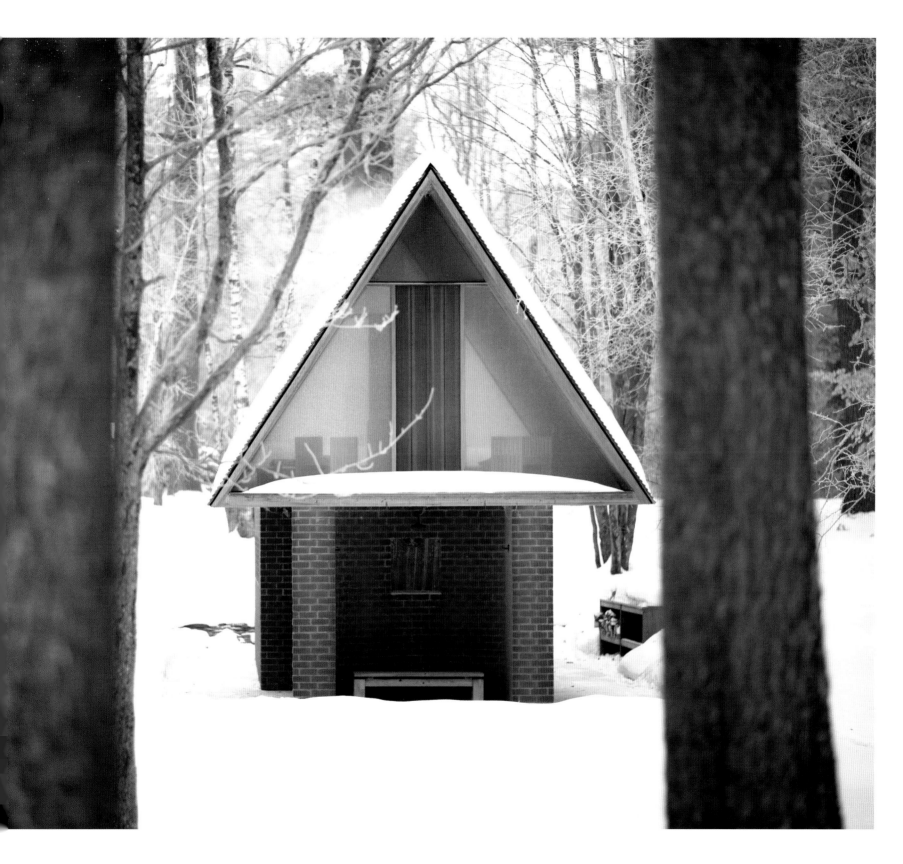

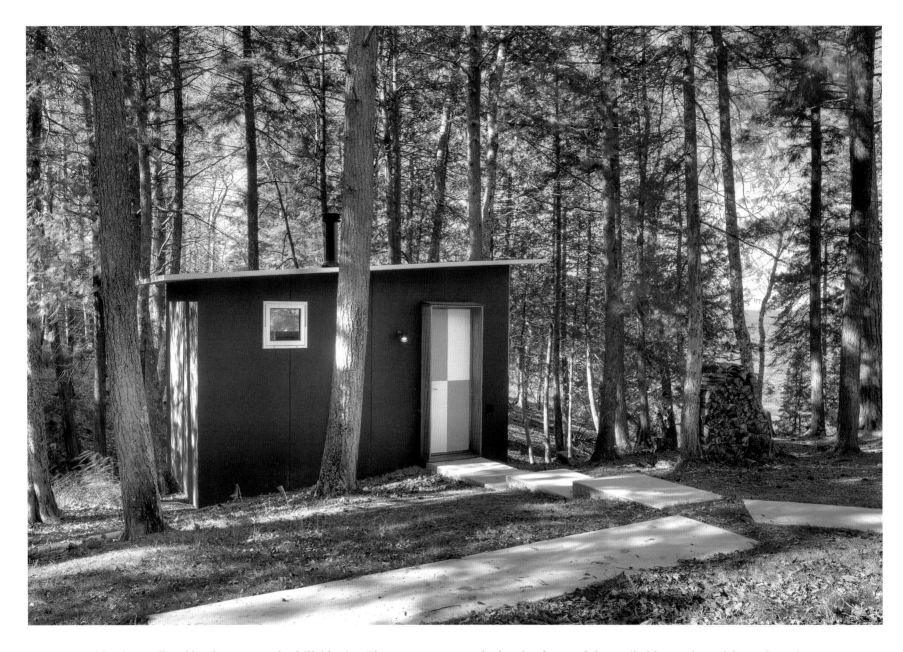

wide vistas offered by the spectacular hillside site. The property long ago sat in the shadow of the elevated Duluth Incline Railway, which was built in the 1890s to deliver passengers over four hundred vertical feet from Superior Street to a pavilion at Skyline Drive through and above a significantly Finnish American neighborhood.

The inspirations of his practice receive open tribute in his studio on the lowest floor: Salmela abstractly displays the notched ends of several dovetailed logs salvaged from the ruins of the homestead where his father grew up near Lake Vermilion in St. Louis County. Other projects hearken the courtyard sense of security, the hallmark of Finnish farmsteads. Like the Emerson project, the sauna at the Streeter residence near Lake Minnetonka, west of Minneapolis, also uses an interior stone surface: the back wall, upon which bathers may recline, is of black block construction and continues as a long, dark spine connecting the

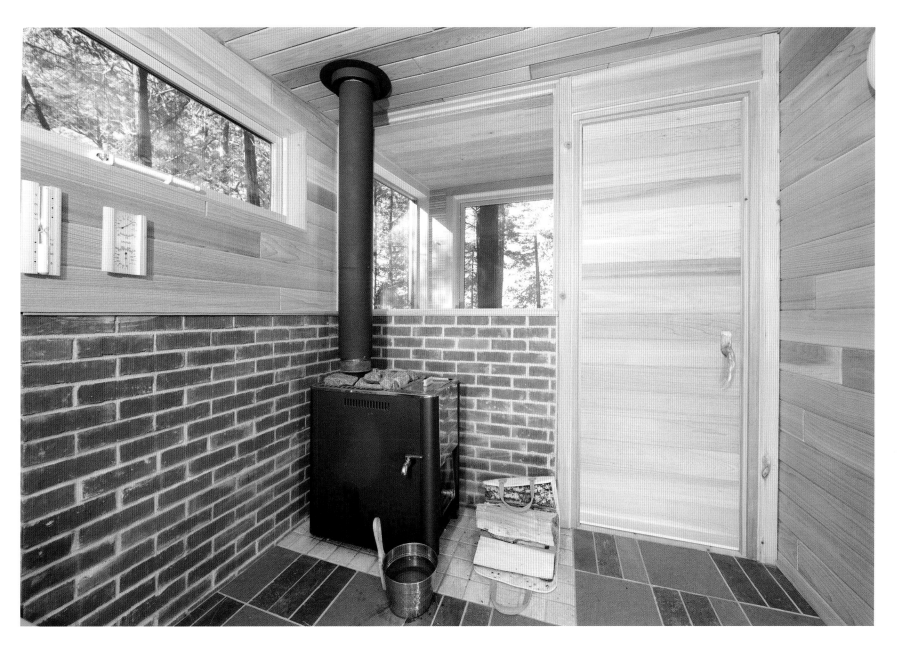

house to the sauna, evoking Aalto's Villa Mairea. He cites the Niemelä homestead in Helsinki's Seurasaari Park as the quintessential Finnish farm courtyard, and aspires to the synergy between sauna and house that is regularly evident in Finnish sites. "Most modern saunas I really don't like; I don't think they have the sensitivity and the respect that those original saunas had—the immigrants were serious about it. It can't be subservient to a swimming pool or a hot tub."

David Salmela designed the Roland Sauna as part of a complex of small buildings at a weekend retreat on Lake Superior's Madeline Island near Bayfield, Wisconsin. He marries the humblest elements of outbuilding design with an elegant modern aesthetic.

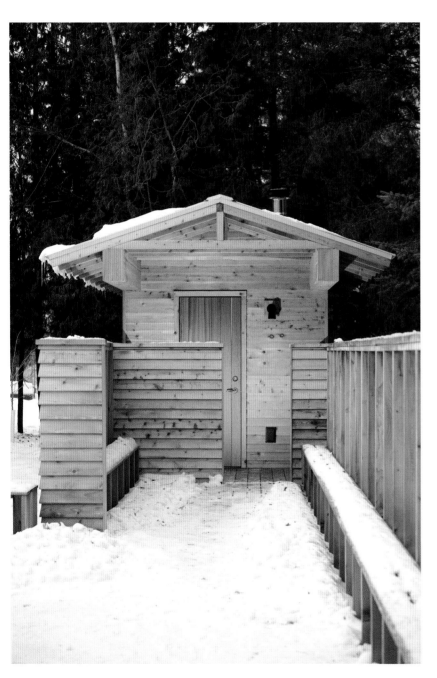

Sauna and the Twenty-First-Century Homestead

Erik Simula inhabits a country far from the backyards and amenities of North American hot tub culture, and he would probably never have reason to refer to sauna as a lifestyle product. Simula lives in a remote section of Minnesota's Cook County, the tip of Minnesota's Arrowhead, on the edge of a wilderness where keeping a dog team is not underappreciated by his neighbors few and far between. He is a musher and master birch-bark canoe builder who seasonally harvests wild rice and whitefish in regular haunts from Ely's Echo Trail to the Gunflint Trail above Grand Marais, and he knows well the roadless Boundary Waters in between from seasons as a canoe guide. In a small clearing in dense forest a decent walk or short ski from his driveway, depending on the season, spruce logs are stacked high and dry awaiting eventual assembly as his cabin. But meanwhile, he lives in a small structure that will someday be, and sometimes already is, his sauna.

One of the most persistent notions about Finnish settlement in the Lake Superior region comes from the many family recollections that the sauna was the first structure that their ancestors built on the homestead. The rare scholarship on this topic suggests

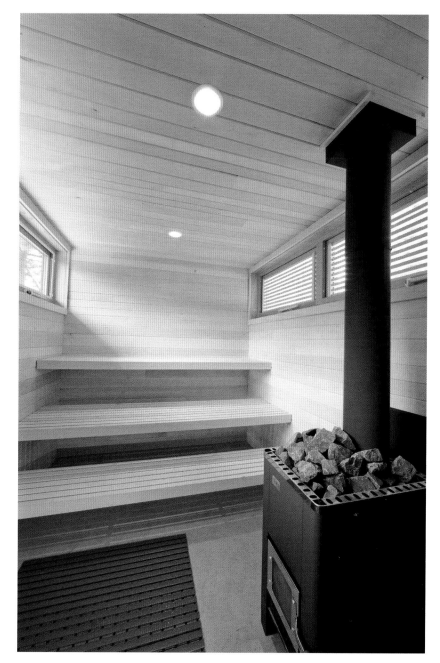

that this may not be true, as indicated by Arnold Alanen's research in northern Wisconsin's Oulu Township and Minnesota's Salo Township.[3] And even those who accept every last one of these anecdotes may find the sequence puzzling: only a cult of cleanliness would build a bathhouse before building a home. But the eventual bathhouse was of course also first and foremost a capable sturdy structure that could shelter a family through a first winter on the land while more land was cleared and larger structures such as a home or barn were erected in sequence depending on the family's immediate priorities. Easily heatable to a furious extreme, the prototypical Finnish sauna is also easily heatable, period.

Simula's cabin in Minnesota's Cook County is a clear contemporary example of the wisdom of planning to adapt a sauna from the first building on the property. Simula has explored the waters and trails of the Arrowhead backwoods for his entire adult life, and he has worked with many institutions dedicated to the history, culture, and recreational significance of the area: the Voyageur Outward Bound School, Grand Portage National Monument, and the North House Folk School in Grand Marais. He ran the John Beargrease Sled Dog Marathon for twelve consecutive years after spending a year in Alaska acquiring a team. He openly expresses his deep reverence for native Anishinabe, Lakota, and Cree cultures and the conveyances that first opened this country

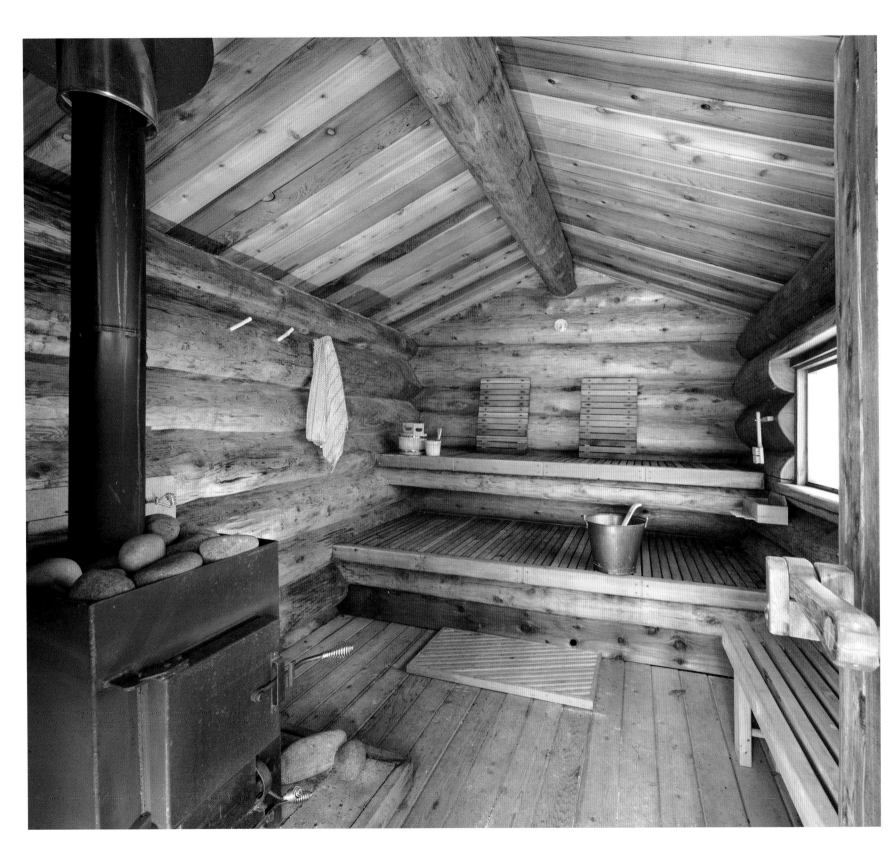

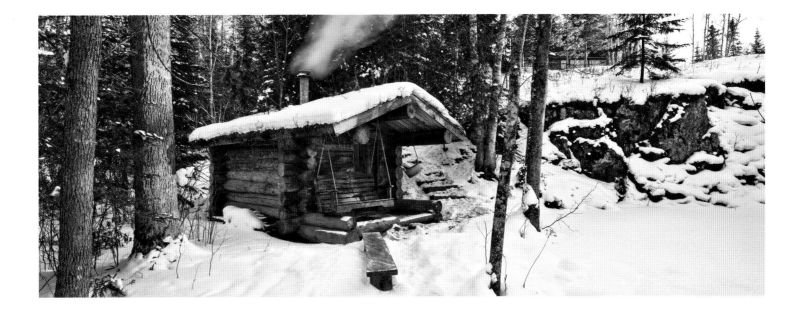

to Europeans. But he evinces an even greater love for the Finnish immigrant culture that he inherited from his father, Vern. His amenability to overlapping cultural passions fostered an opportunity to guide dogsled tours one winter near Lake Inari (Inarijärvi) in Arctic Finland, home to northern Europe's indigenous minority the Sami. With access to a wood-fired sauna every other night, he had plenty of chance to validate some of the local adjuncts: cold beer, cheese, and smoked salmon.

To visit Simula's home in the boreal woods on a morning in deep winter, one must first ski several hundred yards from the nearest road. The path would be an easy and pleasant walk in summer, but Simula enjoys the distance best when the deep snows of March have compacted into a durable skid road so he can most easily move lumber and other supplies in by dogsled. When he is not guiding winter tours near the Gunflint Trail or otherwise about in the forest, he lives in the first structure built on the site, a ten-by-twelve-foot cabin with a flat roof that also shelters an ample porch. The tar paper siding and metal roof testify to his unwavering economic good sense, and the cabin quickly heats up on his return despite the –10°F outside temperature.

One common cargo pulled by his dogs is recent deadfall white spruce, which he harvests from his twenty acres as storms and opportunity afford. "Hunting, fishing, trapping, wild ricing, tapping

A glimpse of Jim and Judy Brandenburg's log sauna, poised next to a pool at the base of a small waterfall, evokes the discovery of a wilderness cabin. They are an exception among David Salmela's clients in that he designed their home and studio but not this preexisting sauna on their property bordering the Boundary Waters wilderness near Ely, Minnesota.

This first cabin that Erik Simula built on his rural Hovland, Minnesota, property will eventually serve exclusively as his sauna. He now converts it to sauna use several times each winter. Photograph by Michael Nordskog.

the sugar bush; you don't make a lot of money, but your life is so rich and full living out this way—physically active every day and working with your hands—you eat better, you sleep better, you feel better, lots of fresh air." In his small clearing, he has peeled and stacked a large proportion of the logs he will need for a twenty-by-twenty-foot log cabin over a stone foundation. But that project is subject to a long seasonal schedule, and Simula has meanwhile given priority to a tidy workshop dedicated to the canoes, snowshoes, and dogsleds he builds every year from other products of the north woods: birch bark; willow, ash, and maple saplings; spruce roots. Meanwhile, he is content living in the small cabin, which already occasionally serves its future dedicated use as a sauna.

Simula more frequently takes a sauna at the lodge where he serves as a guide in winter, and he also praises the public sauna at the Grand Marais municipal pool, particularly on Friday nights when plenty of local off-the-grid regulars are drawn to two timeless attractions of town: a dose of community and running water. But half a dozen times each winter, he divides the interior of his cabin with a tarp curtain, clears off the kitchen counter, which was positioned from the beginning as a future bather's bench, and repurposes his home for a long afternoon. "I fire up the wood stove, it's a little potbelly, put a steel dish of Lake Superior rocks on it, and when it gets good and hot, I throw some water," Simula says. "I've always got plenty of snow outside to roll in," refreshed abundantly in most winters due to the property's elevation one thousand feet above the great blue expanse of Lake Superior, less than ten miles to the southeast.

As a Finnish American with roots west of Cloquet, Minnesota, Simula recalls a childhood of saunas with his older male cousins, often a raucous competitive exercise that led to buck-naked sprints down his grandparents' driveway. "Sauna was initially something I did because it was something I grew up with, but learning more about the sweat lodge, with fasting and mental preparation, I began to realize the spiritual benefits. I think I've taken that aspect of ceremony and carried it over into my sauna experience." Not that he is not still capable of some real exuberance in his sauna practice: he shares that he once attended the annual Heikinpäivä festival in Hancock, Michigan, and joined two hundred other Polar Bear Plungers. According to his father, who watched but did not participate, Simula was by far the most entertaining plunger, and the only one to swim across to the other side of the broad hole in the ice of Portage Lake, and that after a fairly tepid session in the overburdened sauna nearby. He prefers his saunas very hot—verging on 220°F—an environment he cannot yet create at home.

He never paused to build a sweat lodge and mostly could only long for sauna during a recent major summer adventure: a 1,000-

mile paddle with his dog Kitigan in a birch-bark canoe around Minnesota's Arrowhead region that started with 150 miles of travel down the open coastline of the state's Lake Superior shore. Simula was no doubt thoroughly chilled by the time he reached Duluth: his canoe was swamped by steep swells as he entered the confines of the shipping canal beneath the Aerial Bridge. He reluctantly acquiesced to a "rescue" from firefighters, who had received reports of an unlikely distressed arrival from the past.

No doubt a warm bath would have been welcome during a cold May night on the swampy Savanna portage between the St. Louis and Mississippi watersheds: after meticulously removing an army of ticks, he was forced to decamp just before midnight after consecutive intimidating visits by the first wild mountain lion and the biggest black bear he had ever seen. His canoe already needing repairs, he negotiated beaver dams and navigated the shallows by the stars and faint current until 3:30 a.m. "With no high ground available, I slept on a tall hummock of swamp grass under my canoe, in my hip boots, wet socks, and rain coat," but he was soon awoke by a spirited chorus of migrating trumpeter swans. Such hardships bring to mind the epic hero of the *Kalevala,* Lemminkäinen, who is tasked with killing the sacred swan that circles Tuonela, the island realm of the dead. Simula quickly named the location "shiver camp."

But his core temperature was restored in the Rainy River basin on America's midsummer holiday, as his journal best describes: "Paddled 6 miles in headwind to arrive at 7 p.m. at Sommers Canoe Base on Moose Lake (also known as the Northern Tier National High Adventure Base of the Boy Scouts of America) where I began guiding wilderness canoe trips in 1982. Received a very warm welcome . . . Because of the July 4th Holiday, the Base was relatively quiet. However, the sauna was stoked extremely hot, right to my liking. I leisured the dirt and pains away." Four weeks later, he was home again, after hiking cross-country from the Pigeon River, in a modest temporary house built to provide a wide range of warmth.

A Timber-Frame Sauna Project

Unlike Ely, Minnesota's other gateway to the watery northern wilderness, Grand Marais was never one of the Lake Superior region's Finnish enclaves. But the town's North House Folk School, for which Erik Simula leads birch-bark canoe building courses each year, eagerly embraces the value of a variety of traditional folkways, and the enduring significance of the sauna as outbuilding is shown by its availability as a project in the timber-framing course taught by instructor Peter Henrikson.

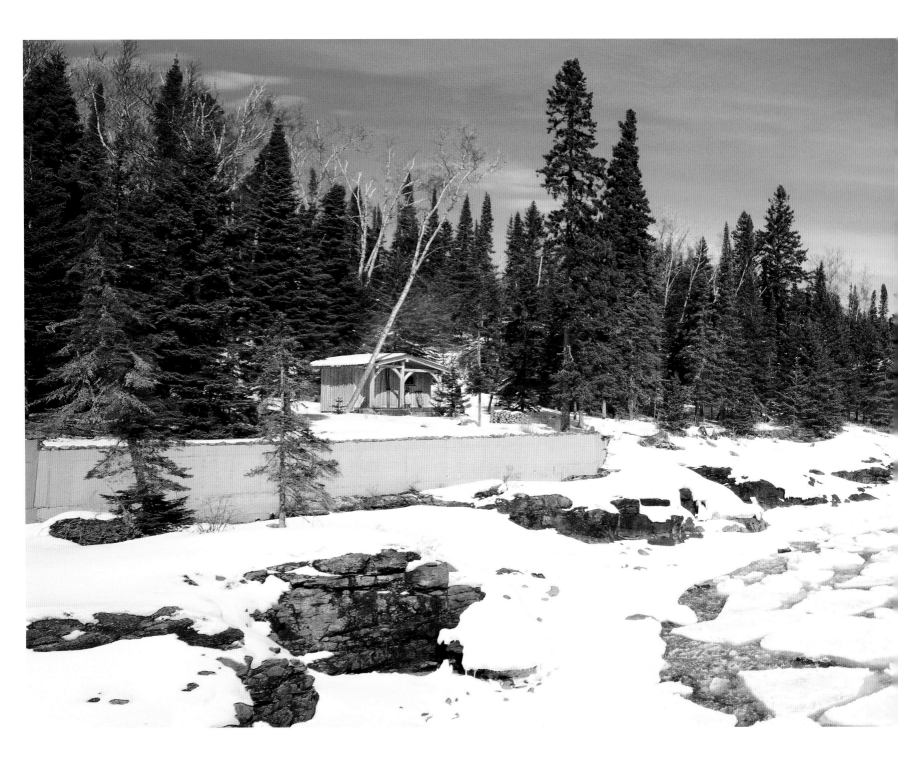

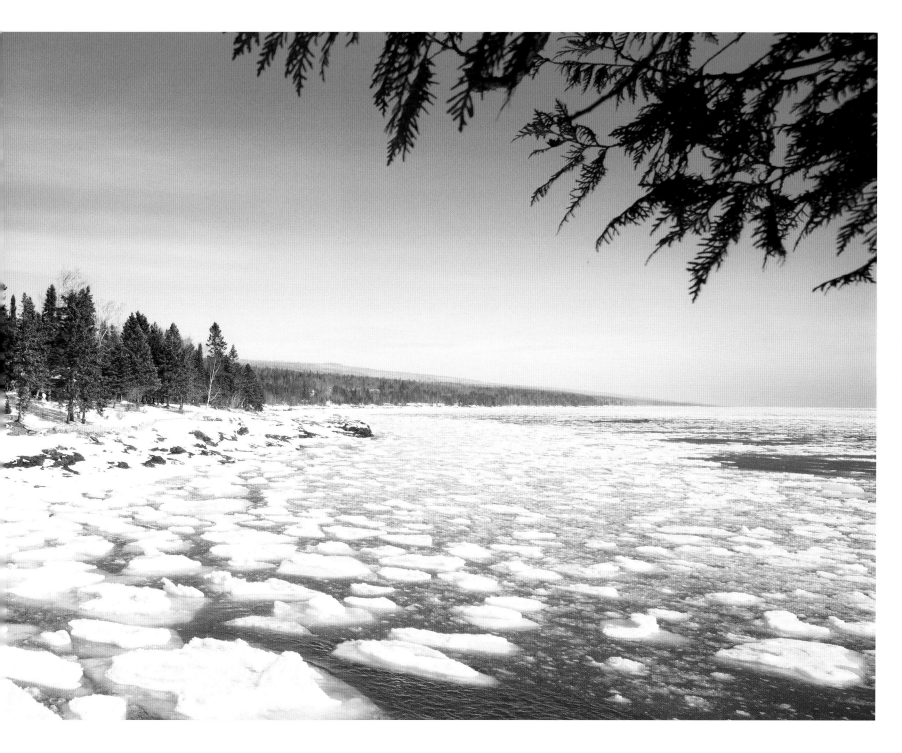

A timber-frame sauna built at the North House Folk School in Grand Marais, Minnesota, commands a rocky Lake Superior shore.

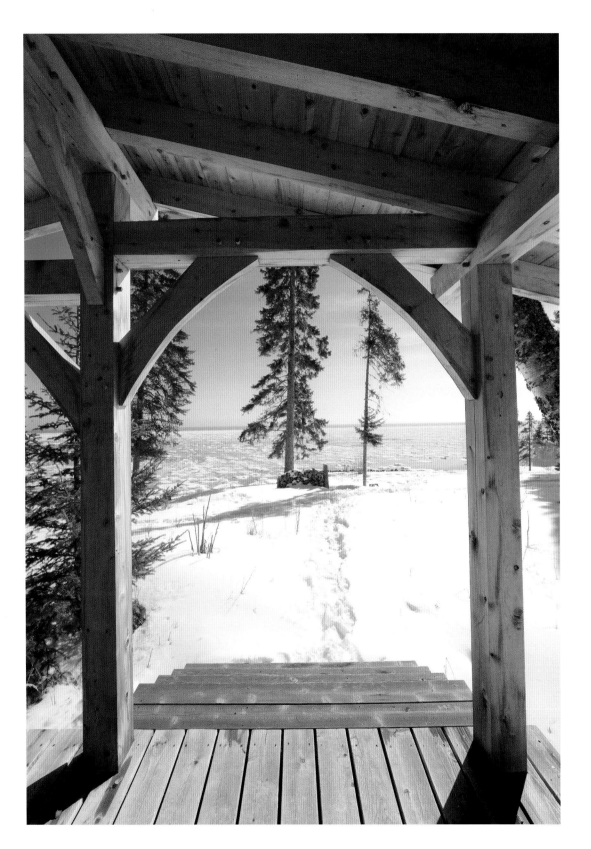

The approach to and the view from the sauna are equally inviting.

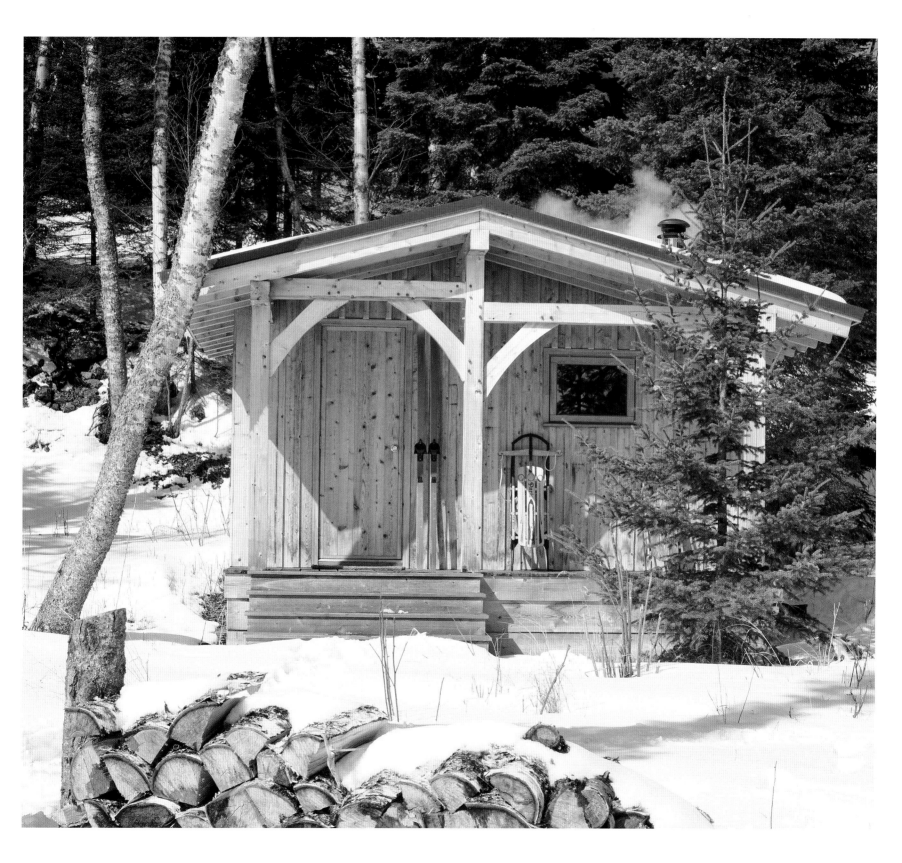

Henrikson and his wife, Amy, chose to settle in the Grand Marais area after he had elsewhere gained experience with log building, timber bridge construction, and traditional logging techniques. As a professional timber framer and designer, he has taught hands-on classes at North House since 1998 in which participants finish with the bones of a timber-frame structure ready for transport home. Among the designs is a thirteen-by-thirteen-foot two-room sauna that replicates the one he built for his family at their home several miles outside of town.

Neither of the Henriksons have Finnish heritage (Peter is half Swedish), but they were dedicated to living close to the land when they chose a homesite, and had plenty of familiarity with the sweat bath. To underscore their affinity for the skills and accommodations of immigrant culture, the site they purchased had two dovetailed log structures: a smaller cabin, which they lived in initially, and a humbly spectacular twenty-four-by-twenty-six-foot two-story dovetailed pine Finnish homestead that had been relocated to the site four owners previous in 1979 and never completed. Peter is uncertain of its origin, but he has heard that it was originally located west of Two Harbors and north of Duluth, and served as a roadhouse on a stage line—very possibly the Vermilion Trail, which runs through the Finnish rural communities of Markham and Palo.

Their own newly constructed timber-frame sauna was ready for use by the time the first of two daughters was born. They even considered using the sauna for the event but for their inability to get a midwife to commit to a home birth at their location. Biweekly family saunas were their sole form of bathing before they eventually added running water to the rehabilitated Finnish log house, and weekly Sunday-night saunas are still the norm, particularly in winter. The adults tend to enjoy the heat of the upper bench—Peter sometimes goes out early to take advantage of a 190°F start—and the girls play with ice and snow on the lower benches and floor, literally toying with winter in the secure warmth. Peter proudly shares that his older daughter has begun to join him in plunges off the sauna porch into the three-plus feet of snow that often fills their meadow by late winter.

The Henriksons were committed to a wood-fired stove for obvious reasons, as well as the abundance of beetle-killed spruce they found on their property. Amy suggested the convenience of an outside feed, a space saver that also keeps the sauna room free of bark, bits, and ash. After Peter began promoting a sauna structure as one of the options in his course, he found that participants were eager to replicate his design, and a frame for that sauna is likely to be one of the seven or eight timber frames that are completed in his courses each year. The design devotes eighty square feet,

or nearly two-thirds of the interior floor plan, to the sauna room, which leaves plenty of practical space for a changing room opening to a broad front porch that would complement any lakefront.

Sauna Harbor

Lakefront settings favor any sauna for the easy accessibility of abundant fresh water to produce steam and hot water, as well as for swimming. But in this region, swimming opportunities that involve a warm lake on a very hot day are uncommon, and during some summers the water never gets quite warm enough unless the sun is blazing. On northern shores in North America, many saunas serve as warming houses as much as bathing chambers. Lake Superior is the deep and wide sea that these lakes feed, and its massive volume, greater than the other Great Lakes combined, ensures universally cold water beyond the shallowest, stillest bays in August—40°F is the lakewide average, a short measure milder than ice.

The north shore from the Minnesota-Ontario border to Pukaskwa National Park features many islands and coves that would be a bather's paradise if not for waters that can skim over with ice up to the brink of June. But these waters have become the playground of recreational boaters from the lakehead port of Thunder Bay and of voyaging sailors from afar. The former Port Arthur and Fort William were the destinations for a sizable number of Finns in the early 1900s, but the largest influx occurred during the 1920s, followed by another in the 1950s. Generations later, local weekend fleets have colonized several coves and narrows along the Ontario shore by building ad hoc saunas on public land in the tradition of unlocked wilderness buildings everywhere. The best-known enduring example is on the outer shore of Thompson Island, equidistant between the Thunder Bay marina and Isle Royale National Park.

This small cove became a regular destination for Thunder Bay boaters because of the most fundamental distinction in recreational boating: motorized cruising versus sailing. Motorboaters had already erected a rustic sauna at Flatland Island deeper within the wide bay. But sailor Al Wray's deep keel prevented access to its shallow dock. He and his wife, Georgina, explored more distant deepwater harbors and saw great potential in a beautifully sheltered cove on the northeastern end of the snaky and steep eight-mile spine of bedrock and spruce duff that fronts thirteen miles of open lake to Isle Royale. On a late May weekend in 1979 they spent an enlightening weekend with friends in the three inaugural vessels of the Thompson Island Yacht Club: *Skylark, Alfie, and Sundowner.* Within a few years of industrious weekend days and cocktail evenings, they had built a formidable cantilevered

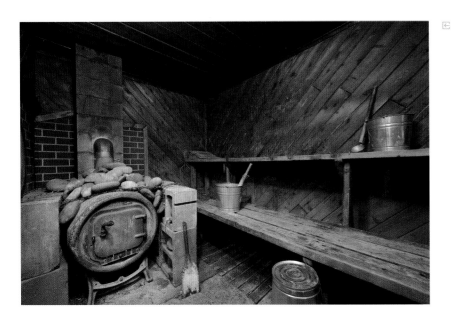

The sauna at Cobblestone Cabins near Tofte, Minnesota, has warmed the aching bones of many visiting North Shore skiers and hikers, who can fulfill their sauna experience with a dip in Lake Superior.

dock that depends on a metal substructure bolted into bedrock and allows the dock to survive the yearly pummeling by surging ice. Wray was a former lighthouse keeper, and he became the unofficial harbormaster of Thompson Island. After his passing in 1985, the other members planted a memorial eighty feet above the cove at the closest overlook.

One of those original three crews, Dave and Brenda Moulson can still be found anchoring overnight at the isolated cove on weekends thirty years later. Their names regularly pop up in the journals kept in the anteroom to the island's wood-fired sauna. The original sauna was capably, if somewhat casually, assembled from spruce logs that had washed up and sun dried on a cobble beach just 250 yards away, mostly uniform eight-foot units that had escaped during storms from rafts of pulpwood destined for Ashland, Wisconsin. By driving large nails into the logs they selected, Thompson Island's weekenders were able to raft the logs by outboard around the point to the cove. Any logs that did not become the walls of the sheltering sauna provided a ready fuel source for its thin and leaky stove for the next decade.

By 1995, the first sauna had been replaced by a sturdier wood-frame building of lumber hauled from the city, and casual weekenders had evolved into the Friends of Thompson Island, which encouraged boaters to bring their own firewood. True to

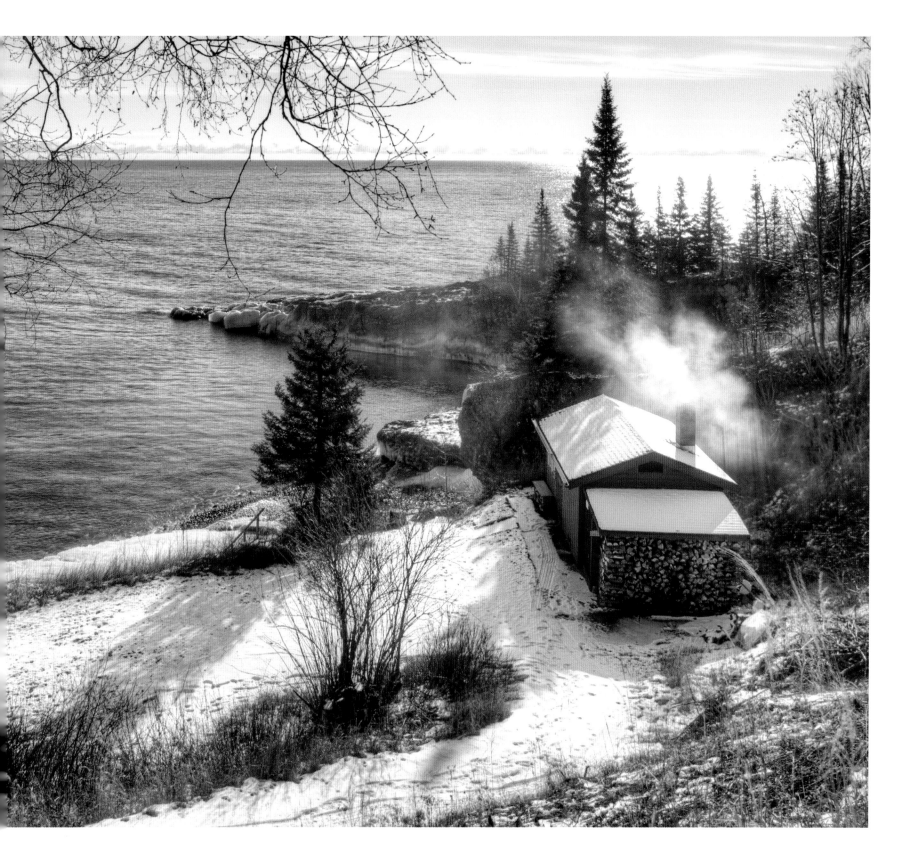

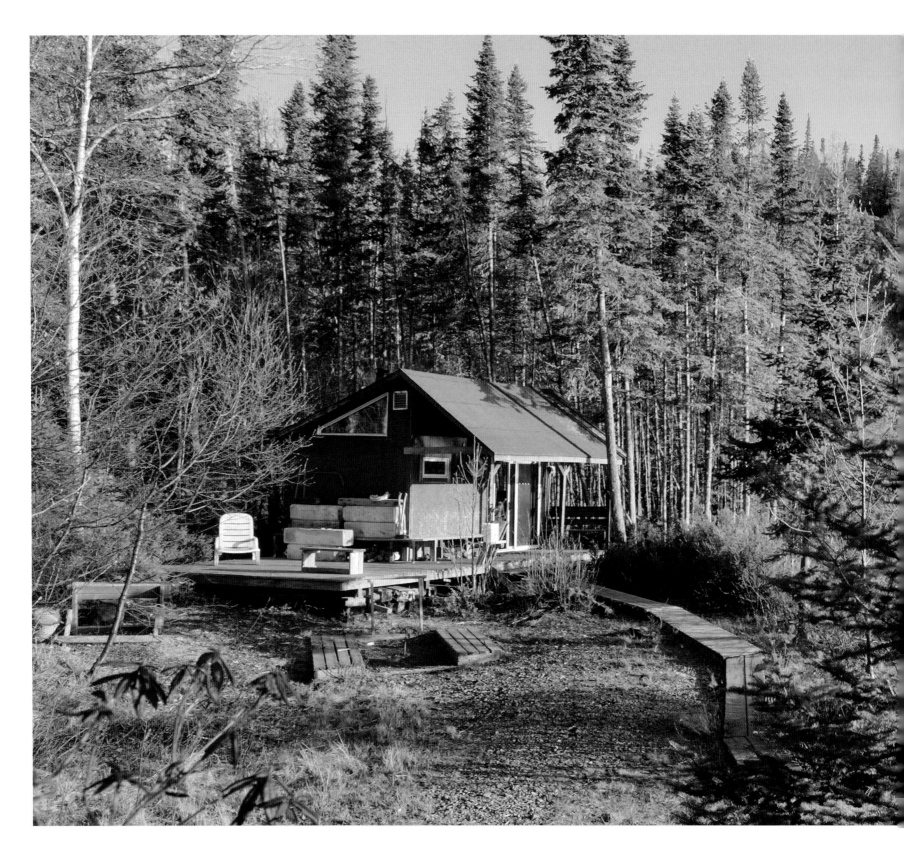

The sauna at Thompson Island presides over a remote Lake Superior cove near the entrance to Thunder Bay. It is situated on crown lands, maintained by local boaters, and available to voyageurs whether they arrive by sail, paddle, or propeller.

form, the old sauna sat nearby only long enough for it to be serially cut up and fed as fuel into the new sauna's tight woodstove, an enhancement contributed by a regular visitor from Minnesota. The new sauna is the only permanent structure at the site, an outbuilding in the broadest sense. It features a cooling porch just a few steps from the beach and seasonal dock, and its tidy changing room has a tile floor.

The current designation of the site by Ontario Parks is the Thompson Island Provincial Nature Reserve, and current land management suggests that existing developments such as this safe and potentially warm harbor will be allowed to endure, though no further development is sanctioned. But the telltale hand of human use of the island is not a recent phenomenon: among its prominent billion-year-old gabbro dikes and sills and rare southerly patches of arctic-alpine vegetation, evidence of aboriginal use of this coast dates back at least five thousand years. One prominent multitiered beachhead on the island features several Pukaskwa Pits, spacious hollows created by the removal of large cobbles found only on beaches along the Canadian shore. While no consensus about their purpose has been reached by researchers, the observer cannot fail to see that if covered with canoes, skins, or spruce bows, they could provide a cozy and dependable refuge for travelers from a raging Lake Superior storm.

The interior of the Thompson Island sauna welcomes the wet and weary after a Lake Superior crossing.

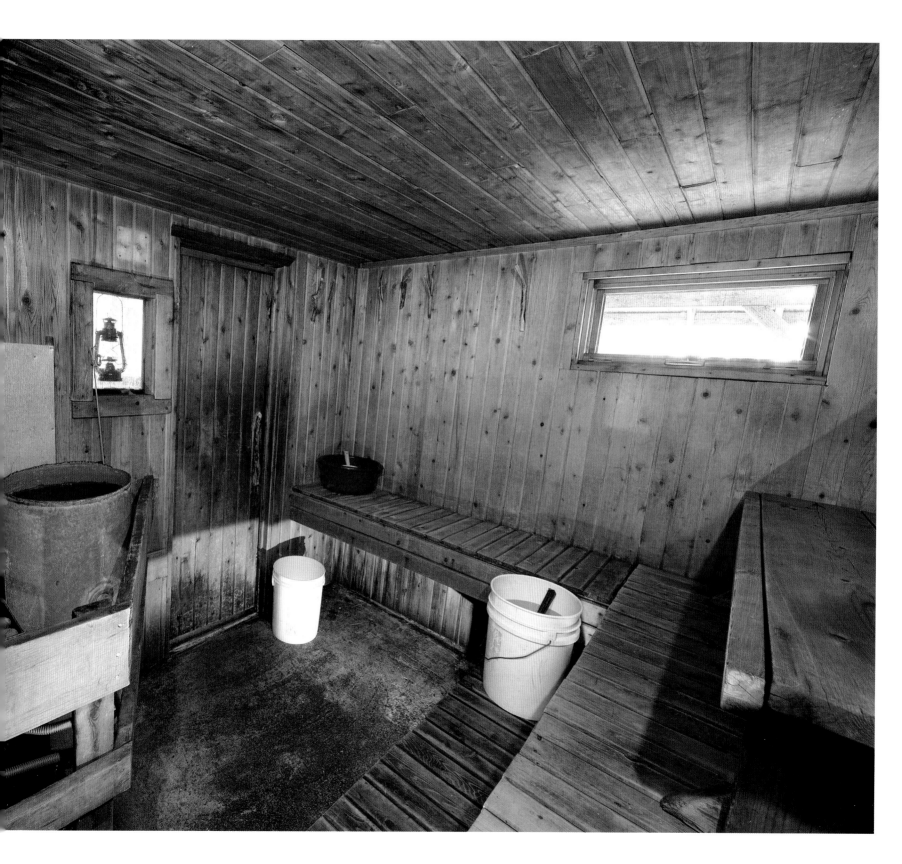

Camps, Cabins, and Cottages

Lake Superior is a vast enough expanse that cultural subdivisions among even Finnish Americans appear, at least with respect to one particular English language usage among the descendant generations. A Minnesota family with a weekend property likely refers to it as "the cabin," inclusive of all structures. In Ontario, the nominal usage is "the cottage." But in Michigan's Upper Peninsula and extending into northern Wisconsin, the aspirational woodland parcel is known as "camp." Perhaps nowhere amid its second-growth of maple, balsam fir, and hemlock did Finnish families more densely lay down lakeside camps than on the shores of the Shag Lakes near the mining town of Gwinn in Marquette County.

Jon Saari grew up in a Milwaukee suburb, the son of a German American mother from Wausau, Wisconsin, and a Finnish American father from the Ironwood-Hurley area on the Michigan-Wisconsin border. But his road to sauna culture was less the product of weekend caravans up Highway 41 or 45 than a detour through Yale and Harvard, where he studied history and followed an interest in non-Western, particularly Chinese, civilizations. But after he landed a professorship at Northern Michigan University in 1971, his scholarly interests also turned to the local history of his many and distant Finnish kin. He was deeply influenced by a 1974 academic forum on Finnish immigration in Duluth, and he eventually crossed paths with cousins in nearby Eben Junction, a location that had received ongoing academic scrutiny from Matti Kaups at the University of Minnesota–Duluth. Saari closely examined the camp culture of Little Shag Lake and noted a popular local practice, evident on other Upper Peninsula lakes, of locating the sauna above the equally practical boathouse. And he thought most deeply about what it means to develop a site that is neither home nor unfamiliar.

"At camp, nature still depends on human sufferance, but the control is light and delight is taken in lakes and woods on their own terms," Saari wrote in a 1997 essay. "Camp stakes out a middle ground; it embodies an attitude towards nature different from awe or conquest." Among the region's Finnish immigrants, a lakeside parcel or river frontage was nearly essential to facilitate sauna, "an almost perfect marker of their presence."[4]

When Saari and his wife, Christine, decided to invest themselves into Upper Peninsula camp culture, they purchased acreage straddling the Whitefish River, only thirty miles from Marquette but spilling ledge by ledge toward Lake Michigan. They purchased an old "hippie homestead," a richly nonjudgmental description when expressed in Saari's resonant storyteller's baritone. They razed a couple of outmoded and decaying buildings and started

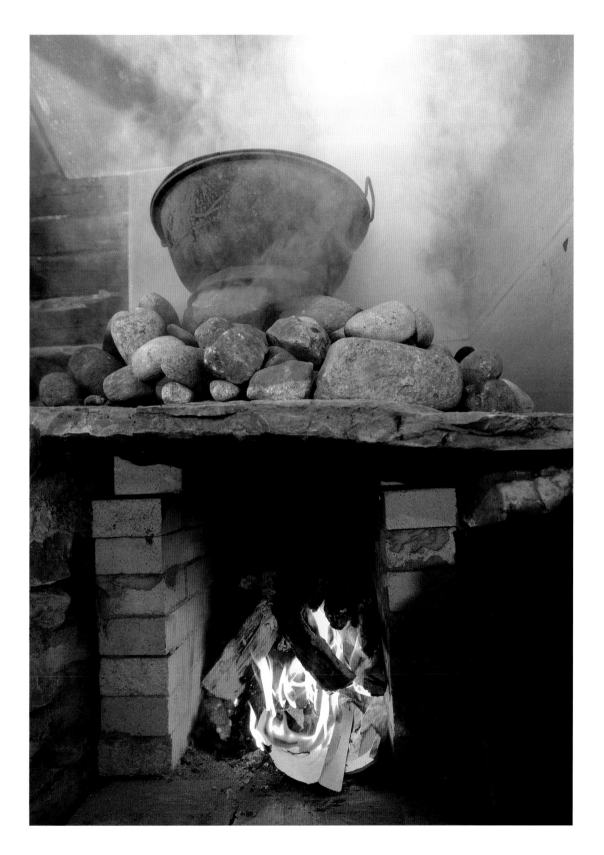

Jon Saari relocated an immigrant savusauna to his Upper Peninsula camp between Marquette and Trenary, Michigan, and restored it to its original purpose. Visiting Finnish relatives helped him build the kiuas in 2001, when traditional smoke sauna practice had almost completely disappeared in North America.

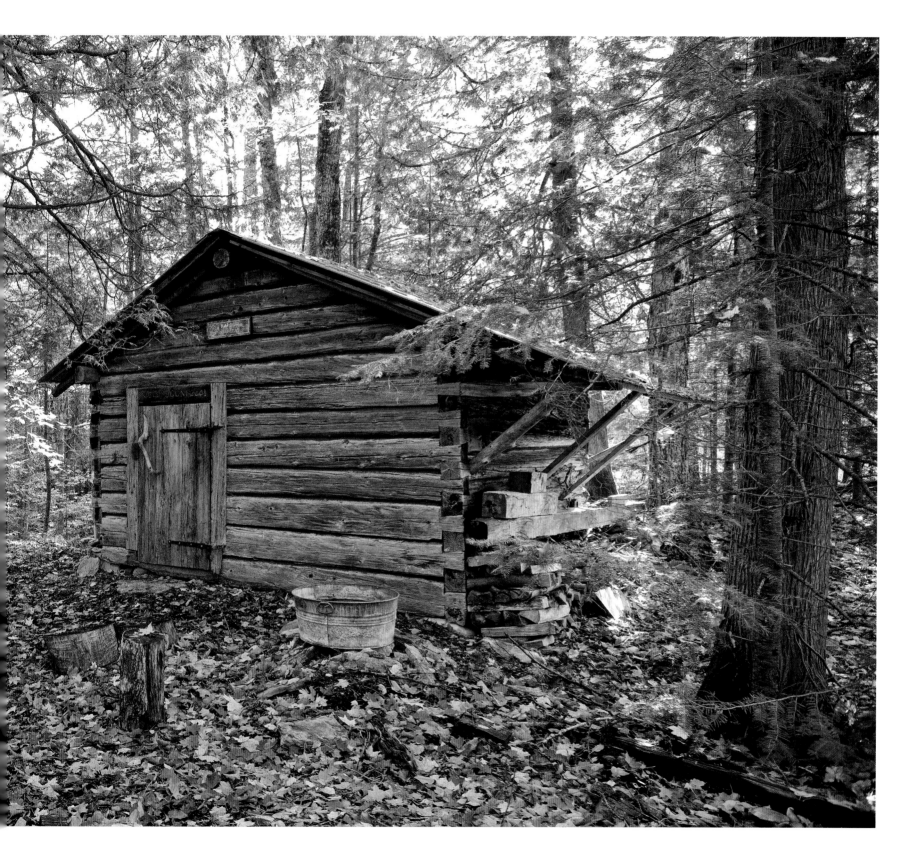

↩ Jon Saari: "When you fire up this sauna, you are committing yourself to something special, a day well spent."

⮉

from scratch with relocated immigrant homestead log structures: a Swedish farmhouse and three Finnish outbuildings, including a relative's outhouse (sans basement) and a log savusauna from a farmstead east of Trenary.

The main house is a two-story compound dovetail structure, relocated from a Swedish farmstead west of Trenary in 1992. The expert log construction runs right up to the peak of the gable ends. The Saaris have reclaimed this building with contemporary usage sensible to its past, and the rooms welcome the visitor to entertain long afternoons looking up from a book to the close forest of cedar, aspen, and hemlock. They intentionally have kept their camp free of electricity and running water, hauling the latter from a spring on their acreage across the river.

But the rarest element is the relocated homestead smoke sauna, which Saari has restored to its original purpose. He paid a small sum in 2000 for the log structure itself, which had sat in a field for so many forgotten seasons that its once sharp dovetailed corners were bull-nosed smooth by generations of cattle rubbing against them for relief from itches. The hearth within had long ago been removed to make room for storage. He invested a tenfold sum to have it relocated with powerful expert assistance, deciding that it could not be disassembled. Because the building had settled into tired old age, it was moved in one piece, hoisted onto a truck with

a Pettibone lift, which then snaked it into the forest at the new site and placed it on concrete piers interfit with resident limestone retrieved from the exposed roots of nearby windthrown trees.

To create the stone hearth—the kiuas—he enlisted the help of two relatives, the Sippilä brothers Veli and Jouni, who visited from Lapua, a village in the Ostrobothnian cradle of Finnish emigration to North America. They worked for four days to assemble the kiuas for their distant cousin. The sides of the kiuas are the same slab limestone that rings the foundation, an abundant resource in Limestone Township. An I-beam and rails support the heavy limestone, and the firebox is lined with brick, all of which holds aloft a large pile of stones collected from a Lake Superior beach on Au Train Bay. Sheets of cement board front air space on the nearby walls and ceiling to protect this invaluable building from the fate of so many of its contemporaries: one fire too far. A piece of bent scrap metal that sits unhinged before the firebox serves as a surprisingly effective stove door, and also bears testament to the Finnish frugality that Saari has naturally embraced.

On a frosty October Saturday midmorning, Saari loaded the firebox, and the flaming tinder quickly filled the room with thickening smoke. True to his prediction, the smoke soon "poured out the door here, like waves of water." He only fires the sauna a couple of times a year—the Saaris also have a sauna in their Marquette home—and platoons of summer spiders rappel from the eaves as the smoke infiltrates every crack and seam in the board ceiling. He has noticed evidence of woodworms in the cedar logs, but figures that the smoke will remedy that problem in time. As the kindling settled into a broad bed of coals, he added the first load of split hard maple logs that are over two feet long, cut to extend to the full depth of the firebox. He must add three to four split logs every half hour for about nine hours to achieve 200°F on the upper bench, the height of which was determined by placing it three feet above the stone hearth across the room.

After the first load was in place, Saari closed the sauna door and let the heat begin to build inside, sharing that "once you have a good bed of coals there's much less smoke, but I still have to get down on my hands and knees to feed the wood." Although he has tracked down many interior gaps and sealed them with oakum and sphagnum moss to help the building hold sufficient heat, he is convinced that the building draws best with a little smoke escaping from the higher courses of logs on all sides, in addition to a dedicated vent on the back wall that is accessible to the top bench. After hours elapse and sufficient heat builds within, he removes any lingering coals with a long-handled shovel, douses the firebox, then throws water on the rocks to draw out the

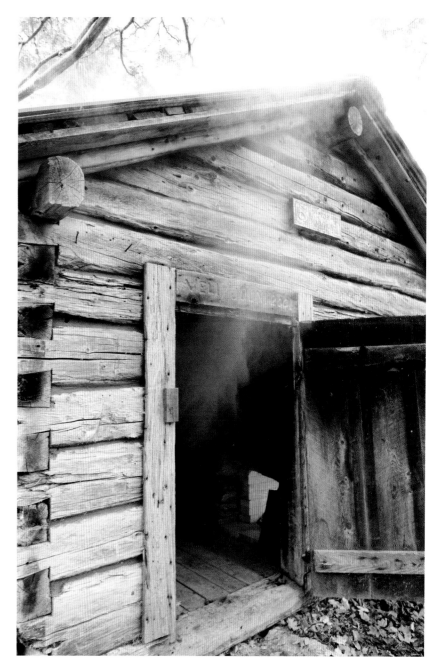

Once the fire is lit, smoke pours from the door and vents. After the fire has burned for hours and the smoke cleared, the building will be well heated, and the rocks ready to emit intense waves of fragrant löyly.

tikku—the last of the eye-stinging gases—and sets the stage for the room's humid second act. This is one of the important details he learned from the Upper Peninsula's second-generation survivors who experienced regular savusaunas as kids, but for many other practical aspects he could rely only on discretion and common sense.

The typical use of the sauna so far has been father-and-son outings involving two to three hours of sauna and dips by the fleetest and bravest into the cold river below. The benches easily host eight participants at a time, and Saari has occasionally auctioned off this most authentic of regional experiences to benefit local environmental causes. "When you fire up this sauna, you are committing yourself to something special, a day well spent." The autumn forest could not disagree, as thawing dampness rose from the ground and the sun approached a lowering noon. A woodpecker rapped on a giant popple, foretelling the tree's destiny as windfall firewood when its beak suddenly struck a dead thud. Saari pulled a log from the woodpile and demonstrated that splitting his custom-long stove lengths was not too difficult. "The secret of camp is to simplify your life, to go back to an earlier technological time and the pace of hand tools, brooms, shovels, saws, and axes." Degree by degree, a simple and ample reward amasses in the structure nearby. ▪

Acknowledgments

FROM MICHAEL NORDSKOG

For inspiration in researching and writing this book, I must single out the late University of Minnesota–Duluth geographer Matti Kaups, who was born in Estonia, grew up in Sweden, and matriculated as a scholar in the midst of the Scandinavian immigrant communities of the upper Midwest. He researched their cultural imprint on the landscape and taught for decades in Duluth, a strong candidate for the capital of Finnish America. When Dr. Kaups died in 1998, he was working on a comprehensive scholarly project about the European origins of sauna and the foothold it gained and has held as a cultural practice in the New World. My easy access to his papers at the Immigration History Research Center at the University of Minnesota brought a great deal of ballast to the text of this book.

Todd Orjala at the University of Minnesota Press immediately recognized the viability of our book proposal, and his insights made it a much better volume, including important additions of historical images. Brian Donahue's elegant book design brought immediate order to these ideas and images and enhanced their beauty. Particular gratitude goes to Arnold Alanen, who offered cogent advice at every stage. I also express my debt to the geography faculty at the University of Minnesota, particularly John Borchert, John Rice, and Joseph Schwartzberg, who taught me how to think expansively and pay attention to details.

This book required the participation of many people, who shared insights, provided hospitality, or allowed Aaron and me to prowl the grounds of historical sites and private residences to capture the many images that illustrate sauna construction and practices. Among those we thank are Ruth and Bill Rabold, Kaius and Johanna Niemi, James and Debbie Kurtti, Harvey Barberg, Amy and Adam Tervola-Hultberg, Kalevi Russka, Sune Överhagen, and Robert Davis. The Finnish Tourist Board was extremely helpful with our midsummer trip; particular thanks to Ari Ålander of Jyväskylä for a productive visit to the heart of Finland's lake country.

Most of all, I thank my patient wife, Eugenia Nordskog (the only person I have seen fire a sauna with flint and steel), along with Cole, Jasper, and Kaia. This book required extended travels, few of which could accommodate an entourage, and I appreciate that the cows were always milked and the sauna heated up by the time I got home.

FROM AARON HAUTALA

My sauna story started from day one. Every Wednesday and Saturday it was Hautala family tradition to take sauna on the homestead outside of Gilbert, Minnesota. We grew up unaware that other folks did not take sauna. Now, thirty-four years later, I look back and need to thank a few people for instilling this rich tradition into my life. Gust Hautala, my grandfather, I thank you for bringing up our family in the rich heritage of the sauna. Walter and Linda Hautala, my parents, I thank you for being champions of Finnish heritage and the ongoing ritual of baptism by steam. Finally, I thank my wife, Beth Holznagel-Hautala, for putting up with my Finnish pride and encouraging my photographic journey to capture for others what I have always seen.

Notes

INTRODUCTION

1. Matti Fred, *Sven Tuuva* [Hancock, Mich.], 27 September 1878; Eugene Van Cleef, "The Finn in America," *Geographical Review* 6 (July 1918): 210.

2. Terry G. Jordan, "New Sweden's Role on the American Frontier: A Study in Cultural Preadaptation," *Geografiska Annaler* 71B (1989): 71–83.

3. Josefiina Tuomela Kästämä, "Sauna asuntona—ensin suoja lehmille," in *Minnesotan suomalaisten juhla-albumi: Minnesotan satavuotias,* 1849–1949, ed. E. A. Pulli (Duluth, Minn.: Minnesotan Amerikalais-Suomalainen Historiallinen Seura, 1949): 42–45.

4. Arnold R. Alanen, "Little Houses on the Prairie: Continuity and Change in the Finnish Vernacular Architecture and Landscapes of Canada," *Journal of Finnish Studies* 9 (December 2005): 128–30.

5. Wilho Reima, "Suomalaiset maanviljelijöinä Minnesotan metsissä," *Kansanvalitusseuran Kalenteri* (1910): 214.

6. Sarah Sherwood, "Among the Finns," *Northwest Magazine,* May 1890, 8.

7. *Iron Ore* [Ishpeming, Mich.], 27 March 1897.

8. Federal Writers' Project of the WPA, *Minnesota: A State Guide* (New York: Viking Press, 1938), 292; *The Minnesota Arrowhead Country* (Chicago: Albert Whitman and Co., 1941), 182; Glanville Smith, "My Winter in the Woods," *Atlantic Monthly,* April 1934, 420–21.

9. *Hibbing Tribune,* 7 November 1907; 5 December 1907.

10. *Työmies* [Hancock, Mich. and Superior, Wis.], 2 December 1909; 7 November 1911; 2 January 1920; *Duluth News Tribune,* 1 January 1922.

11. Unidentified 1915 Finnish-language newspaper advertisement in Matti Kaups papers, Immigration History Research Center, University of Minnesota.

SAUNA IN THE NEW WORLD

1. Aage Roussel, "Sandnes and the Neighbouring Farms," Copenhagen, 1936.

IMMIGRANT SAUNAS IN THE LAKE SUPERIOR REGION

1. Hans R. Wasastjerna, ed., *History of the Finns in Minnesota,* trans. Toivo Rosvall (Duluth, Minn.: Finnish-American Historical Society, 1957), 102.

2. Lillian Barberg, *Erick* (New York: Vantage Press, 1962), 40–41.

3. Armas K. E. Holmio, *History of the Finns in Michigan* (Hancock, Mich.: Michiganin Suomalaisten Historia-Seurap, 1967), 80.

4. Ibid., 98.

5. Gene Meier, *'Askel' Means Step* (*L'Anse Sentinel* and Michigan Council for the Humanities, January 1, 1983).

6. Wasastjerna, *History of the Finns in Minnesota,* 578.

7. Konrad Bercovici, *On New Shores* (New York: The Century Co., 1925), 114.

8. Eugene Van Cleef, "The Finn in America," *Geographical Review* 6 (1918): 185–214.

9. Konrad Bercovici, *It's the Gypsy in Me,* self-published autobiography, 1941.

10. This and quotes in subsequent paragraphs from Bercovici, *On New Shores.*

11. *Fergus Falls Weekly Journal,* 28 March 1925. Bercovici's portrayal of the Embarrass Finns received wider exposure from its publication as "The Mystery of the Finnish Farm," in the *Country Gentleman,* a popular agricultural magazine.

12. Bercovici, *On New Shores.*

13. Jorma Aspergrén and Miriam Yliniemi, *Shepherd Boy Becomes Spiritual Elder,* self-published, 2005.

14. Wasastjerna, *History of the Finns in Minnesota,* 193–94.

FINLAND'S SAUNA CULTURE

1. Daniel Rubin, Knight Ridder Newspapers, January 2003.

2. All quotes are from Alexis Kivi, *Seven Brothers,* trans. Alex Matson (New York: The American-Scandinavian Foundation, 1962).

3. Terry G. Jordan-Bychkov and Matti Kaups, *The American Backwoods Frontier: An Ethnic and Ecological Interpretation* (Baltimore: Johns Hopkins University, 1989).

4. Juhani Aho, *Forbidden Fruit and Other Tales,* trans. by Inkeri Väänänen-Jensen (Iowa City, Iowa: Penfield Press, 1994).

5. Keith Bosley and Satu Salo, *Akseli Gallen-Kallela, National Artist of Finland* (Sulkava: Watti-Kustannus Oy, 1985).

6. Aho, *Forbidden Fruit and Other Tales.*

7. *The Experimental House: Muuratsalo* (Jyväskylä: Alvar Aalto Museum, 2006).

THE VALUE OF HEAT

1. *The Brimson-Toimi Legacy, The History of the Area and Its People (Including Fairbanks, Bassett and Ault Townships),* The Brimson-Toimi History Project Committee, 46.

2. The Upper Peninsula folk legend Heikki Lunta was rumored to be able to "peel the pulp with his bare hands." Conga Se Menne, "Guess Who's Coming [to Sauna]?" *Finnish Reggae and Other Sauna Beats,* compact disc, 2005.

3. Jim Woehrle, "Simply a Soothing Sauna," *Country Gentleman,* Autumn 1980.

4. Raija Warkentin, Kaarina Kailo, and Jorma Halonen, *Sweating with Finns: Sauna Stories from North America* (Thunder Bay, Ont.: Lakehead University, Centre for Northern Studies, 2005). Räty claims that his sauna, fired with finely split, bone-dry oak that has been primed with slivers of pine, can reach 200°F in an astonishing twenty minutes.

5. Mikkel Aaland, *Sweat: The Illustrated History and Description of the Finnish Sauna, Russian Bania, Islamic Hammam, Japanese Mushi-Buro, Mexican Temescal, and American Indian and Eskimo Sweatlodge* (Santa Barbara, Calif.: Capra Press, 1978).

KEEPING THE WOOD-FIRED SAUNA TRADITION ALIVE

1. Quotation attributable to Kip Peltoniemi, the self-proclaimed last of the old-time button accordion players of the district.

2. Thomas Fisher, *Salmela Architect* (Minneapolis: University of Minnesota Press, 2005).

3. Arnold Alanen, "In Search of the Pioneer Finnish Homesteader in America," *Finnish Americana* 4 (1981): 72–92.

4. Jon L. Saari, "Upper Peninsula Summer Camps: An Historical Look at Their Place in Our Lives and Nature," in *A Sense of Place: Michigan's Upper Peninsula,* ed. Russell M. Magnaghi and Michael T. Marsden (Marquette: Northern Michigan University Press, in conjunction with the Center for Upper Peninsula Studies, 1997).

Index

MICHAEL NORDSKOG grew up in the heart of North American sauna country. He works as an attorney, writer, and editor, and he lives with his wife and three children on a farm near Viroqua, Wisconsin.

AARON W. HAUTALA is creative director and owner of RedHouseMedia, an advertising agency in Brainerd, Minnesota. His photographs have been featured in *Minnesota Monthly, Duluth News Tribune, Lake Country Journal Magazine,* and advertising campaigns throughout the region.

DAVID SALMELA is a self-trained architect practicing in Duluth, Minnesota. His projects have won three national American Institute of Architects Honor Awards and twenty-one AIA Minnesota Honor Awards. In 2008 AIA Minnesota awarded him the Gold Medal, its highest award bestowed on an individual member. In 2007 he was a recipient of an honorary doctorate from the University of Minnesota.

ARNOLD R. ALANEN is professor emeritus of landscape architecture at the University of Wisconsin–Madison. He is author of *Morgan Park: Duluth, U.S. Steel, and the Forging of a Company Town* (Minnesota, 2008), and he has written extensively about Finnish immigrant settlements, architecture, and cultural landscapes.

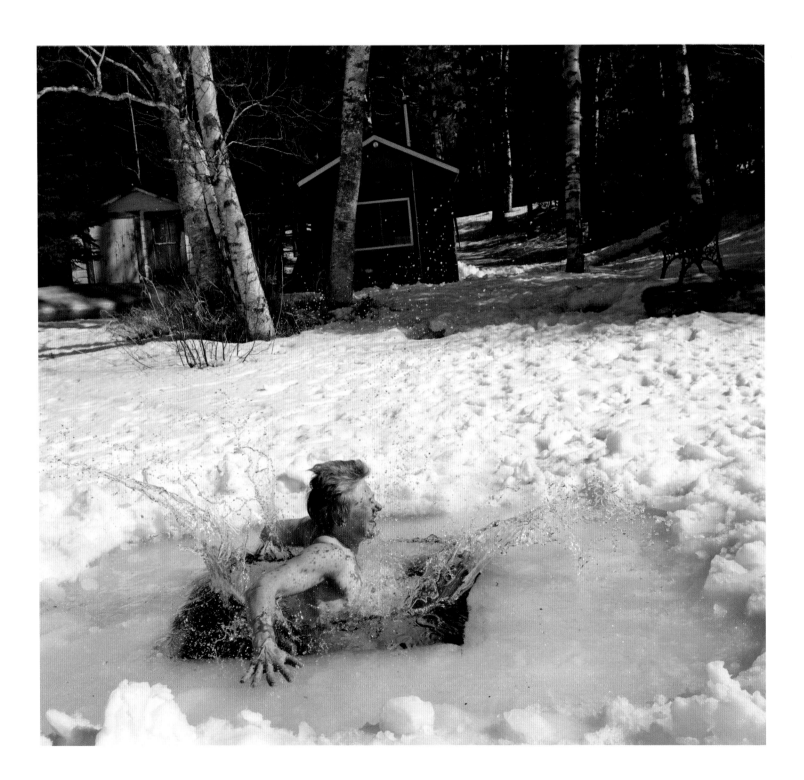